Acclaim for *The Day Laid on the Altar*

Winner of the
Katharine Bakeless Nason Fiction Prize

"Spare, elegant, passionate, and brilliant . . . Like Penelope
Fitzgerald's *The Blue Flower*, drops us deftly into the heart of
another time and place . . . Adria Bernardi inhabits with equal
grace the hearts and minds of men and women, knaves and
saints, artists and beggars, and in the process
has made a novel as moving and precisely detailed as
the paintings she so beautifully describes."
—Andrea Barrett, author of *Ship Fever*
and *The Voyage of the Norwhal*

"Exquisitely crafted . . . seamlessly interweaves three stories
into a superb evocation of sixteenth-century Italy . . .
A reflective tale of art and spiritual survival."
—*Booklist*

"A beautifully written novel." —*Library Journal*

"Near-flawless prose . . . ambitious range . . . sweeping."
—*Publishers Weekly*

"A meditative study on art and life . . . A fine, contemplative
work . . . exploring the passionate impetus to create."
—*Kirkus Reviews*

ADRIA BERNARDI is the author of a collection of short stories, *In
the Gathering Woods*, which was awarded the Drue Heinz
Literature Prize, and *Houses with Names: The Italian
Immigrants of Highwood, Illinois*. She has also published trans-
lations of Italian poetry and nonfiction. She lives in Worcester,
Massachusetts.

The Day Laid on the Altar

Adria Bernardi

A PLUME BOOK

PLUME
Published by the Penguin Group
Penguin Putnam Inc., 375 Hudson Street, New York, New York 10014, U.S.A.
Penguin Books Ltd, 27 Wrights Lane, London W8 5TZ, England
Penguin Books Australia Ltd, Ringwood, Victoria, Australia
Penguin Books Canada Ltd, 10 Alcorn Avenue, Toronto, Ontario,
 Canada M4V 3B2
Penguin Books (N.Z.) Ltd, 182–190 Wairau Road, Auckland 10, New Zealand

Penguin Books Ltd, Registered Offices: Harmondsworth, Middlesex, England

Published by Plume, a member of Penguin Putnam Inc.
This is an authorized reprint of a hardcover edition published by University
Press of New England. For information address Middlebury College Press,
c/o University Press of New England, Hanover, New Hampshire 03755.

First Plume Printing, August 2001
10 9 8 7 6 5 4 3 2 1

Ⓟ REGISTERED TRADEMARK—MARCA REGISTRADA

The Library of Congress has catalogued the hardcover edition
as follows:
Bernardi, Adria.
The day laid on the altar / Adria Bernardi.
 p. cm. — (A Middlebury/Bread Loaf book)
"Katharine Bakeless Nason literary publication prizes" —
 ISBN 1-58465-044-3 (hc.)
 0-452-28257-8 (pbk.)
 I. Title. II. Series.
PS3552.E72725 D39 2000
813'.54—dc21 00-023151

Printed in the United States of America

PUBLISHER'S NOTE
This is a work of fiction. Names, characters, places, and incidents either are
the products of the author's imagination or are used fictitiously, and any
resemblance to actual persons, living or dead, events, or locales is entirely
coincidental.

For

Jeffrey Stovall

Jacob and Isaac

Acknowledgments

Thank you Deborah Adelman, Carol Anshaw, Anne Calcagno, Laurel Fredrickson, Sarah Heekin Redfield, Dean Monti, and Rebecca West for your support. My thanks also to the Heekin Group Foundation, Ledig International Writers' Colony, and to the editors of the journal *Voices in Italian Americana*, which published the first chapter of the novel in its fall 1999 issue under the title "Waiting for Giotto."

The Day Laid on the Altar

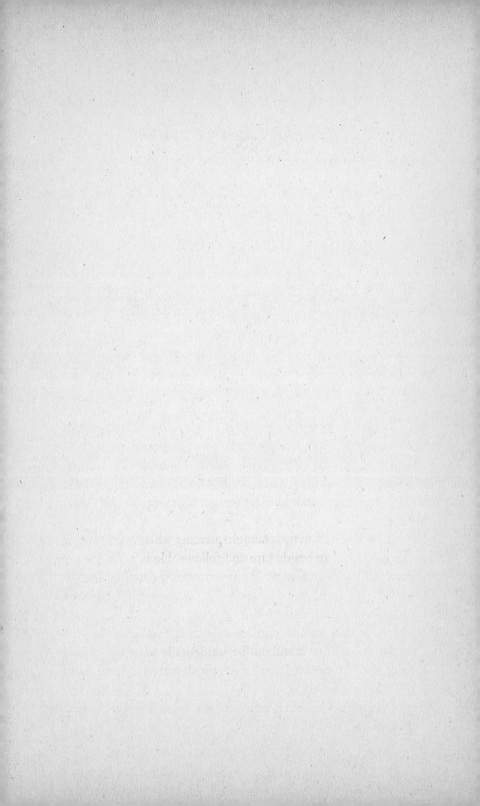

*A*t dusk, he crosses the threshing floor. The soles of his wooden shoes hit against the stones. The stones fit closely, embedded in the ground, squared blocks pressed tightly, one against the other such that no weed can grow between them. The threshing floor is Apennine sandstone, slate-grey, and not easily splintered.

When he exhales, his breath is visible in the faltering light. Below, to his left, in the valley, a bell pounds five times, a hollow knocking toll. He pauses and looks. In Ardonlà, minute lights begin to flicker; the river has already disappeared in the dark. The mountain peak and ridges are looming hunchbacked beasts.

He whistles, a sharp, cranium-piercing whistle, and Diana the goat trots up beside him and follows. He is a tall, gangly man, all limbs and neck. He approaches the stable, leans a shoulder into the door, loosening it, lowering his head as he passes underneath the lintel.

Inside, he lights one candle and sets it up high on a shelf, out of the way, so that it will not be accidentally toppled. A tunic falls to just above his knees; it is a plush material, a purple so deep it is almost black.

Diana the goat settles into the corner and is sleeping like a patient dog.

He takes a panel from the corner, unwinds the piece of sackcloth that covers it. He hangs the cloth on a wooden peg. The panel of chestnut has been planed and smoothed, then coated with lime, which dried, and then was rubbed and smoothed some more. He lays the wooden panel on freshly scattered straw and drops to his haunches, his long legs bent and splayed, the heavy cloth of the tunic draping over his knees.

With jagged fingernails, he scratches his scalp and his arm. Patches of skin have turned white, then red, and he must try not to touch them. The skin throbs and pulls apart from itself, and when he can no longer tolerate it, his nails nick hatch marks into the skin, and the sting relieves his incessant discomfort.

Bartolomeo de Bartolai stares down at what he has drawn: three faces, one floating above the other. Three bodiless beings. Each face is round, with wide, almond-shaped eyes that stare out, impassive and severe, orbs that nearly fill the socket. Each pupil is obsidian, a perfectly round stone. Above the eyes, the thick brows merge together and form a painted gash. He gives each face a tiny, set mouth. In the place of a body, there is an arc, a boat whose prow and stern fan upward into wings. He has copied these figures from angels chiseled in stone above the door of his farmhouse, the work of his grandfather's father. The men of the mountains all know how to work with stone, they can chisel celestial beings from it. His nails are dirty. His fingers are scraped and cut, stiff from the cold. He comes into this stable at night, while the others quietly drink their aqua vita in front of the hearth, dulling their hunger, numbing their sores.

By day he tends the sheep, in the evening he comes to the stable. It is the second night of November in 1560.

The winter is long. Bartolomeo de Bartolai sits drawing on a flat piece of rock, over and over. He draws with clay dug from a ravine and ash taken from the hearth. He draws with charred twigs of chestnut and hawthorn, with charred walnut shells. He makes drawings on flat stones and rough wood. Drawings of

what? The usual things. The things that he knows. Sheep. Goats. Everyday things.

Bartolomeo de Bartolai lives in a remote narrow valley, far away from a city, but knows the story of Giotto, the greatest artist in the history of the world, word of Giotto has made its way even this far. He knows how Giotto's father was a simple fellow who gave his son sheep to tend. How the boy was forever drawing on stones, on the ground, in sand, on anything, and how, one day, he was discovered, by the great painter Cimabue, who saw the boy drawing a sheep on a flat, polished stone. How Cimabue asked the father for permission to take the boy Giotto to Florence, and the father lovingly granted permission. Bartolomeo de Bartolai knows this story, the holy men themselves disseminated it, and he has heard how Giotto, single-handedly, restored good design and drawing to Christendom after it was corrupted by the infidels.

So many others have left to find a way in the world. Others younger than he, who were babies when he was already tending sheep.

He watched them leave with canvas sacks upon their backs, depart and not look behind. From his spot near the river, he was stunned and astonished: They were not waiting. How did they conceive such a thing?

He wanted to say, Stop! You are not ready to go yet! You are too young to set off in the world. This is not how you are supposed to do it. You are supposed to do it like this: sit here by a river, drawing, like me, drawing, drawing, shapes and lines and figures, making them look like they are moving in three dimensions. It is very difficult. You will not necessarily understand the shapes you are making, but you must keep making them and a picture will emerge. Slowly, slowly, until one day, they will dance upon the rock. This is how it must be done. You must serve an apprenticeship, here.

But they did not. They were bold. They told the priest, You have nothing more to teach me. They said to their parents, I break with you.

He watched them leaving, climbing the hill, through the gate of the walled town, up the side of the mountain toward Faidello, up higher toward the house of Abramo, toward the Long Forest and over the hill toward Cutigliano, on to Pistoia. Pistoia, where they have invented a tool, a hand-held weapon that exhales explosion. A pistol. These people who were younger than him headed past Pistoia, past Prato, where abandoned babies are left at the hospice of the Misericordia. They went down the slopes of the foothills, where grapes and acacia grow, onto the plain, into the river bed of the Arno, into the city, Fiorenza.

He envied them, but crossed himself and prayed, because *invidia* is a sin. The envious sinners in purgatory, between the Wrathful and Proud. He saw the others leaving, bounding away, and thought, Do they not risk worse sins?

No, he wanted to shout. Wait. Wait right here with me. Wait your turn. Do not risk abandonment. Come sit beside me; I have been practicing, practicing for years. Come wait with me.

He opened his mouth to shout, he could see them up the hill, but his throat was dry and no sound came out.

Before he can make his way down from the mountains, he must learn the principles; this is his understanding. And so he has prepared and prepared and prepared. Before you even begin to contemplate the journey, you must understand certain things. The principle of perspective. Vanishing point.

Bartolomeo de Bartolai sits making figures on a panel of wood, over and over, waiting for Giotto.

He scavenges and hoards, and whenever he finds a broken plate, a cracked vase, a shattered bottle from the midwife, he gathers the pieces in a canvas sack that hangs from his waist.

4

This sack is called a *scarsella*, an alms purse. Since no one in these mountains possesses coins to fling to beggars, a *scarsella* is any type of gathering sack, whether for mushrooms or for chestnuts.

Whenever he goes to town, to Ardonlà, on market days, he wears the *scarsella* and walks behind the shops on either side of the street to see what has been discarded. Once he found an apothecary jar, broken and without its lid, decorated with blue and yellow scrolls. He gathered the pieces of this ointment jar, wrapped the fragments in a rag, then put the bundle under his cloak. He looked to see what was behind the shop of the blacksmith. Nothing. And behind the tinker. Nothing. Beside the church, he found a broken chalice, made of wine-red glass, which the priest had unblessed and thrown into a heap. Behind the tavern, he found a broken string of beads, pieces of flat blue glass, and he took these as well.

For this scrounging, his mother cuffs the back of his head. At least leave intact our dignity, so that we are not seen picking up broken things from people who have as little as we do. They will call us mendicants and hoarders. But Bartolomeo de Bartolai cannot stop himself from squatting down to pick up a shard if it glints.

He saves the collected fragments in a chest inside the stable.

Halfway down the valley, the windows of the villa are filled with panes of glass. When the Signore married a lady from Ferrara, he put in glass that came from all the way from Venezia. In Venezia, he has heard, there are hordes of men and women and children, arrived from the mountains, who work in shops making glass. How dazzling it would be to live there. Bartolomeo de Bartolai imagines a city of glass, color reflecting everywhere. He imagines heaps of glass everywhere, glistening like the mounds of jewels inside a sultan's tomb. Whenever a glassmaker makes an error, or inadvertently drops a bottle, he tosses the broken pieces into a heap. He has heard of a young person

who travelled to Venezia and is etching spectacular mountains on the insides of vases. In Venezia, the brilliance would only blind him and cause him to wince. Here, instead, he can keep his eyes open, scanning the ground for the rare discarded colored piece.

How were those others able to leave so soon? Not sit up here and wait? He saw their proud chins jutted forward. He saw how they waved to him as they passed by. He believes they saw him as a simple person, sitting there with his sheep. He wanted to remind them that Giotto was a shepherd, but they would not have cared. They would have said, You are left behind by time. They do not even recall Cimabue, he is irrelevant to them, and their gazes are fixed beyond the mountain pass.

He sits and waits for a master, someone to tap his shoulder, to lift him up, usher him by the elbow. Invite him into apprenticeship. Perhaps Giotto himself, stern in profile, will see the drawings, his fine collection of shards, and will say, Yes. Then lead him away, down out of the mountains.

Once, he went to see a great man as the entourage passed on the road above, he had heard he was a great painter. Everyone clapped and sang as the man approached, reached out their hands to him. Young men carried the great man on their backs, on a chair fastened to poles. They sank down in the mud to their knees. From the side of the road, Bartolomeo de Bartolai stretched out his arm, and the great man mimicked the way his hand trembled.

He looks up into the face of each stranger passing through, wondering if he is the Master. Each season, the Giotto he envisions has a different face.

He sits and he waits for Giotto; he knows better than to wait for Cimabue. Too much time has passed. He lives below a narrow dirt road, a mule path no more than three men wide, the only road that passes through the mountains and links one city

to another. He lives in a cluster of ten houses that is too small to be called a hamlet. One house touches the other, and they are all made of the same grey stone as the cliff. The houses sit on a ledge supported by a single granite column. It is called *La Gruccia*, the *crutch*, because from a distance it looks as if it were perched on a walking stick.

Giotto might travel some day along the mule path above. He might stop because he needed to sleep. Or because he needed to eat. Because his horse was tired. Giotto would somehow know that Bartolomeo de Bartolai was sitting by the edge of the river drawing figures of sheep on stone, just as Giotto himself had done, and surely, he would appreciate this diligence.

Did the ones who have gone down receive a call? Because no one goes down without an invitation. How did it enter their minds that they were worthy enough to knock on the door of the privileged? A shepherd does not go through the gates of a rich man's house, not even to a door around back, unless he knows that there is someone who will answer. He knows he would be apprehended, arrested, beaten, put outside the gate to starve. He would be mistaken for a vagrant. Who are they, the ones who went down? These privileged ones who have taken it upon themselves to go down to a master's shop?

He knows that the ones who have left would mock him: That old man, what do you want with that old man? He has nothing to teach you. No one has anything to teach you that you cannot learn by yourself. You are wasting time; your life is passing. Count the days already gone. In winter you could die suddenly of pneumonia; in summer, contagion travels up from the plain. What do you wait for? An invitation on parchment? With gilt edges, rolled tightly into a scroll? Bah, they would say, these young people with sacks hoisted over their shoulders, their chins in the air. Bah. There is no messenger that brings correspondence intended for these parts; the only messages are

7

those that travel through, being carried from one city on the plains to another. This Giotto you wait for is archaic. His students have moved beyond him. They have already stood on his shoulders and seen things he could not dream of. You are too solicitous, too timid. You defer, when you should demand.

But I am only a simple shepherd.

The bell down in the village bongs seven times, a slow weighted rumble. Outside the shed, the sky is black.

He sits on straw in the stable at night and remembers a fresco at a church, the pilgrims' destination, the monastery of San Pellegrino, built on a pinnacle where three valleys come together. The monks say this fresco was done by Giotto.

He carried away the fresco, holds the picture inside his head: San Gioacchino is asleep on the ground in the mountain, chased from the temple into the mountains because he has fathered no children. He wears a rose-colored robe. He is sitting, head on arm, which is resting on his knee. While he is asleep, an angel announces that his barren wife is with child, and that the child will become the mother of God. A shepherd leans on a crutch. One sheep stands on a granite scarp. Another one sleeps. A black goat looks away, while a ram sits wide awake. They are all fat, healthy creatures. The halo of the sleeping saint is golden. A gorse plant nearby is flecked with yellow.

On a piece of stone, Bartolomeo de Bartolai imitates the way the rib cage of the shepherd's dog is visible through its skin, the way the goat's hoof splays as it steps down the side of a cliff.

When Bartolomeo de Bartolai looks around, he sees that all the young people have gone down out of the mountains. One, whom he called friend, Martín de Martinelli, patted him on the head, and then was gone like the rest. He last heard that Martín was in Fiorenza preparing walls for frescoes.

When he left, Martín de Martinelli did not look back or sideways; he had always been preparing to leave. Those who

move away carry off what they wish and remake in their minds those who have stayed, while the ones who remain behind are left to wonder what has become of those who depart. Some who stay in the mountains close their hearts tight to forget the ones who have left; some turn the departed into heroes, making them more than they are. And if those who have ventured out should return, the ones who have remained lose voice in their presence because the returning emigrants claim the expertise of the world.

As a child, Bartolomeo de Bartolai followed after this friend, imitating him. He was intrigued, intimidated. It was excessive adoration. His heart is hardened, and yet he still hopes for a single message. Like a puppy dog. Then he wishes to kick himself for this suppliance, but does not. He turns back into himself and makes marks on stones.

Why was he so dazzled by Martín de Martinelli, a person who treated others like servants? Finally he understands what he had refused to see for so long: Martín de Martinelli is the earth and everyone else is a planet circling.

Martín de Martinelli would occasionally glance over his shoulder as he sat bent over a panel of wood, commenting upon his progress. Bartolomeo de Bartolai wants to know if noteworthiness is like this? Others watching to see if you might be recognized, if you are the one who will go to work in the shop of a master. They watch, afraid of approaching too close lest you remain forever hunched over, eccentric and obscure. It was an infatuation, he decides, a kind of being in love with Martín de Martinelli, with a person incapable of listening. How do you comprehend the world if you see only yourself, over and over and over? Do you see yourself finally as a spectre? As spectre, you then consume the air around you like a flame. And while some pull up cushions to sit at your feet, you fail to notice that others have wandered off, neglected and stung. One person in town called Martín de Martinelli a trinket maker of worthless

things, spoiled, and Bartolomeo de Bartolai said, No, there is genius, wait. I was young, he thinks now. Spellbound. But the truth is, I wanted his way of being for myself, his ease and his boldness. Now I see that these thoughts were a form of Envy, and that this elaborate infatuation was Covetousness, and that I coveted his signature.

He blames others for his timidity:

His great-grandmother who was once a lioness and now does not know her own daughter.

His grandmother who must tend to her and grips his wrist when he passes by.

His mother who drinks a bitter liquid made from distilled walnuts, each time the great-grandmother wails.

His father who leaves the house and wanders into the woods to escape. Bartolomeo de Bartolai stays in the corner waiting to see if his mother will call out for him; when he leaves, his father pats him on the head, and calls him his favorite child, though he knows his favorite child is the one who has stayed, the one who is huddled in the kitchen with a wrist being gripped.

He stays. He waits. He holds his great-grandmother's hand in the dim light while she moans. His grandmother begs him to tell her what is beyond the threshold and he describes the garb of the pilgrims. The painted cart of the book merchant and the books laden onto the back of a mule. Bartolomeo de Bartolai puts a cool cloth on his mother's forehead after she has fallen asleep. He unbolts the door for his father when he comes back home. They all grow old.

It is a new era, the ones who left have said. The old order is gone. Be bold, be deferential no more.

There is calm as his hand moves across a flat, polished stone. He draws, draws, draws, and on his way back from the fields into the house he tosses the stone into a pile in a corner of the

threshing floor. The literate call the threshing floor an *aia*. Aye-a. Like a scream. From all the being beaten down. The peasants like him call it an *ara*, which also means *altar*.

Before they go off, when the journey is still before them, do they feel the twinge of misgiving? In the months before they leave, the impending journey has already changed them. Every encounter becomes a question: Will this be the final encounter? So that in the future you will say, The last time I saw Martín, he was at the fountain in town. But if you should see him once more, this is how he is remembered: The last time I saw Martín, he was in the tavern, playing *tresette* and winning. Once he announced his desire to leave, he could never be Martín in the same way again; he became Martín-who-will-leave-in-September. Once he revealed his intention to leave, he ceased to be part of the daily flow of mundane activity, bodies leaning into plows, planting, training vines against a trellis, harvesting, threshing, butchering a hog, coming into a stone house silently from the snow. He could not be part of the winter's circle around the hearth, or, when the sun emerged in the spring, he was no longer one who replaced slate tiles upon a roof or gathered early berries. At the moment he said he was leaving, Martín de Martinelli placed himself outside all this. It was irreversible. Even if he had changed his mind at the last instant, others would have thought, This year he stayed, but next year? He was no longer part of day-to-day movement, taking tools to the blacksmith or standing against the side of the mountain at the mill as grain was being ground, talking loudly above the roar of the cascade. When the wax of candles dripped onto the stone floor of the church at midnight on Christmas, he was not part of the chanting.

But wasn't it always so, the leaving? Is not the Holy Book that is read on Sunday the story of departure, one after another after another? Were not these mountains populated by nomads

with tents and sheep? The Etrurian people coming up from the plains, some of whom buried the bones of their dead, some of whom buried their ashes in urns. They were followed by Christians who prayed in caves and, then, by Roman soldiers deserting, who were followed by the red-haired, blue-eyed ones with their bagpipes made of sheep gut who built stone huts here, warriors from the north with massive beards and long, consonant-filled words. Then the descendants of Esther fleeing the walled cities on the plains, accused of killing infants. They all fled into the mountains, staggering up here, burying their dead along the way. Trying to outrun war and pestilence. For centuries and centuries, they came up into the mountains. Bartolomeo de Bartolai is all of them. Who can say where he began, and who was the one who begat the person who begat him, who begat that person, all the way back to the beginning? Back to the gods of the northmen. Back to Job.

A man who came back from the Orient with Marco Polo was beaten in Venezia; they beat him on the stone floor under an alcove in the calle dell'Arco. And this man made his way southward to Ravenna, from which he was driven to other cities, Forlì, Ímola, Bologna, skirting the edge of the mountains, persecuted the entire way, until he was driven into a blind alley in Modena by thugs, nearly set afire, and he fled upward, up, up, up, into the mountains. He ran to the highest point, until he could go no farther without descending. He begged for mercy at the feet of the oldest woman of the village who stared down at this man with pitch-black hair. He did not want to go back down onto the plains; he begged her in his native tongue, and because he had a wide smile like her last-born son who had fallen off the mountain, she said to him, *You may stay and be safe.* As she spoke, the others dropped their clubs; one man gave him a massive shepherd's coat, a coat made of skins. He showed the others how to weave reeds into mats of intricate patterns. He built a strange, stringed instrument. He married, and his wife bore twelve children, six of whom survived. Scattered

stone houses hold altars dedicated to a forgotten god whose name means immeasurable light.

The ancestors, yes, were nomads and people in flight, but, once here, they stayed put and lived their lives according to the rhythm of the bell, resounding morning, noon and night; and the seasons, summer, autumn, winter, spring; and all the rituals and holy days, which are repeated in order, in an endless variation. His ancestors of long, long ago, were people in motion, but they were followed by people, he believes, who should remain in this same place, immovable and bound to this soil.

He crosses the *ara* in the fading light of autumn. He sits on straw in a corner of the stable. He picks up a stone and draws. When he is exhausted, he returns to the house and lays his head on a mattress filled with wood shavings and scented with thyme to keep away insects. He dreams of a tap on the shoulder. He dreams about forms, a dog's paw, the curve of an angel's chin. A scaffold. He sees his hand move across a piece of stone, leaving identifiable marks, a sparrow, a lamb that looks as if it could bleat for its mother. He dreams of drawing pictures whole.

At the church of San Pellegrino, he once saw ten angels in a storm-blue sky, and they were all lamenting what occurred below. One threw its head backward, open arms and palms outstretched downward as if pushing away the air. One scratched and tore the skin of its cheeks with its fingernails; another pulled golden strands of hair outward from its scalp. One held a pale yellow cloth up close to its open eyes, as if wanting to conceal the view. The bodies of these angels tapered, then disappeared like flames.

The fresco in the pilgrim's church was a copy, painted by someone who had imitated a fresco down lower in the moun-

tains, which was in turn an imitation of one in the foothills, which was a copy of one from down lower still, an imitation of a fresco in a town on the river, which was a modified version of a fresco farther downriver, a fresco which was an imitation of one in the city. The first one to copy it was called a follower of Giotto, and even after all these copies, the fresco in the mountains at the pilgrims' church site bears the great man's name.

He dreams of drawing pictures whole, but whenever he begins, he falters.

Martín de Martinelli said, Once silenced, we have been unsilenced.

But Bartolomeo de Bartolai sits there knowing that he still stutters, tentative, trepid, trembling.

Tiresome, he knows, and reminds himself he possesses worldly goods: he has a pallet with blankets. He has spiritual wealth. He has all of his fingers and teeth.

When he opens his mouth to say he is timid and weak, to say he cannot speak, a voice behind him says, What, then, is the sound coming from your mouth?

Do you remember how in our youth we rebelled? Martín de Martinelli had said before he left. Do you not recall?

Bartolomeo de Bartolai had replied, *Yes*. But all he remembered were words half-formed in his mouth.

Do you remember how we added our names to the list of demands signed by Iacomo de Petro, Lorenzo de Contro, Rolandino de Berton?

Yes, he said. But in truth he could not write his name.

Boldly, they took down the banner of the duke, and hoisted up another at night in the dark. They fled deep into the woods and sang songs around a fire, and when the sun rose in the morning, the people in the village of Ardonlà woke to find the sky-blue herald of the dissidents suspended from an arch.

Certain reproaches still clang in his ears: The hierarchy has crumbled; we are no longer serfs.

When, on the mule path above, a handbell is rung six times but not at the sixth hour, it means travellers are passing through and are looking for food to purchase. Itinerant merchants, soldiers. Or pilgrims en route to holy places:
San Pellegrino dell'Alpe, they chant,
scendete un po' più giù
abbiam rotto le scarpe
non ne possiamo più.
The penitent traveller says this aloud walking toward the relics of San Pellegrino, the hermit who lived in a hollowed-out beech tree.
San Pellegrino, they mumble aloud,
come down a bit lower,
we have broken our shoes
and cannot go any farther.
Once, eleven years ago, when he heard the bell ringing, Bartolomeo de Bartolai carried up a wooden pail filled with milk; he had no cheese to sell. He climbed the footpath up the side of the mountain, the branches of the hedges brushing his arm, the saw-toothed canes of blackberries pricking through his leggings, the sun beating down on his back.

He arrived at the road out of breath. It was July and pilgrims were travelling south and west toward the mountain pass on their way to the monastery of San Pellegrino. A pilgrim gestured to him. Bartolomeo de Bartolai saw that despite her simple garb of hazel-colored wool, despite her display of poverty, she was privileged; she wore a thick gold ring on a golden chain around her neck. Her alms purse was bulging. Bartolomeo de Bartolai stood in front of her, holding his pail, looking at the ground, waiting to be spoken to.

Mid-conversation, she spoke to another pilgrim. She was not going to the pilgrimage site of San Pellegrino, like the rest,

she said, but rather to the south and east, toward the city of Fiorenza. Then she began speaking of the master Giotto:

Giotto apprenticed with Cimabue for ten years.

Bartolomeo de Bartolai stared at the ground, listening.

The Pope called him to Rome for the Jubilee in 1300, and Giotto worked on the basilica of San Giovanni in Laterno.

Bartolomeo de Bartolai offered her the pail of milk. She batted him away and called her lady-in-waiting.

In that city, he made a mosaic called La Navicella in the portico of Saint Peter's, a mosaic of Christ walking on water.

He listened, open-mouthed. The lady-in-waiting approached and grabbed the pail from him.

In Padova, he painted the Scrovegni chapel, where I myself have prayed, and there is an imitation of it at the pilgrim's church in these savage mountains.

The lady-in-waiting handed the pail to a manservant.

In Assisi, he painted San Francesco's life.

The manservant poured the milk into a large metal flask. The servants watched their lady speak.

He painted the great poet Dante from life.

The manservant thrust the pail back to him.

As she turned to go, Bartolomeo de Bartolai bowed his head and asked the lady, *And, please tell me, on these journeys, what kind of materials does the artist Giotto pack into sacks and transport?*

The pilgrim backed away from him, wrapping her cloak around her, covering her mouth and her nose, and said, *What do you think I am, a book?*

He had seen what a book looked like, he had seen people with their noses looking down into books. So when she said to him, What do you think I am, a book? he was stung, humiliated. He did not know how to understand her insult. He knew that she was not a book; a book is an inanimate object. A book is made of paper, which is made from trees, and the trees come

from forests in the mountains because all of the great forests of the plains have been leveled. No, she was not a book, she was a woman with raven hair visible at the edge of her hood.

But he remembers to this day what the humbly clad pilgrim said, that Giotto painted Dante from life and Bartolomeo de Bartolai does not understand this expression. How else would he have painted him? From death? No, because a painting or mosaic comes from an idea, and an idea is alive. Something you hear or see or smell or touch or taste puts a picture into your head, and this causes you to put down a mark. She was trying to impress them with her knowledge of the world down there, of how far she had travelled, then became offended because she was asked a question she could not answer: What materials does Giotto use? Of course Giotto painted Dante from life; he painted everything from life, a goat with splayed hooves, a shepherd with a tattered hem.

Of course, Bartolomeo de Bartolai knows what a book is. He has seen them at the villa of the Signore. He was shown a page once, during the month of August, when he and his father were summoned to the villa. They were asked to move a wardrobe from one room to another. They hoisted it with great difficulty and carried it on their backs across the hall into another room. The Signore was not sure where he wanted it placed, so he went upstairs to ask his wife, the lady from Ferrara for whom he had put in glass windows. They set down the wardrobe, and while the Signore was gone, Bartolomeo de Bartolai gazed around the room at the polished marble floor with its swirling of onyx and pavonazzo purple and umber.

In the corner, Bartolomeo de Bartolai saw a strange piece of furniture. As tall as his waist, it stood on a single leg, like a crane, a *gru*. There was a tray at the top made of two pieces of wood that fit together and lay like a bird's open wings. A book rested on top. The Signore's voice and footsteps were still up-

stairs, and Bartolomeo de Bartolai peered down into the open book, careful not to breathe on it.

One page was a wall of marks. One page was a drawing. The drawing was this: two circles side by side. Inside the circle on the right was a form with a rounded back, the profile of a monster with a single eye of ultramarine. Inside the other circle was a pair of curved claws that reached up toward the monster.

The Signore swept in and saw him looking. His father raised a hand to cuff him, but the Signore stopped him and said to Bartolomeo de Bartolai, Do you like my book? I bought it in Venezia for three *scudi*. You can buy any book you want in Venezia; it is where most of them are published. In that city, a man is free to think his own thoughts and ideas circulate freely. The thoughts of the reformers are openly discussed. Some doubt the existence of hell, some deny the Trinity.

He pointed to the book and placed an index finger on certain marks, pronouncing the words *Orbis Descriptio*.

This is a map of the world. He pointed to the circle on the right. This is the Old World, and this blue oval is the Mediterranean. We are the Old World.

Then, he pointed to the circle on the left. This is the New World. The Arctic, the territory of Florida, the Terra Incognita of the interior, which all belongs to Spain. Below, America of the South.

Bartolomeo de Bartolai would like him to point out other places, for example, where is Fiorenza? He would like to see where Giotto has travelled. But instead, the Signore says: I have decided after all to put the piece of furniture back into the room where it was originally. On the way out, the Signore tells them that behind the stables there is an old pine board from a table top which they are welcome to take.

At twilight, that evening, he went back down to the villa. He walked through the villa's forest-garden, where the Signore planted pine trees so they formed the letters *V* and *L*, the initials of the Signora. In a corner of this walled forest-garden was

a heap of discarded objects, and there Bartolomeo de Bartolai found the pine board.

For months the board has lain untouched in the corner of the stable; he is afraid to make a mark on it, does not want to spoil it.

Each night, he walks out to the stable, seeking a respite from the house where his great-grandmother sits on a mat in the corner and moans and rocks, her eyes wide and staring at nothing. His grandmother feeds her chestnut gruel with a wooden spoon. The great-grandmother spits the food back out. The grandmother clears her mother's lips with the edge of the spoon. His grandmother grabs the wrist of whoever is nearest, whoever is passing by, whoever is most alive. In springtime, his mother sings of the harvest, *The day laid on the threshing floor is flayed*. She sings love songs all day long. His father bends his head under the granite lintel as he passes through the doorway; his shoulders brush the frame, though he is not a large man, and he slams the door shut. His grandmother grabs him by the wrist and his mother sings. In the day, he takes his cloth hat from the bench and follows his father out the door. He goes off into the field, and watches after the five thin sheep and the three emaciated goats.

In order to pay for grazing rights for a season, when he was a boy, his mother cut his hair. She pulled it tight, away from his head, cut it close to the scalp. Then she sold it to a pillow merchant passing through. After she cut his hair, he would run down the path into the field, where everything was blurred from tears, and he pointed out the grass to the beasts, showing them which blades to eat.

As he walks to the stable, he carries a lantern because darkness comes early. They begrudge him oil for the lamp. His mother says, Where do you think more oil will come from? You think it will seep out of a crack in a stone? His father says,

When a spark turns into a ball of fire what will we do then? This is the discussion every night, every night at dusk, when his uncle and great-uncle, his grandfather's brother, get ready to tell the stories they have told again and again, the same ones, how a grave robber dug up the bones of San Sisto in Rome and tried to sell them to priests all the way up into the mountains, but no one believed him, and, desperate because he was high up in the mountains in winter and without any money, he sold them to a wealthy old woman, who bought the bones with one gold *genovino* and a sword and a bundle of candles, and as soon as he handed the relics to the old woman, he was turned into a pillar of stone, and she had a chapel built right there. He does not want to hear any more of these stories, he has heard them every night of his life: how the poor young man found a key that let him into the princess's heart, how the charcoal-maker's son solved three riddles. He begs them for oil for the lamp. His mother accuses him: *spende fina i capei*; he would spend even the hair on his head. At the villa of the Signore, the lanterns burn all night long, yet they accuse him of being profligate for trying to extend the day.

His father hollers, And if you start an inferno? His mother hollers, If we run out of light? Then his grandmother grabs his wrist and holds it up to them and says, You cut his hair, you sold it, now give the child some light.

If he could, he would write the master Giotto a letter. Tell him that he is ready to come down and work in his shop, to mix plaster, to clean paintbrushes. If only to rake, with a wooden pitchfork, the stall where his horse sleeps at night.

In the stable, he cleans a spot on the dirt and lays the panel on the ground.

We are isolated, but we hear things. We are remote, but we see things.

He hears rumblings of what goes on below; the sounds echo up three valleys, the Valley of the Scoltenna, the Valley of the

Dragon, the Valley of Light, and by the time the sound makes its way up into the mountains, after having bounced off mountain walls, it is only a faint echo. The sounds arrive belatedly, sometimes centuries later. He has heard the priest speak the word, FRACTUM. This is the way the sound comes up, in pieces. After something has already happened to fracture the whole into pieces.

He spills out the pieces of terra-cotta and broken glass and sifts through what he possesses.

What do you think I am, a book? He hears the words again and again. I have never left these mountains, but I know something of other places because people travelling through bring word, the itinerant monk, the copper seller, the merchant who buys flock and hair. They carry up messages from down below, and this is how it is possible to know something of other places. I have seen certain things with my own eyes, like the frescoes at the pilgrims' church, the saint sleeping in the mountains, ten angels wailing in the sky.

In his head, he continues to fight with Martín de Martinelli, ten years gone, thinks of how Martín de Martinelli said to him: Wake up! Raise up your eyes!

And how he replied, I have been taught to keep my head bowed and not to swagger, to not be a braggart and spendthrift like the prosperous shepherd who sees a little of the world, sells his fat sheep down on the plains, and comes back with coins in his pockets, blaspheming and knocking over tables in the tavern. I have been taught to be simple, honest, laborious. Labor is honor. All I have ever seen are heads bent over and down; look at the way everyone's shoulders are curved.

Look up, said Martín de Martinelli.

And Bartolomeo de Bartolai answered, You look up and you see misery. You see how the lords overrun one another's territory, spreading disaster, spreading strife. You see how brigands steal anything that glistens. How soldiers bring contagion and

take away flour. You see starving mothers who leave infants to die on the mountainside so that the ones at home survive.

And Martín de Martinelli replied, The days of a peasant's false humility are over. Do you not see that a new day is coming which will do away with antiquated ways? Do you not see that there will be new systems to classify, new instruments to understand the world?

Bartolomeo de Bartolai asked him, Does it bring comfort to think that there will be instruments to measure cold and heat, that will measure the strength of wind and the weight of air? Will they not take away the hours of the day, the days in their merciful order? The seasons that make this life, with its empty stomach and lesions, bearable? Will it not take away the calendar that begins with the feast day of the Blessed Virgin and ends with the feast day of San Silvestro? Would you have me break this whole?

Martín de Martinelli said, I would not have you break anything. I am not here to cause you to do anything. I can only say what I am going to do: I am leaving. I am not going to remain up here, my stifled voice vibrating against the vocal chords. Do you know how it is when you have a great sadness, a great anger, and try to make no sound? Do you know how it is when you hold it inside your throat? Of course you know, because you are a mountain dweller, made of stone, and you think you can outlast the pain without opening your mouth.

Bartolomeo de Bartolai answered, I notice no such pain.

Martín de Martinelli said, If a dog catches his paw in a trap, and the paw is cut, it yelps and howls, and then, if the dog survives, and the wound heals, he becomes accustomed to the pain and merely winces each time he puts his weight upon the paw.

He must turn away from the admonishments; he must turn away and try to recall something else. Something beautiful. A mosaic. On the other side of the river above Ardonlà are the ru-

ins of a fortress that sits on a steep bluff. Below it is a cave. The entryway is hidden among bushes and rocks along the riverbed. The passageway opens into caverns where Christians hid when they fled into the mountains. They were followers of Sant' Apollinaris of Ravenna. They built an altar in a cave, and, on the vault, they made a mosaic like the ones they had left behind. When it became safe, they built their altars above ground, and the one below were forgotten. The forest above was cleared and a landslide buried the cave's entrance.

He saw the mosaics only once. He was a child. He was taken there by his great-grandmother who is now being fed like a baby. She was not afraid of wolves or bears, and she took his hand and led him there. He was not afraid because she was not afraid. She was bent over as she walked beside him, leaning on her wooden walking stick, which was shaped like the letter T. She told him she was going to show him where a saint was buried, told him that no one else remembered, that they were too afraid to look. As she walked, she became transformed and stood up straight; she threw away her walking stick. She moved like a goat from one rock to another and she was not afraid of slipping on a wet stone. All the lines were erased from her face; her blue eyes were lights; she balanced on one rock, and then another, along the bank of the river.

He is trying to see the mosaic again. There was a strange source of light. There were foreign plants and creatures. A palm tree with leaves that grew out from the center like the legs of a spider. A turtle climbing out of the water onto a bank. There were two cranes drinking from a pedestal fountain.

At night, he crosses the *ara*, and sits on the straw with a sackcloth blanket covering his legs. The lantern hangs on a wooden peg. On the floor, there is a jar containing mastic, which he has made from the resin of pine. Before him on a rag, he has spread out the fragments of broken glass and painted

terra-cotta. Each night, he lays out a row, edging one piece against another.

He thinks, We hear things up in the mountains. We are isolated, but we hear things, just as we heard of Giotto. Just as we have heard that in France on the other side of the river called the Var, men slaughter each other. One man slashes the gullet of the other, like a pig is killed before dressing, from ear to ear, without remorse. Except they are doing this in every season and pigs are only killed once a year, in the autumn, when the weather is cold, just before water freezes. They hang the bodies upside down, bound by the feet, suspended from a tree, and the blood is left to drain out onto the ground. An itinerant bookseller said this.

One man massacres the other over the right to name God. One man slays one man, then, there is retaliation, and five more are slain. Each sect buries its dead in trenches, all together, one body piled on top of another, because there are too many bodies to give each soul its own grave. The foot soldiers of the holy war do not allow firewood to pass through their territory into the towns; there are no trees left to be cut. The wealthy possess furniture to burn, but the poor man, who has already burned his one table and one bench, freezes to death. The warriors are violating women, and the women who survive are left with the hated seed. They are slaying children who are not yet steady on their feet.

They say that Peace, herself, is revolted, and that she holds her stomach and retches; she has hidden her face under a hood and has started to walk away from the battlefields, following along in the ruts made by the wheels of carts, dragging herself along a muddy road that is lined with corpses, not even bothering to lift the hem of her cloak.

This is what the merchant passing through said. We hear things. We hear it in fragments, we hear it in imperfect remnants.

24

Remnants like the tunic he wears, a *saltimindosso* it is called. Giotto's shepherd wears a *saltimindosso* like this, with a hem torn in three places. The tear must have been recent, otherwise the shepherd would have repaired it, because it is the only garment he possesses. Bartolomeo de Bartolai's shirt is made from clothing discarded from the Signore's villa, a deep black-purple of a fine heavy material. But who is to say this *saltimindosso* is made from a discarded article of clothing? Perhaps it was a blanket that covered his horse.

Each night, he looks at all the irregular pieces and stares at them. A dot, a line, a wave. At times, he has to look away; the pieces seem to be moving, clattering against each other like hundreds of rows of broken teeth.

He scratches his scalp, the discomfort is great.

Even as a child, he got scabs on the top of his head. He would stand with his back to his mother, who sat on the bench and looked through his hair at his scalp. She applied an ointment which she made from beeswax and mint and rosemary and lard. She put this on his scalp in the morning and at night before he went to sleep. She told him the skin of his scalp was drying out, and that his scalp was drying out because his head was too hot from thinking. She asked him again and again about the thoughts inside his head. You have to let your thoughts escape with breath. Otherwise your mind will get too warm, and strange things will begin to happen. As a way of encouraging him to speak, she asked him questions constantly: Do you think it will rain tomorrow? Do you think the frost will come early this year? She would ask him, What are the thoughts bouncing around inside your head? He would try his best to answer her, to describe the thoughts in his head. Why, if the bell tower in Ardonlà blessed by San Bernardino is supposed to keep away storms, why then did the roof of the house called Le Borre collapse? And his mother said, It was from the

weight of the snow and it was the will of God. He asked her, If an angel dropped a string from the sky, could you climb to heaven, and, if you could, would your weight pull the angel down? She answered, Angels do not need rope, that is why there is prayer. He asked, Why did the side of the mountain fall into the river and smother the cave with the mosaics? She said, Because the earth has grown heavy and swollen with pride.

In the kitchen, in front of the low stone sink, she grabbed him by the shoulders and shook him, told him not tell anyone about the sores and not to scratch his scalp in public. Otherwise, they will tell the priest and he will call you before him to ask you what you are thinking. They are burning even humble people at the stake for what they are thinking. When I was a girl, they wanted to execute a miller in Savignano because he was going around saying that the world created itself, that God Himself did not make it. His mind was working too hard; he was burning up with thoughts.

His mother put more salve on his scalp and stopped asking what he was thinking. She asked which plants the sheep had eaten and how many weeds he had pulled from the soil.

Talk, talk, she said to her son, putting ointment on his scalp. Let the heat escape. She urged him to speak, but to not say anything.

He must not speak, and so he listens. He listens when the priest speaks in church about books, saying how books are like people. How each one is made differently, how some contain holy thoughts, how some contain impure thoughts, how some contain heresy.

The priest says a book is like a human being; it has a spine, and if the book is opened roughly, too quickly, the spine can be snapped, and that a book can scream in pain, yell out, hurl out words, shriek.

A book, he also says, is like fire, and if there are unholy things inside, when the book is closed, the marks on the pages

rub against each other, embering twigs, one on top of another, smoldering, burning low as long as the book is closed, and then, the moment the covers are opened, the pages ignite and the book explodes into a ball of fire, singeing the skin and blinding the eyes.

An evil book, he says, can be the Devil himself, taking an elegant, refined form, with the hems of his garments embroidered with gold thread. He can take the form of a book, its covers decorated with fine tooled leather, its pages fluttering like silk. And at night, the priest says, the book changes shape and goes to each of the people sleeping under the roof and puts impure pictures inside their heads so that they dream of sinning in unimagined ways.

He speaks about books in the small round church, even though there is no one present who can read.

Bartolomeo de Bartolai cannot read, but he knows this much, that inside a book there are pages. And on those pages are marks. And those who understand the marks get pictures inside their heads. The marks look like vines in spring, brittle and dark, clinging to a wall washed white with lime. He does not understand how to adjust his eyes, the way one does when moving from a field into a forest. In a field, you look for the hare's round shape against the tall straight blades; in the forest you look for a glint of white, the spot on the animal's hind. It is a question of teaching your eyes how to look. This is the secret of understanding a book, he believes, but he does not know how to instruct his eyes.

At night, in the stable, the fragments he has assembled assault his eyes and mock him: This makes no sense, a band of gorse yellow here? Why, Fool?

All the fragments laid out together, separately inarticulate, broken, chipped. It makes him dizzy. It is an untrained swirl, and he becomes so confused he must look away.

He fans the pieces out carefully.

In one pile, the fragments of blue.

Giotto's angels tore their hair, clawed the skin of their faces. And he has made three faces like theirs.

He has sketched them out on the panel, and is now forming them with tiles. But on his panel, in his shed, there are not mere angels. The top one is a god, who, like the Signore, is the most powerful. The one in the middle is a god who is the next most powerful and is his heir. Below him is another god who is the least powerful, but has other powers the other two do not, because he is also Light. Bartolomeo de Bartolai has made three gods; he believes they are three and distinct and separate, each having his place in the hierarchy.

He believes he has made a picture that is holy and sacred, but if the ambitious priest were to hear of it, a priest who wants to escape from the mountains and be allowed to return to the plains, Bartolomeo de Bartolai would be interrogated. Why have you drawn this, my son? You do not really mean to say that God is three different beings? The priest would turn to Bartolomeo de Bartolai, ask him to renounce the work, to redefine it, reminding him that God is one and indivisible. That God created light. That God is not light.

He shows the panel to no one, not because he considers this dissent, but because it is a peasant's habit to conceal. For the cheeks, he has saved his most precious glass, pieces of Asian porcelain tinted pink.

It is nearly winter. No one passes through on the narrow road above. Snow has already fallen. Bartolomeo de Bartolai tells himself he must admit what is obvious, that Giotto is ancient and it is unlikely he will travel up into these mountains.

He returns to the stable each night, crossing the *ara*. He hangs the lantern on a wooden peg, burns the precious oil. He

throws the goat Diana a piece of crust he has saved. He stares at the dried-out board of pine, dreams of pictures he has seen before. He is no longer waiting for the great man. Great men do not arrive. He will never go down out of the mountains. He will soothe the foreheads of his elders, and the past will be his future.

Bartolomeo de Bartolai sits on the ground on clean straw under a dim yellow light, his fingers aching with cold. He fans out the pieces before him. He examines his few shards of cobalt and azurite blue. He begins to set them in mastic, though he has not collected sufficient fragments to complete the sky.

*M*artín de Martinelli, lucky traveller, stands at the front of a barge. His cape flutters, a sinoper corner floating against grey. He is able-bodied, well fed, with the promise of work when he arrives. A contract and his lucky coin. Fiorenza is behind him, a spot of paint already dried and cracked. Ferrara and Padova are behind him, Venezia is still a day away. The journey is made in fog; he cannot tolerate obscureness and silence. The stillness knocks loose memory of another journey: a mule path draped in fog, his foot slipping on stone. He stands with his jaw jutted forward, tightened: I should have been content to live in a small stone house, venerating an ancient threshing floor no wider than this barge?

No.

Martín de Martinelli paces. He turns his head and scans the deck, sizes up the other travellers. An old woman with a basket of eggs sits on a bench, her head covered in a stiff white scarf that is wound around her shoulders, her nose sharp and hooked in profile, massive hands resting on knees. A wandering mendicant stands at the rear of the barge, wringing his hands and mumbling, My heart knocked down like dried-out grass, I forget to eat my bread. At one side of the barge, the father of a family of six, who travels without a wife; the eldest girl, eight years old, herds the children together and wipes their noses.

She slaps the back of the head of a boy whose hand has moved too close to a rope wound around an iron cleat. Her head is wrapped in a soiled piece of linen.

Martín de Martinelli looks at a bargeman standing next to him and says, Oh what a beautiful day to travel, this day. *O che bel dì da viazziar', ste' dì.* Lovely day? The barge is enveloped in fog. Boats moored at the shore are colorless and visible only in silhouette. Reeds are charred faggots sticking upright from the mud. It is a miserable day. Martín de Martinelli has made a joke and the bargeman grunts an incomprehensible word.

He turns his head from left to right, looking for a listener. Someone with whom he can strike up a conversation. Tell a story. He likes to discuss, *scurrar'*. To sit around and talk. But he thinks better of it. Who can you trust when you travel? Better to stand apart, not let them know your destination; otherwise you might find someone waiting for you in a narrow alley of a city you do not know, waiting to slit apart your coat in search of a coin.

But still, a little banter, a friendly little game. He fingers the playing cards. They cost him a small fortune. He says to the bargeman, One quick hand? The bargeman spits over the side of the boat.

He'll wait to talk. Maybe the barge will pick up a companionable passenger farther along the river.

After the hasty departure from Fiorenza, this unending day on the barge has given him too much time to think. He is a man who acts and does not like to brood.

He left when he was fifteen years old. Five is his lucky number. Nobody wants five. They all choose four and three and seven. The holy numbers. But he has always had luck with five and its multiples. This is the fifth day of the fifth month; he is twenty-five years old.

On the barge, the children herded by the girl called Magda are asleep, leaning against each other in a silent heap. From his

sleeve, the mendicant pulls a rosary with wooden beads and holds it to the sky; he recites a prayer in a loud bray, saying over and over,

Awake, I wail, like a solitary bird upon a roof.

At Dolo, the old woman with the basket of eggs stiffly disembarks, her massive right hand reaching to steady herself on a post of the floating dock as she steps off the barge. No other traveller embarks, and Martín de Martinelli is still without a listener and has found no one to tell how he bounded away from those mountains. How he broke free. How they were wrong and old and he was right and young. There was nothing to hold him, the future lay down on the plains, in the city, and anyone who remained was a fool. And timid. Content to live amidst grey. And he was anything but meek. He would see the priest and say to his face: You haven't had a worthwhile thing to say since Saint Peter mended his fishing nets. They sent only senile priests up into the mountains, or those who were corrupt or out of the minds. The priest somehow managed to live well, with belly full, unlike everyone else, who lived from day to day. From meal to meal. And he refused to do this. That was for the others, to stay in a stone house freezing. For the others, to look at an outsider with suspicion. *Who are you? Who are your people?* And if a traveller cannot establish this quickly enough, they turn their backs. Or they sound the bells and wail to warn the others there is a stranger in their midst. They hide their livestock. It is only disease and violence, they say, that come from outside, that come up from the plains. Sores and lacerations.

He should have stayed? And spent the rest of his life hauling boulders up from a ravine so that some nobleman could have a road constructed to please his blushing bride, a road that would never be completed because the pass through which they tried to build it is covered with fog and snow seven months of the year? Martín de Martinelli should have remained so he could push a boulder up the side of a mountain only to have it roll down over him and pulverize his bones?

No. He was not going to remain in one of those hovels the mountaineers self-mockingly called their mansions.

No. He was fifteen years old and the future was his.

When opportunity came, he seized it.

He was sitting in the tavern in Ardonlà. He was playing tresette and winning. He held three sevens in his hand.

There was Menni the peasant, the blacksmith Artù. The muleteer, Zacagnèr, was across the table in his massive sheepskin coat. At the other table in the tavern, sat a stranger, who watched them playing their hands. He called out to Martín de Martinelli, Come play a hand with me. You seem a lucky young man.

Lucky? said Zacagnèr, ice-blue eyes above his wind-burned cheeks. Are you kidding? The stars follow him around, they compete to shine on him. The stars shove each other around just trying to get a good look.

Martín de Martinelli said, Never mind, let's finish the hand.

Artù the blacksmith started in. If my father owned a mill, I'd be lucky too.

And not just any mill, said the peasant Menni. The only mill. The miser. The *pitocco*, with his great yellowing beard and his wooden leg, riding astride his donkey like he's Christ entering town on Palm Sunday. His father the miller is buying up all of our fields which we sell to keep from starving. He tells us: If you can't pay to have the grain ground, then eat it whole.

Zacagnèr began to chant in his gravel-voice, a sing-song in a rumble:

Al mugnaio, al mugnaio,
portemm' il gran' per renderlo fin'
poi prende tutt' ed 'nostri quattrin'
e rende brezhia dal mulin'
ci demma soltanto un po'-po'-in'
quazhi nulla di bon farin'.
E se mumiaremmo al mugnaio
E dizh a nu, "Allor' chiap el dì da metter' in forno."

The others joined: The miller, the miller, we take him our grain to grind it fine, he takes our coins and steals us blind, gives us back a little tiny bit, hardly enough to make one loaf, and when we complain, the miller will say, So open the oven door and bake the day.

Don't blame me for the actions of the miller, take it up with my father, Martín de Martinelli said. Let's play.

The man at the adjacent table held up an index finger to signal that he was buying a round. He held a cup high and drank to their health. Then he put down the cup and said, We need men with good strong backs. We pay daily and well.

The hand, Martín de Martinelli said.

But nobody was playing, listening instead to this man from the plains who was looking to hire men.

We need men who know how to work with stone.

You've come to the right place, Zacagnèr said. He opened his arms wide. Look around. Do you see anything but rock?

Martín de Martinelli folded the cards and cupped them into his hand, the three sevens burning his palms. He pretended he was not listening and he carved the letter *M* into the side of the table.

O Fiorenza, Fiorenza, the recruiter sang, Fiorenza can make you a wealthy man.

An artist I know is looking for good men to work in his workshop, the recruiter said.

Martín de Martinelli turned around to listen.

He has more work than he knows what to do with. He's making frescoes in a church that is bigger than any church you'll see around here.

Martín de Martinelli moved over to his table and sat down.

He wants men who are not afraid of a day's work, who know about walls.

Martín de Martinelli is the one to convince, said Zacagnèr. Just show him where to sign and he'll go. He knows how to write and he's a hungry boy ready to spring loose.

None but Martín de Martinelli put his mark on the document. He put a silver coin on the table, the fee for this transaction. The recruiter gave him back a *quattrino*, which can buy very little; it takes nine to buy a capon. This became his lucky coin. Martín de Martinelli signed his full name twice. He folded the contract. He put it and his lucky coin into the leather pouch that hung around his neck from a string. He sat back down at the other table and then he said, Let's finish the hand.

Martín de Martinelli was not afraid to put his name on a piece of paper; he did not have the peasant's resistance to written things. He was not afraid to speak up. He had a good strong back. Why should he not sign? Why should he not go? He had the versatile skills of the mountaineer, the *montanaro*, and he knew how to use them.

As a child, he learned to grind grain, a skill he rejected, not deigning to wipe clean the ladles and sieves and measuring bowls in a godforsaken mill, in a hamlet tucked into the crevice of a mountain. A miller's son, he was privileged. His father was despised by all for taking a fraction of the harvest as payment; he had costs of his own, he said, and had to pay tribute money to the Signore. The others would have seen him dead had it been in their power. His father was a hard man who beat him. But the miller taught him to read and he never learned the habit of being humble.

He left without saying anything to his father. What did he owe him? Nothing. He had given him nothing but insults and blows with his fists. His mother was dead. Besides, does any father say, Go, I give you my blessing. Go son, have a life filled with joy and abundance, and do not worry about me, go. Is there one who says this? No. Show me one, Martín de Martinelli thought, and I will give you everything I own. I will lay you odds ten to one.

Martín de Martinelli had seen all he wanted to see of those mountains. Children and women out of their minds with hunger, dreaming about a single egg. Selling any milk they had,

selling any cheese they made. And what was left? Nuts. Flour from chestnuts, from which they made a bread called tree bread, which is dry and coarse and bitter. In the winter, whole households going mad, deprived of food that feeds the brain. One day in early February, the little girl Magda climbed up a tree next to the *ara*. She climbed up higher and higher. She thought she saw a medlar. Mamma, I can reach it now. And she climbed and climbed, then reached and tried to grab it. She fell to her death from an oak tree. Fell onto a sheet of milk-white ice.

Martín de Martinelli, contract in pocket, said to his friend Bartolomeo de Bartolai, Don't waste another year. Come along, leave La Gruccia. It's good to have a friend in the world, a *socio*, someone who can look out for you. He should have known that Bartolomeo de Bartolai would never set foot from home. Bartolomeo with scabs on his face and his arms.

Martín de Martinelli grew weary of the weight of all the centuries that came before him. Of all the bent-over heads. Of resignation and servitude. Of the infinite reserve of humility, of the cloak of deferential meekness they wrapped around themselves. Yes Master, Yes Lord, Yes Sir, Whatever you wish. And underneath the tattered cloak, the worn-out *coprimiserie*, stood an immovable mass of granite.

A wandering monk from the North had come to town saying bold things, new things. That pilgrimages are worthless. That you cannot buy your way into heaven with indulgences. That the Host is only an image of Christ and is not Christ himself. And the others did not listen or consider, even as the priest was taking their money to stock his larder. Martín de Martinelli observed them scurry, like mice when a candle is lit in a darkened room. He heard them mumble as they retreated through their doorways and bolted the wooden doors shut, afraid of a spiritualist in their midst, an Anabaptist, a heretic. They were afraid to hear what the traveller had to say, but he was not, why should he be afraid to listen?

He did not want to be buried in the stillness, the preponder-

ance of grey, the darkness of those old mountains, always weight upon weight upon weight. It was too early to be entombed, he was fifteen years old, old enough to see what would happen if he stayed. He knew the world was expanding, a continent each decade.

He saw the mule path above him, a cobblestone road. The leaves of the chestnut trees had fallen, there was a haze over all of the limbs, a sheet of gauze dropped from the sky, and something grabbed hold of his lungs and squeezed so hard he could not breathe, and he saw all possibility, all potential, extinguished. He saw himself like all the others, rooted where they sprang up, acquiring the same nervous twitch of their fathers, their same lame gaits, the same way of cursing the sky. He saw his own father, able to deny a cupful of cornmeal to a starving household, hoarding his money and grain, then drinking it away. When he saw that mule path above, he could feel the stones slick with moss and lichen under his shoes. The woods, acrid like rotten bark and urine, stung his nostrils. When he saw that road above him, he knew he needed to climb up to it and follow it out.

Oh, the city called him, Fiorenza, Fiorenza. It could sing, you know, a siren song. And when you have heard nothing but shepherds wailing across the valley in piercing shrieks, the whine and sear of a bagpipe, the possibility of another melody will draw you away. This, and the possibility that the world is not slab-grey.

Come, Bartolomeo, we can go together, he said. A traveller needs a trustworthy friend.

No, Bartolomeo de Bartolai said. No. My father is planting a new field of beets. Maybe the coming year.

Martín de Martinelli left in the summer with a band of pilgrims. He thought he could travel safely with them. He had no document that said, *Allow passage to Martín de Martinelli, inhabitant of this place, fifteen years of age, of slight build, medium*

height, with abundant curly black hair, sparse beard, and straight nose. In good health. He did not have the travel document he needed, but when opportunity called to him, he left without it. Opportunity called him on a Tuesday in July, a market day, when a pilgrim put her hand on his forearm and invited him to travel with her group, saying they needed someone who knew the roads of the region. She complimented him on his hair and curled a ringlet around her finger.

When he fled, he took a sack that contained a mallet, a hammer, a chisel, a trowel, the implements with which he intended to earn an abundant living. He had the contract underneath his shirt.

The first day of the journey, the pilgrims had gone only a short distance before they stopped at the nearby town, Rio di Alba. Martín de Martinelli, impatient with delay, had wanted to go much farther, but the others wanted to pray at the oratory of San Rocco.

He had seen the oratory already, twenty times, the fresco painted by Saccaccino Saccaccini da Carpi when his father was still a boy. A Madonna and child surrounded by healing saints. Everywhere you go, saints are painted to ward off plague. In his own town, Ardonlà, a fresco above the piazza, the first fresco he ever saw. SALVA POPULUM TUUM VIRGO MARIA. Fourteen hundred and sixty-two. This supplication against the plague, already a century old. The Virgin and saints sit stiff and lifeless, sweet but flat. By the time the artwork arrived, it was already obsolete. Martín de Martinelli wanted to learn new styles, and the only way to learn them was to leave those starving villages, where house after house fell into disuse, and roofs collapsed into hearths.

He had no patience to linger there with the pilgrims; he did not want to encounter someone he knew. He wanted to be on his way out.

He did not pray at the altar. While the others implored San Rocco to protect them from plague, he waited outside the

threshold and leaned against the wall. He believed he was immune to all contagion.

He was tired of small, cramped oratories and narrow grottoes with doors so small you had to lower your head to enter. He wanted to see a picture on the wall that was not painted in a darkened cave. He dreamed of an unmeasurable distance between the top of his head and the vault. Inside, the pilgrims were mumbling, reciting the truisms written on the wall: *Amico fidelis nulla est compartio*. Nothing is equal to a faithful friend.

Well, it is unfortunate, Martín de Martinelli thought, running a stick up and down the mortar between two stones. Too bad that Bartolomeo would not go, his loss, the price of not being bold. Bartolomeo de Bartolai in that crumbling stable, so ancient they have abandoned it and built another one. Bartolomeo bent over night after night in near darkness fitting together broken pieces.

Even as a little boy, Bartolomeo was timorous: Let's steal some apples. No. Leave the sheep and go fishing. No. And when they got older and Martín de Martinelli invited him along, No, I have too much work to do. No, I had better not go into those places. We are agitating against the Duke, changing the flag on the tower at night, we are fleeing into the forest to celebrate. No. He has been this way since they were small boys, born the same month, baptized the same day.

In the house of the Bartolai, they took care of their own. They were humble and faithful. They did not lock their old ones up or smother them with pillows during the night. They knew to hand the ancient woman a rag doll to comfort her. They lifted her on their backs and carried her to the hearth so that she could be bathed in warm water. They carried her, her legs paralyzed and useless, in their arms, took her out to the garden, set her on a chair. They treated her like a newborn baby, and smoothed down her hair and stroked her face. They resembled the saint they were named for, Bartolomeo, a man in whom there was no guile.

Endlessly patient with their sick ones, they hardened and aged quickly. It was more than they could bear. They were always waiting for the next hardship. Reverent, obedient, constant. These traits will erode Bartolomeo de Bartolai and he will not profit from them. He will never know another life. The Bartolai never leave, yet, the nagging question remains: Should I go or stay? And then before they know it, half their days are spent, and they are still asking the same question, tugging at the sleeves of their children who dream of new cities and departure. San Bartolomeo, exemplar saint, was flayed alive.

No, Martín de Martinelli, told himself as he leaned against the wall, No, you are right to leave.

He turned his back away from the street so that no passerby would recognize him and ask where he was going. His shoulders were tensed, waiting for someone to ask, and he prepared his reply. I am going to buy salt for my father.

If the pilgrims would finish, they could be on their way. He wanted to know the outcome, whether being hidden among a group of holy people would allow safe passage into the territory of Toscana. He was ready to go, fearing only that someone would stop him. Go, Martín, go. Go now, otherwise you will wake up one afternoon from a nap drooling, thinking you should have gone when you had the chance.

The pilgrims in the oratory were saying, Amen, amen.

He could not afford to sit around, waiting until he had collected enough coins to pay off his debt. He would have lost his chance forever. Opportunity would not have presented itself again. Think of it, a pilgrim with a bit of life left in her, a widow, who asked him to be a guide. A contract in his pocket. No, he did not want to be like the rest of the men in the tavern on Saturday night, saying, Yes, next year, enough of this miserable place, next year, that will be the year to go. And they sit and they sit and they sit. No, it was his lucky month and his lucky day. When he got to Fiorenza, he would send back the money to Bartolomeo de Bartolai, this is what he intended. But one thing

led to another and he would have the entire sum collected, only to lose it before he could find a trustworthy messenger.

Strà, Dolo, Mira. He recites to himself the names of the towns that the barge has passed. He is drawing nearer to the city where a man with worth will be recognized and rewarded. The Venetians know nothing when it comes to plaster and stone; they import their craftsmen from the mainland. Come, come, we will offer you citizenship. In Venezia, a man will get what is due him. Unlike in Fiorenza.

When the pilgrims reached Fiorenza, they slept outside the wall. Martín de Martinelli slept in the tent and bed of the widow-pilgrim. She would only sin as far as Venezia, she said, and then she would repent before travelling to the Holy Land. My husband has been dead fifteen years. I was betrothed to him when I was five, married to him when I was twelve. I am traversing the land haphazardly, going from shrine to shrine; I am taking pleasure for the first time, I have the means to do it, but I am also praying and preparing to die. In that tent, Martín de Martinelli did everything she asked of him. She seemed pleased and slept well.

In the morning, he entered the city with the pilgrims. He said good-bye to the widow-pilgrim, who gave him five *scudi* and two small books. Martín de Martinelli crossed to the other side of the Arno, across from the cathedral and bell tower, weaving his way through narrow streets, stepping over ducks and geese, pinned to the wall whenever a cart passed by. The air was thick with smoke from the furnaces and fires. He looked through wide arched doorways and saw men hunched over benches and wheels and fires, each workshop, each *bottega*, a cave that opened up into the street.

He stepped into the shop of a blacksmith, who leaned into a horse's flank, its back leg bent upward, the hoof resting against his thigh. With a short curved knife, he pared the hoof.

Where is the workshop of the artist Pontormo?

Between the via Laura and via della Colanna, the blacksmith said without looking back.

When Martín de Martinelli found it, he went right up to the front door. Didn't he have a contract under his shirt? The metal knocker was the shape of a lion's claw gripped around a ball. He lifted it and dropped it. He looked at the window above to see if someone would fling open the shutter.

Instead, the door opened in front of him, and a boy with a pock-marked face stuck his head out. A vertical scar ran along the side of his face, close to his left ear.

What? What do you want? he said.

I'm here to work for Pontormo.

He's not looking for anyone. Besides, he only takes locals.

That is not what I heard, said Martín de Martinelli.

What did you hear?

I heard that he needed some mountain men who are not afraid to work.

You did not hear correctly then.

But I have the contract, Martín de Martinelli said, pulling out the piece of paper from inside his tunic.

What's this? This is nothing.

The boy who looked at the piece of paper could not read.

Martín de Martinelli started speaking rapidly.

A recruiter named Baldini said the Master was looking for men with good strong backs, who know how to make walls. I paid him his fee, now let me talk to your superior.

You paid money for a worthless piece of paper? How much did you pay? *Montanaro*.

Rube, hick, country boy. The insults clanged in his ears. Get away, there's no work for you.

Martín de Martinelli wedged a foot inside the doorway.

Let me talk to your superior, he said to the boy with the pock-marked face.

No.

Is there no one I can talk to?

No.

I'll show him how I work stone, show him how I know walls.

No. Go.

The boy with the pock-marked face tried to shut the door.

I was born on Sunday.

The boy cracked open the door.

So?

I'm lucky.

So go be lucky somewhere else. We don't need another hungry boy to feed.

Wait. I'll show you something, said Martín de Martinelli.

The boy opened the door a bit wider and watched as Martín de Martinelli pulled a deck of cards from his sack.

Get away, I don't play cards or dice. Be gone or I'll call Orson' down from upstairs and he'll tear your lungs out.

No, no, stay calm, not to play a game, I want to tell you one quick story.

Martín de Martinelli shuffled the cards in one hand, his foot still planted over the threshold.

One by one he flipped over cards, five in all: The King of Clubs, the three of Clubs, the Knight of Cups, the Knight of Coins, the Knight of Clubs.

Without hesitation, he improvised a story as each card appeared.

The King of Clubs had three sons, the first Prince, the second Prince, the third Prince.

He put those cards underneath the deck, and the turned over three others: the Deuce of Coins, the Five of Clubs, the Seven of Swords.

One son was born on the second day of December, one on the fifth, and one on the seventh.

Martín de Martinelli turned over the Four of Coins:

Now the King called his sons to the table where dinner was being served.

The boy with the pock-marked face straightened up and scratched a scab on his cheek.

Martín de Martinelli turned over the Queen of Coins:

A female Servant brought out a covered platter.

He turned over the Queen and the Four of Cups:

And a second female Servant carried out four cups to the table.

The next cards to appear were the Three of Coins, the Ace of Clubs, the Four of Swords, the Six of Coins, the Six of Swords, the Ace of Cups, the Five of Cups, the Seven of Coins, the Five of Coins.

Martín de Martinelli said, Well, we both know they were eating well, the best of everything. Three different kinds of meat. A leg of lamb. Four tiny squab roasted on a spit. Six cutlets of pork simmered in six sprigs of rosemary and a generous tureen of gravy. There were five different kinds of wine. Seven loaves of bread made of the finest flour. Five different platters of boiled greens and vegetables.

The boy with the pock-marked face swallowed. Martín de Martinelli slipped these cards underneath.

As he turned each card over, he continued:

For dessert, seven of the roundest, thinnest, most delicate pancakes drowning in an abundance of honey.

Oh, what a feast, the boy said.

When you eat so much, Martín de Martinelli said, tapping the boy's chest lightly with his finger, you have to take something to help you digest, that's how the stomachs of the *signori* are. Three of them drank a cup of tea, all except the Third Prince.

Oh, what a fine meal, the boy said.

Well, Martín de Martinelli continued, nearing the end of the deck:

The King stood up from the table and asked for his walking stick, and he said, I need something done, and whoever can perform this feat will inherit each of my three kingdoms: the

Land from whence the Best Warriors Come, the Land of Gold Mines, the Land of Bountiful Harvests. Well, don't you know the three Princes started to shove each other around, trying to be the first to try. Follow me to the garden, the King said, and they passed through the orchard with all of its fruit trees and bushes. Now, in the middle of this garden was an enormous stone; it was perfectly round and standing upright. I need for one of you to move this stone.

Well the First Prince struck his sword against the rock three times.

Nothing.

And the Second Prince said, Wait, I have a better idea. And he struck a club against the stone six times.

Nothing.

And then he hit the club against the rock four times.

Nothing again.

Well, the Third Prince said, Wait, I have a better idea.

He called two servant girls, both of whom had black hair, one of whom was tall and thin as a pole, one of whom was tall and very mature on top.

The Third Prince ordered them, Now play that song that draws the people down from the mountains.

And the two servant girls both sang. Suddenly, a handsome young man with a full head of hair and a very broad chest appeared at the western gate of the garden. He wore a sack on his back and was holding a walking stick that resembled a sword.

The Third Prince said, Stranger, if you can move this stone, I will take you into this household and you will become my most trusted advisor. You will be given two servants. You will never again sleep out in the cold, you will never know hunger, and you will always wear the finest clothing.

The Stranger carrying the walking stick did not hesitate. He took five objects from his sack and laid them on the ground. A mallet, a hammer, a chisel, a trowel and a double-fluted whistle made of two long reeds. He picked up the whistle, held it to his

lips and blew. The sound was like the highest pitched bell, it made them all deaf for a moment, and in that moment when they could not hear, a tiny crack appeared in the stone. The crack grew and spread through the stone, like a vine sending shoots all directions, and the stone shattered into a thousand tiny pieces.

The Third Prince said to the Stranger, Well done. Now one more thing. You must tell me where you come from, so that travellers from whence you come will be welcome wherever they go and always treated with respect, always find a friendly ear and open door.

Martín de Martinelli paused. The boy raised his eyebrows, jutted his chin forward, motioning for him to continue and finish the story. There was one card left that had not been shown.

The pock-marked boy watched to see as Martín de Martinelli flipped it over.

The Deuce of Clubs.

Well, Martín de Martinelli said, the Stranger who had dealt with the stone so handily, picked up the two weapons, a club and a sword, which had been discarded by the first two Princes, and with them he formed a V, saying to the Third Prince, Sir, when you want a mountain moved, who would you call upon, but someone from the mountains? And the Stranger held aloft the V, then inverted it high above his head, so that it looked like a mountain.

Martín de Martinelli, quick learner, had opened the front door, he had gotten himself into the *bottega*. A lucky break: as it happened, one of the other shop-boys, the cousin of the boy with the pock-marked face, had just died of influenza.

Nothing went wrong for Martín de Martinelli. He never questioned his good fortune, never gave thought to the possibility that it might change. There are those who never have a lucky break, poor beasts, like Bartolomeo de Bartolai, who will

never have a thing to his name except debts to the past and claims on his days. Then there are the ones, like Martín de Martinelli, who have all the fortune and never doubt it, never question it, that is part of being lucky. Plague and famine made wide circles around him. Skin afflictions and tapeworm did not touch him. He could cut a cloak in two and still have a whole one. Like loaves and fishes. A miracle. Like Martín the saint, who gave half his coat to a naked beggar and did not suffer from the cold.

He began as a shop-boy, a *garzon*, and moved up quickly to apprentice and then to assistant of the Master's assistants. He learned and prospered. He learned, in order, all that a painter needed to know, beginning with how to cut a quill for drawing. How to make a paintbrush from a miniver tail. Years later, he learned how to make colors. He learned how to prepare the wall for fresco, and this became his talent.

At the tavern called Attaviano, Martín de Martinelli drank wine and played cards in the evening until very late. The Master disapproved of his appetite. He passed down word through the supervisor Orson' that great works cannot be made without abstinence and parsimony and fasting, that libation and gluttony poison the source of inspiration and contaminate the well. But in the morning, no matter how much he had drunk or played, Martín de Martinelli was always the first to enter the workshop. He had a body that could tolerate excess: his eye was unfailing and his hands were unfaltering. He could grind and mix colors blind. And Pontormo, the miser, the *pitocco*, indulged Martín de Martinelli. Once, in March of fifty-six, he pulled Martín aside to work on the wall in his living quarters, asked him to fix up a crack that had appeared under a window. He watched as Martín de Martinelli tested the sand, sifting it through his fingers before grinding it some more. He applied the plaster to the wall as the Master looked on.

He stayed four years after Pontormo's death, on the first day

of January in 1557, but by then the *bottega* had fallen apart. Oh, that they had listened to the counsel of Martín de Martinelli, but no, and he left the Master's followers to fight it out among themselves, and found a situation in another workshop. Before he left, Orson' had cursed him, warned him against his arrogance, said that the days of assured work were over, that the skill of preparing a wall for fresco, of knowing the secrets of mixing paint and applying it to wet plaster, were over. Don't think you will always prosper, friend, don't think you will always have a position. The wealthy determine our plight, their tastes, their whimsies, and if they want their walls painted, fine, but if not, you are just another out-of-work waterboy. Martín de Martinelli laughed in his face and said, I'll work no more for you, and he went to the *bottega* of a painter who was much in demand. He prospered. He could eye a wall and detect its flaws, predict where water damage would begin. He could make a plaster whose quality never varied from one season to another.

Now, on this barge, Martín de Martinelli is floating toward Venezia, where he is confident that another workshop will need his skills. He prospered during the difficult years of fifty-four, fifty-five, and fifty-six, when most everyone else was suffering. Why should it be any different in a new city, where they will welcome a man who shares the secrets of how color is handled in Fiorenza? Why should he stay in a place where he is not given adequate time to pay back his debts? Everyone knows he will eventually repay a lost bet.

Good luck has always been his faithful companion, more faithful than any friend or woman or dog. He has always been lucky, and this stirs envy. Oh, better that he had wallowed in discontent and humbly accepted misfortune along with them? The others in the workshop resented his entry into the guild. To become an apprentice one must be born in the city itself, not come in from outside. But in time of contagion, famine, disaster, there are always those who can slip in and find their service valued.

A dream instructed him to leave Fiorenza:

A workbench, waist high. On it, pots and jars filled with pigment. Sheets of paper, the cartoons affixed to the wall to make the underdrawings. It all sat there in a great muddle, its usual state of order, the sign of work being done. This table folded into the middle, dropped into a V. Nothing on the table had been removed, there was not enough time, yet nothing spilled or fell; everything remained attached to the surface. The folded table became a flat box with a handle, which could be carried.

The only town of any size before the barge reaches the lagoon is called Malcontenta. Martín de Martinelli fingers his lucky coin. The moon is in opposition and it is a good time to be making a change, he tells himself. He is not overly superstitious about ill omens, but wishes he did not have to pass a town whose name is Malcontenta.

The mendicant sits on a bench on the side of the barge, his back turned toward the shore. He is rocking back and forth. He is looking at his shoes, mumbling,

My days dissolve in smoke, my bones burn like embers.

I sustain myself with ashes instead of bread; with my drink I mix tears.

My days are like an evening shadow, and I am like dried-out grass.

The mendicant notices Martín de Martinelli staring, and he beckons him over. Martín de Martinelli will talk to anyone who will listen. He walks over and sits. The mendicant smells of rotten onions. His body has been untouched by water for months and months. His skin is caked with dust, a darkened puce, dried and stiffened from exposure to the elements.

He says nothing to Martín de Martinelli.

A seagull screeches overhead.

Martín de Martinelli breaks the silence:

Do you think the sky will clear?

Blessed is the Lord who made Light.

Martín de Martinelli begins to stand up, but the mendicant grabs his wrist.

Blessed is the Lord who made the Wind.

Yes, says Martín de Martinelli.

Blessed is the Lord who made the Moon and the Stars.

Yes.

Blessed is the Lord who made the Day, the Month, the Year.

He stands. The mendicant grabs the knapsack flung over his shoulder, and Martín de Martinelli sits down once more.

What is in your sack, young man?

The tools of my trade.

And what is your trade?

Martín de Martinelli tells him.

The Lord blesses a tradesman. Work and work and work.

Martín de Martinelli nods in agreement.

Work is good, the mendicant says. But grace is better. Do you know how to read a soul?

Martín de Martinelli has not spoken to anyone in hours, so he must talk, even if it is to a mendicant who utters gibberish.

I know a great deal about color, he says.

The mendicant says, Color.

Should he discuss his trade? Is it safe? Is it wise? What harm can there be in speaking to this beggar-monk dressed in his cloak of sackcloth? He will not tell him about the tavern, about how he wins at card games. He will tell him of his work:

Ultramarine is made from lapis lazuli, a stone having more value than gold. Lapis is pounded in a mortar and broken down without water. The stone must be covered or the dust will float away. Powder is passed through a sieve again and again. Resin and mastic and wax are placed in a bowl that has never been used, and they are melded together. Lapis is mixed into the

paste and it is kneaded as if it were bread. Each day, for three days, it is worked a little more.

The mendicant hums.

When it is time, the mixture is poured into a bowl with a cupful of lye and two wooden sticks will turn it. When the lye is saturated with blue, the paste is moved into another container, and it is bathed in lye again. This is done for several days, until the paste no longer yields color.

You must turn away from the things of this world, the mendicant says.

I still have much to tell, says Martín de Martinelli.

The mendicant continues humming.

The bowls of blue-colored lye are lined up: the first from the first day, the second from the second, the third from the third. The blues from the first two days are the richest and care must be taken not to adulterate the rich with the poor. The blue will settle on the bottom. Each day, the lye must be drained until the blue is dry.

The mendicant pulls at his tangled hair. And this is how you make the Sky?

Ultramarine was once used for the sky, Martín de Martinelli replies, but now, it is more complex, and there is a preference for muted colors. Of all the colors, ultramarine is the most valuable. Keep the ultramarine in a safe place, for it could be your salvation.

Martín de Martinelli's knowledge of ultramarine and his ability to prepare walls and apply color for fresco will bring his bounty in Venezia. Halls are being prepared for the arrival of kings and he has a contract inside his shirt.

The mendicant looks to the sky.

Praise to the Lord. Praise the sky and the birds and the river.

The mendicant starts to stand. Martín de Martinelli says, Are you leaving? I have so much more to tell you; it will make the hours of our journey pass more quickly.

There are many hours, he says. Many hours. And now is the

hour of silence and I must not talk or listen, so turn your discourse elsewhere.

On a barge among reeds, he smells the first sting of brine. The Venetians will be glad to see him coming; a tradesman is always welcome. He will reestablish himself and start anew, now that Fiorenza has proven stingy. It is 1561, and he is confident of a new city. He has lived free and well, why should it not continue? Venezia imports craftsmen from the mainland. Come, come, we will offer you citizenship. Why should he have stayed in Fiorenza, with envy everywhere? He might be there still were it not for that little debt and irate cardplayers too impatient to wait.

Remind yourself of the rules of wall preparation, so that when you step off this creaking barge, you will disembark with vigor:

Sweep the wall well and wet it down thoroughly.

The lime must be at least fifteen years old.

Apply plaster with a trowel unevenly. Apply it at the boundaries of light and dark.

Apply color more deeply than it is intended to be seen.

Now finish, Martín, for God's sake, you are almost there:

Paint is applied while the plaster is damp. The section of plaster laid is equal to the amount of work that can be done in one day; each section is called a *giornata*. The size of a day's work varies. The *giornata* with the mountains and sky is vast, because mountains and sky can be painted more quickly. You strive to conceal the seam between one *giornata* and another, but the division can sometimes be seen, where one day's work gives way to another.

Martín de Martinelli, fortunate traveller, stands at the front of the barge, his view now unimpeded. Venezia is a ribbon, paint-dropped thin. It floats in front of his eyes, towers and

domes, hatching across the horizon. His cape flutters, sinoper, a corner stretching toward the horizon, where buildings are jewels strung out on rope, a necklace made of precious stones, topaz, ruby, amber, glinting in the late-day sun, forming an enormous, wide mansion, a floating structure with outstretched wings whose threshing floor is the sea.

*T*itian sits with his back to the sea. Most days, he sits at the head of the table, facing the lagoon, but today he does not want to be distracted. He has already lost precious time to a fleck of red on the distant cape of a passenger floating by, yanked back in time unexpectedly, unwillingly. He was so young then. He painted the fresco in just three days, a Saint Christopher in the ducal palace, but, oh, how he had lost sleep over the color of that cloak. The foreigners threatening the city from every direction, the French, the Turks, but Venezia reigned supreme and she would be protected by Christopher, patron saint of wayfarers, protector from daily harm. Saint Christopher, who hoisted that plump, robust Christ child upon his shoulder and ferried him across the lagoon. He painted those bulging figures into the *intonaco*. Behind them, on the horizon, dashes and dots, spires and the basilica of San Marco strung out, the corner of the cloak almost touching the Campanile. To the right of the saint's bulging calf in the background, his mountains. But that cloak, that billowing cloak had given him a headache, throbbing, throbbing, it could not be too triumphant a red, or too muted. The color would not meld properly with the still-wet plaster. Redder than russet, browner than garnet. Wasn't there also a hint of crimson? He stared at paint, then wall, then paint, a stand-off, until he coaxed out sinoper.

And now, where was he? There are financial matters at hand and he cannot lose sight of them. His children do not concentrate. The new generation is soft, complacent, and he must see to it that they understand. He must guarantee that the affairs of his house will be well managed.

Lavinia Vecellio, compliant daughter, has watched as her father sits there brooding on this late afternoon in August. She watched as he sat under the pergola, framed by it, the sea stretched behind him, the lagoon grey-blue and lolling. Murano is in the distance, though in this stillborn heat, the island is not distinct, and its spires are not visible. Water and sky are indistinguishable, and all is covered with a haze that causes her to squint.

Clear the table, Titian bellows.

There is nothing on the table, except a vase with flowers. Musk roses and oriental poppies, signs of capricious beauty and silence.

Clear the table of everything, he says again.

I want a pitcher of water flavored with tamarind. And a glass. Clear the table of everything but that.

Lavinia, with a nod of her head, summons the servant.

The servant slips quickly to the table from the edge of the pergola where she has been standing, her folded hands resting on her belly, below her ample bosom. She moves lightly, quickly, like a young woman still, but her shoulders, slightly rounded, reveal the beginnings of dissolving bone. Her neck is fine, her hands and feet small. Her hair is covered with a cap, grey tendrils escaping. The servant removes the vase of flowers. She brings a pitcher and a violet drinking glass.

There, *papà*, Lavinia says.

Titian holds a volume that is bound in green leather, stamped with the insignia of a lion. He raises the book, drops it, hard, onto the table's surface. The water in the pitcher rolls and he calls the meeting to order.

It is necessary to speak of such things, he says.

His children are assembled around him.

If something were to happen to me. If, for example, I were to die of influenza.

What does he say? What?

If I were to be taken by heart attack.

What? What does he say?

Or pestilence.

Do not say that. Impossible to think. Titian succumbing. The last plague just four years ago. Put it out of your mind.

Or, if, Titian says, pausing, If I were to be killed in a duel.

Lavinia laughs uneasily at her father, in his seventy-second year, sketching this scene of himself.

We need to start thinking about it now because otherwise the wealth we have accrued will disappear like water on an un- protected pavement in August at noon.

Relief again. Even when he does not have a paintbrush in hand, her father paints with such broad, dramatic strokes.

He reaches for the handle of the pitcher. Beads of moisture have formed on its surface.

The servant glides closer to pour it, but with a flick of the wrist he waves her away and she retreats toward the back of the house, ascending the stone staircase.

Let me begin by saying, I see this as an opportunity.

An opportunity to do something for my children, and some day, for my grandchildren, for my grandchildren's children.

Grandchildren's children? Lavinia thinks. But I just got here. We all just got here, and already we're on our way out? You mean to say that this table will be no more. Impossible. Not one or two missing. But all of us?

Halfway down the tunnel of the pergola, behind Titian's head, Lavinia sees two birds. Yellow. Yes, but what kind of yel- low? She tests herself. This is a household in which there can be

no slackness in naming color. Against the sea, which is pearl green and lagoon blue, two flecks bob on perches. Canary yellow.

The pergola is covered with jasmine and ivy, signs of elegance and friendship. In moments of discomfort, she loses herself to detail.

Her father speaking of his own demise. Impossible.

And suddenly, for one moment, she feels a vast space between the top of her head and the beams, a vast and weightless square. It sits there without putting pressure upon her skull, but its depth fills her fleetingly with vertigo; it is a space to fall up into and be forever lost. Her chest constricts and she loses a breath.

Oh stop, Lavinia. Stop. She wills herself to swallow air.

A breeze will generally circulate well through this pergola, but there must be at least a hint of air movement, and on this day there is none. She fans herself with her hand. He should have postponed this meeting for a cooler day, but this is the day he has designated for this meeting, and so be it, if we all die from heat stroke discussing his will.

Pomponio, the eldest, has taken the chair with direct view of the sea. Facing his father, there is a table between them. His face is chalk white and his cheeks are a network of claret-colored veins. Pomponio is not aging well, Lavinia thinks. He drinks too much, eats too often, and does not rest sufficiently. My brother the clergyman acts distracted to convey indifference. He crosses his arms and strokes his jaw. He wears a shirt of Flemish linen; delicate drawstrings weighted with gold beads hang from his collar and sleeves. He clears his throat frequently and adjusts the dangling strings. He does not act as a priest should act.

Orazio, the middle child, sits across from her. Attentive, he tries so hard to project a businesslike demeanor, emotional detachment, but he cannot bear to hear Titian talking about his

death. Orazio gazes earnestly, Lavinia sees, not at their father's face, but at some fixed, invisible, point just above his head.

Lavinia faces the gardens. She wears garnet earrings that are shaped like teardrops. Her feet are flat on the pavement and she is a picture of serenity in this covered courtyard.

Titian is austere, somber, his joke about duels long gone. Lavinia makes herself listen as he begins to read numbers, the distribution of assets, the balance of debt and credit. When he talks of commerce, he does not seem like her father, but like someone unrelated to her. It is not usual for a woman to be called to take a seat in the discussion of an estate. Were her mother alive, Lavinia would not be sitting here, but her mother has been dead for years and years and Lavinia has no memory of her.

She listens. The amount paid annually to the Vecellio family for timber that is floated down from mountain rivers onto the plains. How the timber is contracted to companies that make paper. Lavinia sees Pomponio wince at this mention of the lumber; her brother does not think that a family of this stature should soil its hands in commerce of this kind. A gentleman's hands should not touch common things, and there is always paint underneath his father's nails.

She cannot look at her father's eyes. She looks at his overall face, until it becomes a blur, then she shifts to his ear, his chin, so as to be looking in the direction of his face. When he looks at Lavinia, she looks at her hands. She stares down as long as she can, until she thinks it gives the appearance of inattentiveness, which it is not; it is merely that she finds it difficult to maintain a steady gaze while her father speaks of assets that will exist when he does not.

How much he resembles his self-portrait, a painting she turns away from whenever she passes it in the upstairs hall.

In the portrait, Titian sits at the corner of a table, his right leg hidden under it, his left leg visible at the side. He wears a

sleeveless coat of sable and a white silk shirt. A russet chain bestowed upon him by Charles the Fifth. All the weight of his right hand and forearm are concentrated into his fingertips, which he presses into the table. He looks ready to spring up, as if he were a reluctant subject and someone else has forced him to be still.

In his face, vitality is drained away. On his bald head sits a black velvet skull cap, his zucchetto. The bones of his skull are apparent, the temple a deeply recessed cave. His mouth is pulled tight, the beard nearly grey. The canvas is dark: bracken, raven, puce. The only light, the only places in the painting where Titian saw fit to put white, are in the glints at the corner of his collar, the buttons of his shirt, and the crisp fold of cloth that is draped over the table's edge. He sits there, solid, still the Master, but disappearing at the edges, and his hands remain unfinished.

She cannot bear to look at it. It is a remarkable likeness, but it is not the Titian she wants to see. Stern and grave. Consumed by thought. He can go for days without saying a word. He has sat at this very table under the pergola, leaning over his soup bowl like a peasant, elbows on the table, looking down, not lifting his eyes, except to take a piece of bread from beside his plate and tear off a smaller piece with his hands. Without his looking up, the servant Giovanna da Malborghetto knows when he wants more wine, when he is dissatisfied with it. She can tell from the position of his shoulders.

In these moods, without saying a word, he orders Lavinia to sit beside him. She sits dutifully, while he stares straight ahead. She wants to get up, leave, attend to her affairs, but she is fixed to her seat. She feels somehow at fault. He sits with his arms folded, glaring and saying nothing. Sometimes, she wants to laugh, it is so much like the tantrum of a three-year-old child. She does not care for Titian's self-portrait, not because it is not a fine thing, but because it reminds her too much of an aspect she would prefer not to see.

This is the attitude of her father as he sits under the pergola now, presiding from the end of the table. He reads from the book, listing inventory: costumes in his wardrobe, swords, easels and canvas, rare colors of paint.

Lavinia does not like to watch him as he orders his assistants. She does not like to see the fear he instills in them, and then, when he is again benevolent and indulgent, she cringes to see their relief. She does not like to see his easy familiarity with patrons, their representatives and envoys. He changes mood as the moment requires: jovial, somber, regal, deferential. She has seen how he comes away with whatever he wants. She has seen him humble himself as the boy from the mountain hamlet of Cadore, and then, the instant the representative is out the door, speak with glee of the pious bribe he has just transacted, a painting in exchange for a canonry.

Titian senses Lavinia's distaste, and once he said to her, You think it is crass, but how else do you think I keep a roof over your head and over the heads of all the others who depend upon me?

Whenever I go, Titian says, and I'm not planning on going anywhere anytime soon, there will be canvases throughout the house, because I will paint until the day I die. No, now, don't go getting morose; it's a fact of life, children, dying.

He tells them that, as they all know, they have been fortunate, blessed, that sickness has passed by the door more than once. He tells them that, as far as the inventory goes, it will always be evolving, so it is impossible to predict what it will contain at the time of his death. No long faces, please, he says to them, it is better to talk about this now, while he is still here, so that that they can have a clear picture of the situation. He tells them to negotiate, hard, after he's gone, reminding them how patrons will try to squirm their way out of agreements, how they will say the agreed-upon price was less than it was. Dukes will haggle like fishmongers, he says, claiming

the painting is incomplete, that it is not as had been discussed. They will say that the agreement was for a painting of Saint Paul and this is a Saint Peter, but for a lower price they will take it.

Your hearts will be heavy, Titian says. Well I hope so; at any rate, I won't have any control over that.

Perhaps they may want to dispose of the paintings as quickly as possible, or perhaps they may find it too painful to sell them. He cannot foresee their response, but he tells them again to negotiate as if he were still alive and to not take one *scudo* less than a painting is worth. The more astonishingly wealthy the clients are, the more numerous and sumptuous their palaces, he says, the tighter they hold their money, the tighter they wear their shoes.

He pauses.

But we can be just as tight; it's not for nothing that we come from the mountains.

And he waits for his children to laugh at this joke.

He says again that it is time to think of these matters, as painful as it may be. It seems like yesterday when each of them was teething, sucking on their tiny fists. He tells about the time Orazio gnawed a groove in the leg of chair. About the time Lavinia fell going up the stairs and cut her chin. It pains him to have to talk about these things, he says, but the sooner they do it, the sooner it will be done.

He turns a page and begins at the top:

Your uncle Francesco and I were trying to sell our interest in the iron mine up in Cadore, but I have not had much progress since he died eighteen months and four days ago.

Without having taken a drink, he swallows.

He notes the amount he sends semi-annually to a cousin in Cadore for the welfare of her daugher who will never be able to care for herself, who will never be able to find a husband. She is a mild-mannered girl, he says, but has the mind of a child,

and he expects them to continue to support her after he is gone.

He taps the piece of paper with his right index finger.

This is for the upkeep of the cemetery at Cadore.

He reads an amount.

This is for the upkeep of the church.

He says how much is set aside to pay the men who shovel snow in the mountains in winter.

He takes a sip of water and carefully sets down the glass.

This is the amount of a loan I have made to the municipality of Cadore. The rest has been given outright.

Pomponio unties the drawstring of his right cuff and methodically rolls up the shirt sleeve, turning one fold over the other.

Titian points to a number.

This is the amount annually contributed for the corn reserves in Cadore. I would ask that you continue this practice in remembrance of your grandfather, who was respected by the poor people for his generosity.

Titian's finger continues down the piece of paper. He turns the page, scanning up and down.

Now, in Venezia, he says. And he tells them of the payment made annually to the hospital of the Pietà, the foundling hospital. He tells them how five or six are left each day. Of course, they may give to any charity they wish, but he would be grateful if they would continue to support the abandoned infants.

Titian draws a handkerchief from his sleeve and pats his forehead, wipes away the beads of perspiration.

Orazio starts to get up from his chair, asking, *Papà*, do you want your hat?

Titian motions for Orazio to remain seated, tells him to calm himself. What good is a hat if I'm sitting in the shade?

He takes another sip of water and continues:

A contribution to the church of San Canciano, an annual offering for Mass November twenty-second, the feast day of

Santa Cecilia. An annual offering to the church of San Lazzaro dei Mendicanti for those with skin diseases.

In the event of my death, the servants are to be provided for. The gardener. The laundress. And Giovanna da Malborghetto, who has been in this household for so many years.

Lavinia looks through the end of the pergola and sees that a gull has settled in the garden on the head of a statue of Venus. As Titian enumerates his holdings, she makes an inventory of her own: eight of the pergola's columns are Roman Doric, six are Ionic from Greece. The climbing vines on beams above are clematis and bindweed.

A terrace runs across the back of the house, and six steps lead down to a travertine walkway. To the right, the topiary garden with its boxwoods and yews shaped into geometrical forms. Circles, triangles, hexagons, spirals. And in the expanse between topiary garden and lagoon are three other gardens enclosed in privet. Two rose gardens with every type of bush. French roses, damask, musk. One garden with flowers and herbs. Larkspur, anemone, iris, and hyssop. Mallow and sweet violet. Anise and rosemary. Through the topiary garden, Lavinia glimpses the orchard that extends to the lagoon. Inside are almond, hazel, medlar, Seville orange, lemon, plum, cherry, pomegranate, jujube, and walnut.

Why have we been granted a life in this place?

Her compilation has not begun to take into account the value of what is inside this house. The furniture, the organ. Titian's paintings. It does not include the charcoal drawings, engravings. The value of the country houses, one in the hills of Conegliano, another at Castel Roganzuolo. Or the family property in the mountains at Cadore.

Oh, that we have so much and others nothing.

She calculates the value of the workshop materials, the expensive paints, cinnabar and kermes. A jar of ultramarine could feed a family for a decade.

Sunday on her way to Mass on the Rio Priuli, she saw a girl, no more than eight, sifting through the refuse. She saw the girl push aside an old woman to get to an apple peeling first.

Why is it that I find myself here, the sea and Murano to my left, instead of in a hovel, unable to feed my children, begging my next cup of rice. I sit here on this chair, there is no breeze, the temperature is unbearable; this is my complaint. My hands are swollen, my rings too tight. I have eaten; I will eat. My children sit upon my lap and want for nothing except more attention, which I will gladly give them, having been indulged and doted upon myself. I am embarrassed by all the riches, and yet I have such fondness for these jewels that I wear. I did nothing to deserve them. I landed here, under this pergola, in this shaded space, instead of on some threshing floor, holding a flail and having to strike, strike, strike stalks for day upon day, my hands cracked and dry, my cheeks permanently windburned, and still after all the work, at night, in the winter, not enough to eat, listening to my children moan from hunger pains. Why am I here and not there? Why am I not in some mean wooden shed, a *tezza*, over in the Giudecca, with no charcoal to burn during the last days of winter? Every piece of linen is embroidered with my initials, a trunk full of linens. \mathcal{V} and \mathcal{L}, the letters scrolled and ornate, well nourished. Vecellio Lavinia, the girl that I was once, the girl I was allowed to be, my aunt teaching me to do my needlework, first the cross stitch then the chain stitch, why am I permitted quiet, cleanliness, while others scavenge?

Everyone has wearied of the poor. There is no more mercy left. The poor mendicant or vagabond is no longer the object of pity. Once a beggar was believed to be closer to God for having given up worldly things and entrusting his well-being to the mercy of others. And now they are defined as sinners and their sin is Sloth. What was once their virtue, unworldliness, has been redefined as sin.

My brother Pomponio, a priest, a holy man, is hateful and despises them. Orazio and my father do not see them. Their

heads are so full of their own thoughts, my father's with his impossibly brilliant images, Orazio's with the logistics of commerce. They do not see the wanderers, but I do. I see them and I do not know what to do.

My duty is to my family, and when I have finished with my children, I will give something of myself to the poor. Perhaps I will trade my golden chains and jewels for rough sackcloth, this villa for a hermit's cell.

WAKE UP!

Lavinia, jolted, hears Titian saying, Come out of your reverie. Pay attention, daughter! There is no one who will manage your affairs more honestly than you, not even your husband, Cornelio, who is an honorable man, so pay attention.

Concentrate, he says, because, when he is gone, strangers will descend on this place like vultures. They will pick it clean. Listen carefully now, because I may not be able to take stock of my life again like this, may not be able to measure how far I have travelled since your mother died.

Lavinia, you are how old? he asks. Thirty? Well, I have outlived Cecilia by thirty years, and may have another thirty to go.

Lavinia looks down at her hands. Orazio shifts in his seat. Pomponio examines his fingernails.

Titian lightly slaps the table and says, Well, no need to be melancholy.

He says this as if it were the others, and not him, who had just been speaking of death. For a second, his eyes are playful: I'm not planning on going anywhere anytime soon, and I hope none of you are either.

He looks back down at the book.

Now, about the warehouse, which is leased to a merchant from Chioggia for fifty ducats a year. The lease is renegotiated every second year. The lease is never to be extended for more than two years. Prices rise too quickly. Titian discusses the maintenance costs, how often he sends Orazio to survey it, the possibility of acquiring a piece of property next to it, the di-

mensions of the property, the number of windows, the repairs that must be made.

How much could you get for it?

Pomponio asks this.

Lavinia is stung; she turns red in embarrassment for her brother. How very much like him to ask how much a fragmentized inheritance would bring.

Titian has frozen Pomponio out of his view.

I don't know.

His voice is hoarse.

He takes another sip of the tamarind water.

The sun still has not begun to drop.

Each page reveals something unknown, things Lavinia does not want to know. How little he pays the charcoal makers in the mountains; how little he pays the servants who maintain the property there. How is it possible the holdings are so vast? True, he did not begin with nothing. He is from a family of a certain rank, but his wealth, his power, was nothing like this. And here I sit, estimating the value of the horse chestnuts.

And still more to reckon. Behind her is the small forest Titian calls his mountain forest. There are plane trees, pines, cypresses, chestnuts, Mediterranean oaks. Conifers brought down from the mountains that have adapted to the marsh. Ferns, lady's slippers, and blue bells. A path through the woods leads to a grotto made of pumice. The surface is rough and glistens with moisture. There is a fountain. A she-bear and cubs. Water arcs from her mouth to feed them. At the base, Titian's motto is inscribed: *Natura Potentior Ars*. All this recreated to invite a visitor to wander through nature, feeling pine needles underfoot, leading him to a grotto that says, *Art Is More Powerful Than Nature*. This is the way in which my father plays, Lavinia thinks. Urging a visitor through the woods, marveling, only to be splashed by water while reading a dictum.

For Titian, art is more powerful than nature, but for Orazio,

Pomponio, me? We will be overcome and buried by nature. These gardens will disappear, and no one will be able to say for certain which one was our house, which were our living quarters and how they were configured. As for Titian? Let landslides cover whole towns, the gaze of his portraits will take away the breath of viewers five hundred years from now.

Titian reads aloud:

Item. Mother of pearl earrings, which belonged to my deceased wife, Cecilia, shall become the property of my daughter, Lavinia, as shall all of the jewelry of my deceased wife, including one amethyst brooch, one gold wedding band with small sapphire embedded, a gold chain with three medallions, one of the blessed Virgin, one of Saint Christopher, and one of the four protectors against plague: Cosmas and Damian, Rocco and Sebastian.

Afternoon has started to become evening but still there is no sign that the sun has dropped lower behind the haze. Lavinia feels her fingers swollen and stiff from the humid air.

And now, she thinks, I am to inherit my mother's jewelry. What is left of her. What she wore on her body when she was young and alive, leaning on a window sill and calling down to someone below. There could never be pleasure in wearing it, belonging, as it did, to the woman who died while giving birth to me. It would hang too heavily around my neck.

Cecilia, Lavinia knows, was peach-skinned, with almond-shaped eyes and a full round face. She was healthy and full. Titian painted her many times as the Madonna holding a plump child on her lap, as a Venus with pearls strung around her neck. She was a humble mountain girl, but still Cecilia learned to love her jewelry, the way Venetians love their finery and see no sin in vaunting it. In this respect, Lavinia thinks, she is her mother's daughter as surely as she is Venetian.

67

Venezia, the city of merchants, which Titian knew how to charm from the beginning. A city of brokering and trading, bluffing and cajoling and flattering, winding through mazes of intrigues as twisted as its canals. Titian, the young man who rubbed his hands together in anticipation.

Titian embraced this city when he was a boy, and talks of his home in the mountains with affection, although when he speaks of it, it is as something separate from himself, kept in a box, which he takes down to examine. He puts it on display for his colleagues and friends, telling them of his childhood. Of the mountain snowfalls. Of eating so many blackberries he thought he would pop. Cadore is in his paintings. In the background. It is something he has painted again and again. The chasms. The cliffs. The slab-grey buildings of stone. The farmhouse with the threshing floor, the crumbling fortress above.

But Venezia. Venezia is his city, the only city. He shows you the veins on his wrist and arm, and says, These are the canals.

Even though the city is no longer supreme, even as others move to the mainland, turning away from the sea and looking to profit from the plains, Venezia is still his city. Titian built up his house on the lagoon, facing north. He built it in the middle of the back of the fish that is the map of Venezia, and he will not be moved from it.

Often, in an expansive mood, Titian gives his guests a tour of the house, which he calls his own *palazzetto*, his own little palace. He shows them the workshop, the *bottega*, what here is called a *tezza*. He sometimes shows them where his assistants live and work; he shows them where he stores materials. He walks them into a dining room with a frescoed ceiling, shows them the organ he received in exchange for a painting. The visitor is astounded by the canvases scattered everywhere. Stacked three deep against the wall in a hallway. Hanging by sturdy cords from nails. Everywhere a visitor walks, he encounters the gaze of a portrait-sitter or a saint lifting eyes toward heaven.

Paintings in progress. *Agony in the Garden, Rape of Europa, Victories of Caesar.* There are drawings stacked on tables, pinned to curtains, sketches of helmets and sewing baskets and lap dogs. And yet, this is not chaos. It is an order that spills from one thought to another, one impulse to another, wrestled with and stared at, until exhaustion overtakes him, and he turns the painting to face the wall, leaving it there for days, weeks, months, years. The way he set aside a painting for the high altar at Santo Spirito. He had made a strong beginning. An outline, a series of abstract strokes, and then he stared at it hard and listened. But there was no voice coming from the canvas, no tension between him and the colors. Not so much as a rumor from it. It sat untouched in his studio for years. And when he finally presented it to the friars, they were not satisfied. He told them he would take the painting back, that he would sort it out. At all costs, he wished, and still wishes, to avoid an imbroglio, and yet, in this case, he could not, and the dispute continued. In a certain circles his reputation was tarnished by the incident, but over all, the conflict cost him nothing.

In public, Titian is measured and does not give himself over to temper. But here in his house, oblivious to anyone around him, he can storm. Lavinia thinks of him as the wind, unpredictable. Sitting in his garden, surrounded by friends, he can be a dulcet breeze. Angered, he is the Sirocco, which breathes hot and puts a pall on anyone nearby. He can turn a cold shoulder like the wind Corus Circius, rebuffing; like he was for years with Pomponio, who had dared to cross him.

There have always fights between Pomponio and her father, and she always walked out into the gardens so as not to have to listen. Lavinia does not understand the source of this antipathy, why her father cannot bear to hear Pomponio speak, why Pomponio resists. It was three years ago that they uneasily reconciled. How can Orazio be so gracious and Pomponio so rude? What does Pomponio have to complain of? He has lived in luxury, doing nothing, spreading discontent and disharmony. He

was always unreasonable, he could not just go along. They did not teach him anything useful. He learned only to be idle.

She does not know why her father has blocked Pomponio out of his view, only that it was this way before she was born, before the family moved to this house in the Biri Grande. Lavinia has no memory of the old house in the crowded part of the city where Titian lived with Cecilia and Pomponio and Orazio. Lavinia never knew that house near the church of the Frari, yet she knows their disagreement began there, in a house with cramped, jumbled rooms; Titian has complained of it often enough, the slamming doors, the leaking roof.

Their battles continue in this expansive house, which is distant from the city's center, yet close enough to allow Titian to keep abreast of affairs. A country house within the city, Titian has always said. To the north, the peaks of his mountains can sometimes be seen. Titian boasts of that day when he no longer had to pay rent for a house and *bottega*. Why should they earn ducats with mine? In transactions, he is unflinching, insistent. He has a banker's mind for figures. He has the tight fist of a *montanaro*, and parts reluctantly with a single coin, will not spend it unless it will bring him something much more valuable. This great house on the sea, for example. He could not purchase it today. And yet, the cost has been paid for many times over. The gardens entice visitors who come to spend an evening, which they later write about in letters. People fall under his spell.

And see how the three of us sit here, Lavinia thinks. In silence. In awe. Intimidated. Orazio, somber, wants to please. Pomponio stifles a yawn. And me, lost to details. His life has taken on dimensions that ours never will. He has brought himself up from provincial origins to a man who corresponds with kings. Who would not stand in awe? No matter how our lives unravel, we will always remain the offspring of Titian. Titian is always my father; I am always his child. He painted his self-portrait for us, Lavinia thinks, so that we will remember what

he looks like. Once, he held my face in his hands, his face close to mine, and whispered fiercely, "Never forget me." As if that would be possible.

There are myths that his children live with. How as a boy of seven, having had neither instruction nor encouragement, he crushed a certain type of flower, and spontaneously, in an instant, drew a magnificent Madonna on the side of his father's house in Cadore. The execution of the drawing was superb, and it became renowned. How, as a boy of ten, he was sent down from the mountains to work with the mosaicist Zuccati in Venezia. How he went from there to the workshop of Gentile Bellini. From there to Giovanni Bellini, and then to the workshop of Giorgione. How he outpaced them all. When stories are told about him, like the story of the Madonna, Titian neither disputes nor confirms, but listens, bemused, as one person tries to impress another with his supposedly intimate acquaintanceship with the great man. Whenever the story is told, he nods with pleasure, allowing the legend of natural genius to be spread: a simple mountain boy, without the benefit of paint, destined to become an artist.

Once he pulled Lavinia aside, and said, in mock indignation, *if* he had painted this Madonna that everyone talks about, it certainly would have been painted with the juice from crushed berries, *not* the liquid of crushed marigolds.

At every turn, he has landed on his feet. He is lucky as well as strong. He has made a fortune, his sister said, and she did not say this with malice or envy, as much as bewilderment, astonished and humbled by the breadth of her brother's influence. There is not a prince or king he hasn't painted. The Habsburgs, the Farnese, the Gonzaga, the Pesaro, the Vendramin.

It is true when they say that Titian has received nothing from heaven but favors and blessings, she thinks, except for the death of his wife.

His children do not have these gifts, though Pomponio believes he does. He struts ineffectively as he imitates his father.

Blusters. Lavinia is embarrassed for him, pities him, because he is unable to distinguish substance from gesture.

Orazio, on the other hand, knows he does not have his father's talents; he is a competent painter. He is diligent, trustworthy, honest. He is keenly intelligent, but without imagination, which he understands, which is his salvation, living as he does in his father's shadow. And me? Lavinia asks. I am the sister, the daughter. Even with children of my own, I am defined as Titian's daughter. I have never lacked material goods. The youngest, the girl, I am spoiled, certainly, I know this, petted, teased, but in an intermittent and neglectful way. Am I always to be the fair-haired girl in the white dress? I have never had the audacity to think of picking up a paintbrush, I have never had the impulse to crush flowers or berries and paint a Madonna on the side of my father's house.

Titian reads from a list:
Item. I leave my clothing to the church of the Mendicanti.
Forks and knives and spoons.
The organ.
Pomponio wipes the perspiration from his eyelids with his middle finger. Orazio dabs his upper lip with a folded handkerchief. Lavinia fans herself again with her hand. Titian's voice is unwavering, a monotone.
Item. The ultramarine ...
Item. The kermes ...
Item. The cinnabar ...
Item. I leave my paintbrushes to my assistants ...
Item. Any unused frames to the Guild ...
Item. As well as any unstretched canvas ...
Item. Linseed oil, walnut oil ...
Item. Mastic ...
Item. Vitriol ...
Item. Lead white ...
And the house in Cadore?

Pomponio, from the end of the table, has shattered the litany.

All are silent. The only noise is the distant sound of seawater lapping the wall at the lagoon.

Orazio shifts his weight. Lavinia pulls at an earring.

Titian's jaw is set, the vein on the side of his head protruding. Without looking up at his son, he says, Which property?

The house in Cadore with the courtyard.

Which house, which courtyard? Titian demands.

Of course, there is only one house to be speaking of. They all know this. How can Pomponio be so hardened against his father that he does not flinch? Pomponio is unruffled.

The house below the castle, above the town, where my grandfather lived.

Titian looks up, opens his hands in mock amazement.

Oh. You mean the house where your grandfather, Gregorio, my father, lived?

Pomponio gives an incredulous look, sticking his chin forward and jabbing it slightly for emphasis. Yes, that very one.

Titian says, You mean the house where your grandfather was born?

Yes, of course, that one.

The one from which you can see the mountain Anteleo to the west?

Pomponio says nothing.

You mean the one with the cemetery where your stillborn sister is buried?

Pomponio, silent.

Good, Titian says, because I wanted to make sure we were talking about the same house.

Titian looks down and does not speak. He leans back, placing his hands one on either side of the book, and grips the edge of the table. Orazio's chair scrapes slightly against the pavement. Pomponio wets his lips.

Still Titian is silent.

73

Voices sound from a far-off boat on the canal.

A twig falls to the ground.

The canaries trill.

Titian looks suddenly weary.

Silence.

He taps on the lower corner of the right-hand page with his index finger.

And still more silence.

And more.

Finally, Titian looks up. He says in a tight monotone, looking directly at Pomponio but not seeing him, The house in Cadore is to be maintained as it is now. It is to remain in the family. I would ask that you do everything possible to see that it remains in the possession of the family.

Pomponio is unchastened. He shows no remorse.

Lavinia's face flushes crimson, in shame, again for him. For his greed.

She looks down at her hands. Her fingers swollen, her rings tight.

Titian stares down at the page.

No one speaks, each lost in his own thoughts, as if the others are no longer present.

In truth, Pomponio has asked a fair question, a question neither she nor Orazio would have dared to ask. A question that would arise immediately after Titian's death. Could they sell the house in the mountains? You need only look at his paintings to know how much Cadore is part of him. He retreats to the mountains, and comes back each time more vigorous. Pomponio, brazen, seeping with avarice, always wants something for nothing, but he has asked a fair question. What would they, the city-dwellers, three products of this floating republic, do with a house in the mountains? There is not one of them who loves it. The journey is difficult. They cannot acquire the foods to which they are accustomed. Their father can rediscover his childhood; the brooks and meadows have

meaning to him. But what are his children? Outsiders. Conceited city-dwellers. The *montanari*, even those related by blood, are closed off. They are unrevealing and suspicious, and even the offspring of Titian, a man revered in Cadore, would remain foreigners.

To what end would we retain possession of the house? Lavinia asks herself. To go to a place we do not want to be? To be in a place we are not wanted? Listening to the interminable conversations of who is related to whom, how many times removed, who married so-and-so's cousin, who bought the field by the mill. No, she realizes, I am settled in my ways. I am no longer a girl, and cannot see how I, or my brothers, would benefit, except to try to escape from plague. No, if I want the mountains, I can look at the paintings.

Pomponio sits at the end of the table, hardened. He had a right to ask, she thinks, but I know he would sell our father's possessions one by one, every work of art, just to be rid of it.

Titian has resumed reading aloud from the pages.

Lavinia looks at a vine at the base of a column. Marvel of Peru, a jasmine. Though it has been in the ground three months, it is not creeping upward yet, and she fears it will not adapt.

Finally, the sun is lower, but the heat remains unchanged.

Lavinia looks at her father, his back to the canal.

He asks them to consider what this house will be like without him. After every whim and mood and tantrum has determined the tenor of the household for decades. After he has dominated and occupied every corner. What is a room without air?

She sits with her hands folded. She attempts to commit to memory a numerical figure for a household expense, but, in truth, at the moment, she does not care how much the laundress is paid. The number in her mind dissolves and instead she

sees, a void at the end of the table, painted over by the sea, azurite, cobalt, ultramarine, and her father a pentimento.

The meeting over, Titian stands up, stiffly, from sitting so long.

There is the slightest hint of a breeze.

He puts his hands on the table to steady himself. If we aren't smart about it, the taxes will kill us, he says.

Everyone laughs a little.

*I*t bounces off the wall. Vacantly. Mutely. Stupidly.

He thinks that the light is mocking him. In an instant it can change.

There should be movement: a canvas being stretched, pigments being ground, a scaffold being dragged across the floor, a painter atop a ladder stretching.

There should be sound: feet shuffling up the stairs, hammering. Chatter, banter. Humming, whistling.

This is a great workshop, a vast international enterprise, frantic with daily activity, always behind in orders, and Orazio Vecellio cannot tolerate the stillness.

Outside, the bells at the Chiesa dei Gesuiti clang at midday. Then the bells at the Chiesa di San Lazzaro dei Mendicanti rumble from the east, always a minute later. In the space between these two churches, in a building whose interior is a vast warehouse, a cavern, canvases remain untouched, unchanged. It has been seventeen days without movement. Seventeen days since they were all sent away. Told not to come back for thirty days.

The trestle tables are covered with bowls and jars and tools laid down midstroke.

Stop, Titian said. Get out. Everyone go.

In a corner where the light is no good, a cousin of the assistant Nadolino da Murano hurried to finish grinding a costly pigment. He wanted, at least, to knead it into a paste and store it inside a jar.

But Titian saw his wrist move, and bellowed, Are you deaf? I said get out.

The young man looked to Orazio, who nodded, confirming that his father was serious, that he should leave the pigment there where it was. He set down the crushing stone, not even daring to wipe it clean.

This workshop is not accustomed to silence, and the day is never long enough for Orazio, who wanders now, stepping before one canvas, walking up to another, but seeing nothing in front of his face. A cloud passes across the sun, and suddenly, briefly, the room is darker. In an instant it can all change.

His sister's face was swollen and round. Her fingers twice their natural size. Her eyelids crimson. Her face shining, the clear skin blotched with fever. She could not see, she had told her husband, Cornelio. It was all a whitish blur.

The light of the eastern and western windows is good, but the light of the three northern windows is the fortune of this space. The light from the north is pure, distilled, buffed. It does not burn or bore. The noonday light sweeps across the room and gently bounces off the wall.

The light is mocking me. A waste of daylight hours.

Orazio is a man who cannot be still, and he needs to move, move, move.

Each day, he has spoken to his father, tried to encourage him, comfort him, cajole him.

Papà . . .

Orazio does not want to leave the workshop, go down the stairs, through the garden, back into the house where the sound of a footstep is too distinct. If only he can get back to work, to managing contracts, to painting.

And where is Pomponio? He is gone and has not returned to he house for days. Pomponio absents himself. Declares himself helpless with nothing to add.

Pomponio at a house of prostitution? His whores are always too expensive.

This morning, there was a note delivered by messenger from the assistant Lambert Sustris: *Is it time to come back? I need to finish the canvas for that merchant from Brescia.* And yesterday, a note from Girolamo Dente, who has been part of the workshop for as long as Orazio can remember.

At midday, *mezzodì*, he prefers to take his meals with them, not in his father's house. In the evening, he likes to play a round of cards. It is time they all return and tend to the business of the workshop, but Titian has not yet called them back.

When his mother died, his father did the same thing: He closed the doors of his house for a month. He did not speak, did not eat. He became stone. Orazio, a child of six, could not stand the silence, and after a week, he tried to tease his father. He tapped his father's shoulder from behind and ducked quickly to the left, hiding, so that when Titian looked right, no one was there. Orazio, who did this to amuse his father, to bring him back, giggled. Titian cupped his hand and cuffed Orazio's ear, and his aunt pulled the crying child out of the room.

His father, with his huge, willful heart pounding, puts everything in motion. His father is the lion who pounces on the present and he has closed himself up in the house. He will see no visitors. They send him notes. *May I call on you, Messer Titian?* No.

Titian forbids Orazio to hover. He waves him away, bats him away. Orazio sees how his father disregards his health. In the damp November air, he will not wear his skullcap, his zucchetto. He will not cover his throat with a scarf. When everyone else is asleep, he opens the window of his bedroom, giving entry to the malignant night air of the lagoon.

It is the servant Giovanna da Malborghetto who tells Orazio this in the morning. The Master's window was open all night.

He did not close the shutters. He permitted the dangerous vapors to enter.

Father, Orazio said, gently confronting him. Why do you open the window at night?

Titian looked at him and said, I need to wake up.

On one wall hangs a strip of canvas marked with three strokes of paint, the key for one painting, its palette. The cloth has not been moved in weeks. Usually there are patrons asking about their order, but there have been no inquiries, a measured observance of mourning. Then, on the Monday of the third week, the letters begin to arrive, each introduced by an expression of condolence.

M. Titian, each begins. *You cannot imagine the sorrow I feel for you and for your distinguished family . . .*

There are genuine expressions of sadness followed by postscripts: *My secretary will be in Venezia the twenty-third of December, and, if you are amenable, I will visit your workshop to check on the progress of my Venus and Adonis.*

Titian does not see these letters. Orazio takes them to his father's writing table that sits beneath a western window, not under a northern window with its view of the lagoon, because a man seated there would block good light.

Orazio responds to each letter, one by one.

Most Illustrious Lord, he begins. *On my father's behalf, I send you thanks for your kind words of consolation.* And then he begs pardon and replies that his father will be unable to make further arrangements until the period of mourning has passed.

Orazio cannot tolerate stillness any longer, every thought turned inward. He believes his humors are mingled in such a way that if he sits motionless for too long, the blood in his veins will begin to thicken and harden. It is time to look outward again. He sits at the writing table making columns of figures. He drafts letters to timber merchants and to a printing press that distributes engravings of Titian's drawings. He takes advantage of the stoppage of time to organize the affairs of the

workshop, completes tasks that are put off from day to day in the usual incessant movement.

He stands up and crosses the room to look out a northern window. In the distance, he sees a line of lacquered black dashes moving through the water, bobbing up and down. Vessels with black crepe fluttering. A gondola with a coffin.

He walks across the room to the top of the granite staircase. Titian built the workshop he had always wanted, and he did not want a wooden staircase, he preferred stone, another thing to remind him of the mountains. Titian dreamed of the workshop he would build, his *tezza*. He wanted it built of plaster and stone; he did not want wood. He did not want his paintings catching fire. The mountaineers do not trust the wooden structures of the city.

He wanted a solid wall that would block out the mercurial southern light. As it was being constructed, the neighbors stood on the walkway and watched:

Look. He is not putting in a single window in the wall that faces the rest of us. How rude. How superior. Well, when you're Titian, you don't care if you put yourself above everyone else. When the Emperor gives you a title, you can build a house any way you want, wall off the rest of us, block us out, and if we do not like it, well, we can just take up our complaints with the Devil in hell.

Let them talk. After years of working in inadequate space, after years of tacking up muslin on southern windows only to have it fall down, Titian built the workshop he wanted. There would be a minimum of wood. Insects make their home in wood, rats prefer it. He wanted a wide staircase, after having watched for years as workers wasted time maneuvering canvases down a staircase, framed or rolled like rugs, angling them into every conceivable position as they tried to go around a corner. No, he wanted an adequate staircase.

At the bottom of the steps, Orazio slides the iron latch, pushes open the door, and sees the servant Giovanna da Malborghetto sitting to the left on a bench. She sits erectly and does not lean against the wall. With her right hand she rubs the knuckles of her left. They ache from the dampness.

She has been waiting an hour. She would never have entered the *tezza*, a man's domain. Never would she have disturbed the young master, not even with an urgent message. She would wait until he came out.

Giovanna da Malborghetto bows her head and says that Signor Titian has eaten nothing all day. Not even broth, not even bread.

She grabs Orazio's wrist.

A glint of light bounces off a tear in her left eye.

How old is she now? Fifty? Fifty-five? She was a beautiful woman with a heart-shaped face, enormous brown eyes, like a doe.

Orazio places his hand lightly on her cheek, but the touch of her skin startles him, and he nearly draws his hand away because the slackened skin repels him. She has always been youthful, tireless, as she waited upon the family these past ten years, hired as a household servant after his aunt died. They lost a mother when they lost Orsola, never to be replaced, but the presence of Giovanna, as she padded around, clucking over them, always gave comfort. Occasionally, she is able to roust his father from one of his black moods with a gentle tease. He notices that her neck is sinking into her shoulder blades.

I will go and speak with him, he tells her, patting her wrist.

She grabs his forearm.

Has he taken any of the medicine yet? Has he taken any of the cure?

She had crossed the rio dei Gesuiti, walked toward the Grand Canal to the parish of Santa Marcuola, to the pharmacy called Due Colombini; it is rumored that the owners there are heretics, but she does not care, their cures are reputed to be among the most efficacious, and she purchased a *triaca*, a packet of powdered herbs, made with two hundred ingredients. The *triaca* made by the pharmacists of this city are the best in the world, everyone knows this, and the one procured from Silvestro and Helena Gemma contains rosemary, for those oppressed with anxiety of mind. It contains artemesia, to ward off disturbances while sleeping. Nettle, to rejuvenate the blood. More than two hundred ingredients to be mixed into wine and drunk. Has he taken it? Has he taken the medicine?

I have prayed to Mary Magdalene, she tells him. I have gone to the church of the Frari to touch the jar that holds the holy spikenard she used to heal, but it was locked away in the sacristy. They have hidden it there inside.

Giovanna da Malborghetto asks Orazio again, Has he taken the medicine?

Orazio tells her that he has, even though his father has not touched it.

She hands Orazio a spring of rosemary. Put this under your father's pillow to help him regain peace of mind.

Orazio takes if from her. He thanks her, does not tell her that a peaceful state of mind is something his father cannot regain, because he has never possessed one.

He walks toward the house, and on his right, against the wall, a damask rose tries to force one last autumn bloom.

Orazio enters the great hall of the house, the *portengo*. His father sits at the head of the table in a straight-back chair. He puts his hand on his father's shoulder.

Please, you must eat something.

They have tried preparing his favorite foods. Yesterday,

capon stuffed with raisins from the island of Zante and dates from Palestine. But he would not touch it.

His father stares directly ahead, saying nothing.

Eat something, Orazio says again.

Titian picks up the spoon, highly polished with a heavy ladle. He holds it, not like a paintbrush, but like a hammer, his fingers wrapped around the handle. He drags it upward, lifting the spoon slowly, tightening his grip. It hangs horizontally, suspended above the bowl. Steam rises and passes his face; he puts down the spoon without having tasted.

In the afternoon, Orazio returns to the *tezza*. He stands on a ladder in front of a painting. He rubs walnut oil onto his palms. He rubs the varnish into the canvas, in a circle, working an area of sky.

The top left corner of the painting is nothing but dark colors, braken, raven, puce. An unflinching cliff. A mountain broods again in the background of Titian's painting, this one behind a penitent Magdalene.

He uses his palms and fingertips to rub in the varnish. This is the work of the assistants' assistants, but he has not forgotten how to do it. He must be careful that dark areas do not become too dark or they will fall backward and become a void.

There should be water coming down the mountain wall, clinging to the rock and trickling, making a white streak in the painting, but the dash of white is not found here; it is splattered down the saint's fever-red cheek in glinting and lachrymose drops.

The saint has dimpled hands, a sign of well-being. Of health. Of lack of hunger. Her fingers are free of any ornamentation, which is as it should be since whores, by strict decree, are forbidden from wearing necklaces or rings. In front is her alabaster ointment jar.

How many Magdalenes has Titian painted?

Orazio applies the varnish the way he learned as boy. He is

precise. Orazio has always listened to Titian: a layer of varnish can give the illusion of smoothness and wholeness, or, if counterapplied, it can accentuate a break.

This layer of varnish will dry and be covered with another layer of paint, broad strokes and dashes and dots. Increasingly, his father works this way, making jagged and blurred marks. Orazio climbs down the ladder. Stands back. From corner to corner to corner to corner it is whole, unified. But up close? Each day's work is visible and you can see where a finger has gouged.

For three nights following the funeral, Titian slept in a damp room below, in the *volta*. He lay on a cot that belonged to the young cousin of Nadolino da Murano, his body unmoving and contracted. He remained in this cramped room next to the storage area that holds the boating supplies, ropes and pitch, the lumber used to make crates and scaffolding, and brooms.

On the afternoon of the second day that Titian was down there, Orazio approached him.

Come, take a walk in the garden. A stroll.

Come back to the house. The air is less damp.

His father sat on the edge of the cot, legs bent, staring at the wall.

Orazio leaned over and cupped his hand around the back of his father's bald head: Come, at least, and have dinner today.

Titian stood up. He looked at Orazio. Then he picked up the cot and threw it at his son.

The doctor had said not to worry. The priest came and prayed.

The midwife had spread her sage leaves and given Lavinia a drink that would deliver her back safely to her life after childbirth.

Lavinia had had three other pregnancies, safe and without complication. It was as if she had been born to have children,

which came as a great surprise. Orazio had thought she would be too frightened and helpless to take on such burdens. When this baby was born, the fourth one, a little boy, mother and child seemed healthy.

He had visited after the birth. Lavinia, in bed, breathed heavily, but nothing to cause alarm. It was natural she would be tired, a little flushed, normal that her face and hands would still be swollen. A woman's face is nice and round in the final days of carrying a child, and Lavinia's face was round to begin with. Six days after the delivery, she was rosy, shining almost, it was as if her cheeks were on fire, the color of red-rimmed eyes. Color in the cheeks is a sign of health and prosperity. The children sat at the end of her bed. Propped up on cushions, she wrote notes, which a servant carried from her house to her father's house.

They won't let me stand up and I haven't worn a pair of shoes for two weeks.

I'm going out of my mind with boredom. Send muller and stone; the least I can do is grind pigment.

Send sweets, the ones Giovanna makes. Tell her not to be stingy with the honey.

After the funeral, Titian stayed in the *volta* for days, eating only bread and hard-boiled eggs. Finally, Orazio heard shuffling against stone, his father coming up the stairs. Titian paused at the top of the stairs to catch his breath. Orazio got up from his chair, but Titian, his hand leaning against the wall, said, No, stay there, the canvas has been prepared.

Orazio returned to the account books. He feigned preoccupation and listened.

He heard a stool dragged across the wooden floor, he heard a canvas dropped onto an easel. He heard the stool being dragged some more.

When he turned around, he saw Titian sitting near the northern wall, his easel perpendicular to the window. He stared at the canvas, his hands cupped around his knees.

Titian cleared his throat. Go and get me the paint. He added in a whisper, Please.

He wanted the *pavonazzo*, the *cinabrese*, the *lacca rossa*. Purple. Cinnabar. Red lake.

The colors had been mixed and stored in covered earthenware pots. Orazio uncovered each one, taking a pinch between index finger and thumb, rubbing the mixture together to see that pigment and oil were still well combined and that there had been no separation or crumbling.

He brought his father these three pots and a jar of walnut oil. Titian took them without looking up and lifted a palette from the bench beside him. His voice hoarse, he shouted to Orazio, And bring me the boar bristle, that brush that's as big as my fist.

Titian took the brush from his son, telling him to get two more of the next bigger size.

He arranged the three colors of paint on his palette, then stared at the empty canvas.

Orazio, sitting at the writing table, took up a letter, an inquiry about the progress being made on a painting. He did no work, but listened to his father's silence, which lasted for an hour. When he heard a rustling, he turned around.

Titian made a gash that angled from the center of the left edge and plunged to the lower right corner. He made this mark with the *pavonazzo*, a color named for the deep purple at the center of a peacock's tail. He took a larger brush and made the red lake, a color of low intensity but one of deep penetration. With it, he painted an arc that curved around a vacant spot in the center. Then he took the third color, the cinnabar, a very deep vermilion, and made a circular spot between the two other marks, in the middle of the canvas.

He had made three marks, one for each of his children.

Titian then picked up the canvas and walked to the southern wall. He turned the painting toward the wall and left it leaning there. He said, I'm going back to my house. He walked stiffly to

the head of the stairs, and, before taking the first step down, he looked back and said, Where is your brother?

Orazio did not know where Pomponio was, where he had been the last few days. Orazio wanted to say, He is at a brothel in the arms of someone he says is his mistress, but he doesn't have enough spending money to afford a mistress.

Orazio held his tongue. He said only, I sent him to check on a shipment of canvas.

Titian tapped the wall lightly with the knuckle of his right index finger. He grunted nearly silently. He then walked down the stairs, gripping the railing made of rope.

Two weeks have gone by, and Titian has not stepped into the workshop since.

When will they be back? Orazio misses chatter and movement, the banter as a finished canvas is rolled around a spindle that is laid between two trestles.

Watch the corner.

Pull it taut, for Christ's sake.

Are you watching your end?

Slow down.

Are you going to take all day? It'll be New Year's before you finish.

Sta zitto, mangiapolenta, the one says. Shut up cornmeal-eater; Shut up, mountaineer.

Eel swallower, the other replies. You know what an eel is?

Yes, yes. I know.

He has heard it a thousand times. The same joke back and forth. *Mangiapolenta*. Eel-eater.

An eel is a worm that feeds in the bottom of the lagoon and eats all the debris.

Say something original for once.

Enough, says a third one, Amedeo, who oversees the canvas as it is being rolled, watching to make sure that when the winding is finished there will be no great discrepancy between the

right corner and left. It must be rolled up evenly. Not too tight, not too loose. He has little faith in the Spaniards on the other end of the painting's journey. It must be packed well to allow for any carelessness when the canvas is unrolled and restretched in Madrid.

One canvas has lain untouched, suspended on the spindle, since Titian sent them all away. From the end, it looks like a pinwheel. One stripe is the thin, tawny edge of the canvas, one stripe is the creamy muslin that was laid across the canvas before it was rolled up.

Now that they have missed one ship, they must wait a month for the departure of the next, and Orazio figures the cost of delay.

In the far left corner of the writing table, there are sheets of paper with columns of numbers, diagrams of crates, sketches of cloth. Just before Lavinia's death, Orazio and his father had been in the middle of a discussion about changing the type of packing material. About whether something other than muslin should be put on top of the canvas before it is rolled. Something more inert. Orazio has been urging his father to try a new material made with a plant that comes from the Indies. Something, he argued, that would interact minimally with the paint when the painting is rolled up into itself. There are new fabrics arriving all the time. Titian is not interested in experimenting with packing methods. Orazio searches for a material that will lift up no particles of paint from the surface when the canvas is packed and stored and transported. He strictly enforces the preparation of the canvas for his father, but on this question of packing, he believes they must make some adjustments.

Why risk it in the final moment? he said to Titian.

I haven't heard any complaints, his father said.

No, I know, but . . .

The *Noli Me Tangere*. Done before I had lain with your

mother. There. There's an example, no fading, no loss of color. *Bacchus and Ariadne*, the same. Aretino's portrait.

Yes, I know but . . .

And the discussion had ended there.

This was not the first time that Orazio had implored to introduce innovation. An assistant from the Netherlands had described enormous hooks and pulleys embedded into the walls of the upper stories in buildings in Amsterdam. He heard how furniture and works of art were hoisted up from the canals directly into windows. Orazio made drawing after drawing of hook and pulley. Adapted to his father's workshop, it would save hours of labor. The paintings could be lowered to the small courtyard below, then carried a few steps away to a boat waiting in the canal. How much easier than carrying it down the stairs. He had talked with Dutch merchants, told them he wanted an enormous hook embedded in the façade of the building, and a pulley attached to the hook.

The northerners are ingenious, he told his father. Bold and vigorous. We should have thought of this sooner, Orazio said, arguing his case.

The people of the neighborhood came and stared and watched as the hook-and-pulley was assembled. They stood on the other side of the small canal and on the small courtyard, the *campo*, that bordered Titian's property. A few brought baskets of food and stayed through the midday meal to watch. The laborers knocked an opening into Titian's windowless southern wall. Orazio and his father watched from below.

Titian stroked his beard and squinted as he looked up.

Two men were perched at the top of a scaffold, balancing on a narrow ledge. One held a chisel and hammer and pounded into the bricks. The bystanders below heard a grunt with each stroke. The arm of the second man was wrapped around the waist of the first, his feet wedged against the

building. The first man pounded into the wall until he tired. Then he handed the tool to the second man, and became the safety belt and brace.

Titian spoke to the foreman beside him.

They're going to sink the hook deep enough?

Of course, sir. And he explained the calculations of how far back they would drill and what type of beam support would be inserted, how wide and how heavy, and how much weight the mechanism would be able to bear.

Titian tolerated the commotion, the disruption, in order to end an argument he had had with his friend, the architect Sansovino, as they sat at the table underneath the pergola one August evening. Nothing ever grows under great trees, Sansovino had said. An admonishment and a warning. Titian had sputtered and mumbled, Nonsense, nonsense, it does not apply in this house. But he took the comment as a challenge, vowing to give his son more say, and so permitted a hole to shatter his perfectly solid wall.

It had worked. It had saved time and the backs of the men employed in the workshop. They could carry a painting out onto a small balcony, lay it across two hempen slings attached to the hook, and lower it. The pulley, the hoisting ropes, the trolley pull, seamlessly raised and lowered. It had worked. It had worked like a dream. It had worked until the day the counterweight embedded in the rafters slipped and lurched, and sent a canvas plunging to the small courtyard below.

The wide door in the southern wall is a constant reminder to Orazio of having overreached. The painting was salvaged, the hook removed, but the marred wall remains.

Orazio knows he is not like Pomponio. With Pomponio, it has always been someone else's fault. His tutor's. The banker's. Titian's. No, Orazio took responsibility for his great miscalculation, did not blame the contractor or the assistant from the

North who had first given him the idea. He became more diligent, more industrious, more careful. His wrist tightened, his brushwork became more restrained. He painted without abandon but with all the care necessary to produce a painting worthy of Titian's workshop.

No, he did not make excuses, as Pomponio does at every turn. Or as Lavinia had in the years before her marriage. Lavinia so pampered, so quick to tattle. The youngest. The only girl, doted-upon. She would not wage her battles openly, instead scurrying to her aunt or father, crying and whining, over the slightest offense. *Mi hanno picchià.* They hit me. When in fact, all her brothers had done was to touch her ever so lightly with an index finger, baiting her, so that when confronted they could say, But we barely laid a finger on her.

Lavinia, always a little too easily injured, always too quick to go crying for help, a mama's girl, except, there was no mother. It came as a surprise to him that she could take a husband, become a wife, bear children, be a mother to them, and not quiver in the face of responsibility. Orazio had been convinced she would not go through with the marriage to Cornelio of Serravalle. Pomponio had doubted this as well and had tried to make a wager about it with Orazio. Lavinia had told her father, Yes, he is pleasing to me, go ahead with the marriage agreement. But Orazio believed in the end she would be unable to risk the trauma of changing households or accept the finality of such a decision.

On the contrary, she became resolute and firm and took over duties that, in the past, she had declared herself too afraid to undertake. Suddenly she could make decisions. She became the one who, when a child's forehead was sliced open in a fall from a chair against the corner of a table, knew enough to staunch the wound, to keep the child calm, and not to run in circles like the rest staying, What happened! What happened! Who let the baby climb up onto that chair?

Lavinia had only recently caught up to Orazio. The seven

years difference in age had closed and she was finally an adult, a peer. It was as if, all those years before, she had barely existed, existing somewhere still in the realm of childhood.

He recalls Lavinia serene and distracted in the garden, inspecting graftings. He recalls how she talked of her plans to procure a certain bulb; there were rumors of a new flower arriving from the Orient, a scentless flower shaped like a turban. Merchants were secretive about it and the price was astronomical. At the midday meal one Sunday at the long table, Titian had teased her, trying to get her back up: They say you could feed a family of five for three months for the cost of a single bulb. And, Cornelio, dabbing a napkin to the corner of his mouth, his eyes playful, searching out his father-in-law, saying, You how it is, when a woman makes up her mind. And he shrugged his shoulders and opened his hands to the air in mock resignation, and the men at the table laughed. Lavinia tapped her index finger against the table. Orazio remembers the clicking sound the nail made. Lavinia looked across the table at Cornelio, flirting, but also with an edge to her voice. You know, my dear husband, she said, my beloved, my heart, it is not only men who are capable of making a good investment. Lavinia took Giovanna with her to the warehouse district, where ladies do not venture, and she found the merchant she needed to find, cajoling from him information about the exotic flower. She returned to him with the money she had made selling a brooch on the Rialto, and she placed an order, speculating on the future.

Orazio had thought there would be time to get to know his sister, he did not have fear about death in his mind. True, he was careful not do anything that would tempt fate. He took the usual precautions: He held a handkerchief scented with herbs to his nose when he went into the middle of the city. He did not touch unwashed coins with his naked hand. He did not shake the hand of a stranger. And when he thought about death,

which was not often, he imagined they would die in order. Titian. Pomponio. Orazio. Lavinia. The death for which they must prepare was his father's. Titian, still in good form. A lion at seventy-three. Orazio would watch his father walk down stairs, assessing his steadiness and agility as he bent over to pick up a dropped coin. He would see how Titian bent, not at the knees, he was not nimble enough to drop into a squat, but how instead he lowered himself by stretching out one leg to the side, his back straight and stiff. Titian still would rise to his feet without difficulty, and Orazio, reassured of his father's vitality, returned to his work, not thinking about it for many months, until he routinely checked again.

Before Lavinia's death, Orazio anticipated that he and his brother would be left to fight it out without their father between them in some very distant future. Maybe Pomponio would find a way out of his resentment and there would be a reconciliation. Orazio has felt the sting of his brother's malice, his envy, for an entire lifetime. When they were small boys, Orazio was always able to answer a question before his older brother. Pomponio, he thinks, will not live as long a life as Titian, or as I, because he is already in poor health. His hands are white as birdlime, his cheeks are splotched with spider veins. Pomponio, tall, has expanded in size, in width. A stout, prematurely balding man, collarless and perspiring, who speaks in wounded tones. How can the son of such a great man become so lost and filled with such antipathy?

When he considered the future, Orazio thought Lavinia would be the last to die, and that it would be his responsibility to make sure she had been provided for. He trusted Cornelio, but not completely; a brother-in-law was not a brother, and Cornelio would have no part overseeing the estate. Orazio had worked it out in his mind, and he was certain he would precede her in death.

A sister is always there, someone to think of later, when you have time, when the responsibilities of the workday lessen.

<center>***</center>

In the ledger, at the top of a new page, Orazio writes, *Adì. 20 novembre 1561.*

The date is his companion on the page.

She died two days after All Saints' Day, a day after All Souls' Day.

If she had made it past the Day of the Dead, you would think she would have made it altogether.

An image appears out of nowhere: tiny balled fists inside his hands.

His sister with scarlatina, her tiny fists on fire. He was twelve, she was five, and to relieve the nurse and his father and his aunt, he held her on his lap on a chair in her bedroom in the middle of the afternoon. She was wrapped in a blanket and she shivered, and in her delirium she uttered nonsense. He thinks of Cornelio's face when he came in to say, out of breath, Something has changed, her face is on fire, she has had a seizure and will not wake up. Cornelio talking so fast, frantic, We had already started to talk about the baptism. Orazio thinks of her balled little fists, burning with fever as he tried to rock her to sleep, and how she kept telling him to pull the drape shut, pull the drape shut, because the dust motes in the beam of light coming through the window were tiny birds, millions of them, and she could not make them stop singing.

The day before his mother, Cecilia, died, the sky was ash-grey and it drizzled. He tentatively opened the bedroom door and she beckoned him to enter. He went into the room and kissed her. His mother lay on the bed exhausted. This is all he can remember.

He did not know that after a day and a half, the contractions had stopped altogether, and the midwife had inserted a stick made of dried flowers to stimulate contractions

<center>95</center>

again. If it was a boy, they planned to call him Licio. If a girl, Lavinia.

Orazio did not know that his mother lay on the bed as if unconscious. She was resting, but the midwife did not want her to rest. She feared that if the baby were not born by the end of the day, the birth would not occur. She knew the history of the mother, had delivered her of three other babies, and two others who were stillborn. When she had heard that Cecilia was with child again, she was displeased. The midwife had told Cecilia that another pregnancy might kill her and that she must tell her husband, the painter, of this. Would you like me to say something to him?

No, no, Cecilia said. I will take care of it.

The baby was a girl, Faustina Zorzin, the midwife, had been certain. Cecilia carried the child sideways, it made her hips wide. A boy made the mother lovely, a girl drains beauty by taking too much of her blood. And in fact, Cecilia had looked haggard and worn, the usual good color of her round face drained. The midwife, the others, ascribed it to the little girl baby inside her. No one thought to say: There are two other children, Pomponio who is always agitated, his mouth frozen into a stiff smile, always cross, gangling and awkward, scowling, never a smile, with his nervous habit of tap, tap, tapping his foot, his father can't even get him to sit still for a portrait, and he's too old to be having tantrums, but he still does, pounding the wall with his fists. Nor did they ascribe her exhaustion to Orazio, the one referred to as *bravo, buono*. He's lively, spirited, mischievous, and he's not afraid of his mother, his nurse, his tutor, his uncle, only his father can discipline him, which he won't do, because he is consumed with work, he doesn't want to give up a single hour of daylight, and, besides, he doesn't like to discipline him, he leaves that to Cecilia, he wants them always to come running, arms flung open, saying *Papà. Papà*, throw me in the air.

No one thought of this when they saw how haggard Cecilia had become, her eyes sunken into the sockets. No one said any-

thing about the other two children. Nor did they dare say that she lived with a difficult man. They said only, It's a girl in there, sucking away life-humors.

The day before Cecilia died, it rained the entire day, this much Orazio can remember.

He does not know that at the fourth hour past noon, the contractions began again, and Faustina Zorzin was relieved when Cecilia began to scream that a pair of tongs was twisting, twisting her insides. She screamed to be allowed to die and said she could go no further. Faustina Zorzin had heard all of this before by every woman she had ever attended in childbirth, and she said to Cecilia, We are almost there, the head is showing, very fair hair, lots of it, curls, you are so close, now let's put this cloth between your teeth and push. A cloth was placed in Cecilia's mouth, the sensation of alcohol numbing the gums, the taste of mint soothing her.

When the bells from the churches pounded six times, Faustina Zorzin was saying the same thing: We are close, we are close. She said the same thing when the bells pounded three hours later. It was not yet midnight and Cecilia, propped up by the midwife, said aloud, If it does not happen now, it will not happen. She gripped the midwife's arm, and, with the last ounce of strength left in her, she thought about light. About blindingly white sunlight. That she wanted the child out of the dark. She thought and thought about light until she saw blistering white sunlight breaking into particles of color.

Lavinia emerged, screaming seconds later, perfectly formed and large. Then, the midwife removed the afterbirth.

Cecilia took the child and nursed her. Not being a woman born in the city or born to privileged society, she did not hand the child to a wet nurse. Faustina Zorzin then took the child from her and began to pound on her stomach, kneaded the muscles until Cecilia cried out, Enough. But the midwife calmly continued, saying, We must, or the insides will not return as they were.

Finally, they brought the baby back to her. A girl, just as they had all predicted. Named Lavinia, as had already been decided. Cecilia took up the child, and began again to nurse her.

She lay there in a dream, her body collapsing into the pillows, the mouth of the newborn sucking. She put her head back on the pillow, still seeing the white light, and as she lay there resting, she began to feel liquid flow between her legs, warm and heavy, she did not know what to think, only that her legs were moist. She saw alarm in Faustina Zorzin's face, a look she had not seen during three days of labor, not even during the time when contractions had ceased. She heard the midwife's panic as she called for torn strips of bed sheet. She again felt the infant being pulled from her arms. Cecilia said, No. The midwife said, Signora, yes. Again, Cecilia said, No. Yes. No. We'll bring her back later, Signora. No. Please, we must attend to the bleeding.

Then Cecilia said, Before you take the baby away, send in Messer Titiano, send him in while the baby is here so that we can be all together.

No, the midwife said.

Yes, Cecilia said. I order it, yes.

And the midwife silently nodded to the assistant who went out the door into the hall to call the husband.

When Lavinia entered the world, Cecilia left it. And now Lavinia has left it.

Orazio rubs a spot on the writing table with the knuckle of his index finger. Lavinia died less than three weeks ago, it seems like three years. It is as if time stands still, encased between four walls, and outside a decade has passed.

Pomponio has absented himself during this period of mourning, has declared himself unable to dwell in a place where there is death. Unavailable when the funeral arrangements were made, he could have been of use, is he not a priest?

Pomponio only takes and never contributes to this enterprise. Pomponio, so utterly without resource.

Pomponio will never comprehend duty, he is too consumed with his own discontent. Pomponio will never concede the greatness of his father's workshop, the perseverance needed to keep it running day after day. He sees Titian only as prosperous and domineering. He does not see how one success was built upon another. Pomponio can see it only with his unhappy eyes, asking, Why did I not get some of that talent, why was I denied?

Pomponio cannot fathom Titian's genius because he does not understand his work, does not know what it takes to make a painting.

He does not know how Titian began as a mosaicist, trained with the most distinguished master Zuccato. And there he learned that specks of color placed against one another can produce a brilliant effect, that fragments of color can shimmer in variegated undulation. Pomponio does not know how Titian took a mosaicist's eye to painting and was capable of seeing particles of color where others could not. He saw color within color. He learned to tolerate fragmentation, certain that the splashes and blots would give an illusion of wholeness.

Has Pomponio in his ramblings ever sought out an opportunity to consider his father's life work? It could be so easily arranged. Let me show you, Pomponio. Let me show you where he did something no one else has done. The fresco of Saint Christopher, there in the Ducal Palace. He did not trace from cartoons but went directly to damp plaster. He went directly to the *intonaco* and his day-lines are not visible. Can you see what he painted? Saint Christopher crossing the water with the Christ Child hoisted upon on his shoulder. A tree limb is his walking stick, which he thrusts into water like a bargeman pushing his pole into the river's shallow bottom. Saint Christopher wading shin-deep, his calves bulging. He painted this in three days, in three *giornate*.

Did you ever consider the work he did each day, over many days?

Pomponio, you will never comprehend my father.

Titian has found the secret of concentrating light at specific points, not permitting it to scatter and diffuse, so it burns through layers of pigment.

Titian makes the transitions in flesh or cloth indiscernible by allowing the undertone to be seen through the overpainting.

Titian makes paintings with spots, variegated and pock-marked, while others are still content to paint with unblemished blocks of colors.

Titian does not sketch on the canvas before painting, as his predecessors did, but takes a brush directly to the canvas.

He invented broken neutral tones.

Titian takes light apart and puts it back together.

Titian uses brushes the size of brooms.

Will Titian begin again? Will he rouse himself and walk, as he has done every year on the twenty-second of November, to the church of San Canciano for the feast of Santa Cecilia, patron saint of music? Will he offer a mass for the soul of his wife, make a donation so that there will be music, so that tapers will be lit?

Now, after Lavinia's death, the days are spent waiting.

The feast day of Santa Cecilia arrives warm and grey. It has rained for the past two days. This unseasonably warm month has been cheered by no one and regarded with dread. A cold snap before the end of November is imperative, otherwise malignant vapors, harbinger of disease in the spring, will linger.

The bells peal seven times. Titian sits in the Vecellio pew, his skullcap rolled up and inserted into his sleeve. There is music. *Te Deum*.

After Mass, in the small *campo* outside the church, Titian accepts the condolences of the priest. Of parishioners. The silk

dyer Manfredi, the cloth merchant Guzzin. Titian fits the zucchetto onto his skull. He and Orazio turn left, link arms, then turn left again and proceed alongside the church. They come to a narrow walkway, enter one that is even narrower. As they cross the bridge of the rio di San Canciano, Titian says to Orazio without looking up, Your mother loved music. She sang her heart out in church.

He takes a few more steps, then stops. She was tone deaf, you know.

That afternoon, Titian shuffles up the stone steps into his *tezza*. At the top of the stairs, he pauses to catch his breath. He is talking to himself, mumbling.

Titian says, I woke up with Leonardo's word on my brain. *Sfumato*.

Blurred smoke on the canvas. A dark haze.

Titian takes up the canvas which he had turned toward the wall, the canvas with three strokes.

He paints over the mark he painted last, the cinnabar mark.

Sfumato, his father says again.

The cinnabar is covered with lead white. Titian takes his fingers and pushes the white outward from the center.

He paints over the other two remaining marks, the red-lake arc around the center, the slash of *pavonazzo* that cuts the lower half of the canvas in two. He intensifies these marks, he widens them, expanding their zones.

He has smothered the cinnabar with white, imitating its space; he creates its negative image. It was to have been a dark zone that would recede into the back of the canvas. Now, he has made it a zone of lightness, which will be painted over again, but will show through, even after all the many days of painting, hatching and scumbling, thousands of smeared and smudged blots, even after varnish has been laid down, it will be what everything in the painting swirls around, it will be as if a candle

burns behind the frame, no, whiter than the light of a candle, which is too yellow, it will be a white light, a white light that has not yet been invented, and somehow a white luminous core will emerge through the layers of material that have been laid down over it.

Titian is at the head of his great stone staircase, heading back down. He turns toward Orazio, who sits at the writing table pouring over numbers. Titian sees the bald spot on the skull of his middle child, sees that his tight black curls are greying. He puts out of his mind the flawed hoisting mechanism, the violated solid wall, thinks reluctantly about the new types of packing material his son wants to introduce.

Titian shouts across the empty room, Fine, go ahead, fine. Go down to the warehouse and buy some of that cloth that the merchant Guzzin is trying to unload.

*P*omponio Vecellio grips the doorframe to steady himself
and takes a half step down. He sees a tail. A tightly coiled, rope-
like tail. Then, the body of a rodent, flattened as if run over by
the wheel of a laden cart, which would be impossible, the ro-
dent lies in a shallow alcove. It would have been too quick. Un-
less it had been sick. He steps over the rat, adjusts his collar. A
tall, thin man with stiff joints, he turns left and walks alongside
the building. He turns left again into a passageway, a gangway
so narrow his shoulders graze the walls. His neck is rigid, his
head leans slightly forward. At the end of the passageway, be-
hind the tenement where he lives, is a wooden shed, a *tezza*. He
pushes the door. Pushes it hard a second time. A third time.
The upper right corner sticks and needs to be planed. He low-
ers his head to fit through the doorway. On the floor, buckets
and brooms and sacks of lime are piled. He squints in the dark
and searches the wall, where tools are hung on wooden pegs.
He finds the shovel with a flat edge that is used to load char-
coal, a heavy shovel, with a thick, ill-carved handle. Bowing his
head, he steps outside.

The walkway in front of the building is strewn with filth of
every sort: shattered crates, rotten fruit, the contents of emptied
chamber pots. In the canal below, the water is lichen-green and
debris floats.

He can tolerate the filth, he can tolerate the vermin, but he is nearly seventy and cannot tolerate the noise: two mongrel dogs on the other side of the narrow canal barking at each other, snarling, in a fight now, growling, yelping, whining. Women screaming out of windows to their children to hurry up, to come inside, go here, go there, do this, do that. The salvage man shouting and singing, looking to buy, looking to sell. A cat shrieking. Metal pots in apartments above the canal clanging. Children taunting one another with dirty songs, the *strombetti* they have learned from their parents. The crowing of roosters. The guttural cooing of pigeons from nooks inside the walls. The slamming of shutters. And now at midday, bells, bells clattering and clashing relentlessly, reminding him of time, one solitary, nagging clang, every quarter hour.

He tries to work the lip of the shovel under the body of the dead rat but he cannot quite lift it, it keeps slipping away. He will not touch it, does not even want to kick it with the toe of his shoe. With each attempt to lift it, the stiff, flattened body edges closer toward the doorway, finally becoming wedged against the stone of the half-step, which he is able to use for leverage. He scoops the dead rat onto the blade. He carries the shovel with his arms stiffened, extended straight down, and moves toward the edge of the rio di Sant'Anna, where he dumps the carcass into the water.

From just inside the doorway, he takes a broom. He sweeps the shallow alcove, then the walkway, his arms making slow, wide arcs with the long switches of the broom. He walks to the edge of the *rio* and genuflects stiffly, extending a hand straight down and submerging the bucket in water. He straightens his legs and stands. Then he tosses the water across the pavement and sweeps clean the area in front of the doorway as if it were a threshing floor.

This is the place he has come to live. One pinched room in a row house, in exchange for acting as caretaker. Sweeping out

the vestibule, periodically painting shutters and doors. He has grown accustomed to the sound of rats in the walls. The scraping and thuds. To the holes they gnaw in the walls.

It is rumored on the rio di Sant'Anna that he was once one of the *potenti*, one of the well-off people.

The others can tell that. He looks no one in the eye. They know by the way that he carries himself. By the way he holds a handkerchief to his nose, balled up and filled with crushed herbs that are inhaled to block unpleasant smells and ward off disease. Dried out pine shavings, myrrh, aloes-wood. He carries himself like a priest, one of the arrogant types, who despises the remote parish he has been sent to, thinks its people backward and rude. Looking to the left or right, he turns his head slowly, as if moving it gives him pain. He wears clothing of sumptuous, frayed material. Those who inhabit this district have seen this type of cloth worn only by officials in civic processions or by priests. Velvet. Brocade trims. Albs of Flemish linen. His clothing is too big, voluminous around him. Threadbare and twenty years out of date. His pointed beard, a shock of white, is untrimmed. Behind his back, the workers who live nearby mock him, calling him "the rich Franciscan," the joke being that only the rich decide to take a vow of poverty.

He moved here in hope that no one would know him, that no one would recognize him. He hoped he would no longer hear passersby making comments:

Do you know what failure smells like?

No.

Inhale. It just walked by.

Or, as on a spring day, thirty years ago, when two young men walking arm in arm toward him along the rio Priuli passed him and said,

Sai chi è?

You know who that is? the one asked the other, just after they passed, while he was still within earshot.

Who?

You don't know who?

No. Who?

Titian's son.

The son that paints?

No. The other one.

And he could their voices trailing behind him, sniggering.

He has heard what they all have to say about him:

The good for nothing.

The scapegrace son.

The profligate.

The worthless son of a great father.

What are his transgressions? Sloth. Dissipation. Envy.

Everyone speaks with pleasure of his brother, an artist in his father's illustrious workshop, relieved to move on from the elder brother's sorry tale: impoverished, having earned what he so justly deserved. Living now in the parish of San Pietro di Castello near the Arsenale at the far eastern part of the city. If Venezia is shaped like a fish, the hump of its back being north, where his family once lived in their villa and gardens in Biri Grande, and if the tail is in the east with two fins, one north, one south, then Pomponio Vecellio moved as far away from the center as possible, to between the fins, away from the Grand Canal, the Fondaco, the church of the Frari, the piazza San Marco. He moved to the opposite side of the city from his father's bastion. He went to a poor man's zone, a working-man's zone, and exists among the laborers who make their living at the Arsenale, sixteen thousand men in its employ. He lives among water carriers and porters. He has gone from high to low, and his father's holdings, which were once listed in a thick leather book stamped with the insignia of a lion, have been re-

duced to one small cottage, two rye mills, and three hardscrabble fields on the mainland.

Squanderer of his father's fields.

Their battles always played out at a table, either under the pergola or more frequently at the table in the *portengo*, the narrow room that ran the length of the house, its three windows looking north over the gardens and lagoon. Ornately carved chairs with massive arms lined the walls, gifts of King Philip of Spain. The floor, a mosaic swirling with serpentine and pavonazzo marble, were always polished and shining. Giovanna da Malborghetto would kneel on the pavement each afternoon and polish it tile by tile, caressing it, as if there were nothing else in the world she would rather have done than keep clean the house of the great man. She carried a thick cotton cloth, which she placed under her knees as she worked. In this glistening room, the family gathered. Brilliant clutter was scattered: an unfinished Titian canvas on a chair against the wall, a paintbrush on the mantle.

This was the room, the long table, where Titian and Pomponio fought their battles.

Why do you vex me?

Why do you intentionally displease me?

Titian slaps the table. Points a finger.

Last time, that was something, but this time? This time takes it. Just when I think it's the last of it, I am called: *Messer Titian, I am sorry to say, but you must do something about your son.* First, caught stealing candles from the church. Fine, I said, he is just a boy whose impulses need to be redirected. Then, the roaming the streets at night with other troublemakers wreaking havoc. Yelling, singing. Fine, I said, he is just a youth, with impulses that need to be checked.

Don't interrupt me, let me finish.

When I told you that you were to become a man of the

church, your behavior grew worse, the tantrums started up again, you were nine years old, you should have been more controlled. You shrieked, hit your fist against the walls. It continued, continued, and we all tried to be patient. He never really recovered from his mother's death, we would say. He has never been the same. Then you refused to speak to anyone, made your desires known through little notes and hand signs. To say things like, Pass me the wine please, you invented your own language, gestures that bordered on obscenity, but were not quite obscene, they skirted the edge. We lived with this crazy language for nearly a year, humoring you, accommodating you. A client would come into the gardens, sit at the table, and I would introduce you: *This is my first-born. He is going to be a priest.*

And instead of saying "good day" or "good evening," you would tap your index finger to your temple and then open your palms upward toward the sky. Then bow and back away, taking tiny steps.

And I would try to make a joke about it. Always, I protected you. *You know what it is like when they realize they don't have to listen to you anymore!* I would say, and laugh, and the client would politely agree. I would say, *He's an original. He's so spirited.* We indulged you for nearly a year, even responding to you in that infernal language you had made up.

Then one day, at *mezzodì*, you came to the table. I saluted you with your sign of greeting, tapping my forehead with three fingers of the right hand. You pulled out a chair, sat down, unfurled your napkin, and said, This napkin is not clean.

Ten months without a word, and then, *This napkin is not clean.*

We were overjoyed. Thrilled. It didn't matter what you had said.

I thought it was over, all the problems. And for awhile it was fine. But then it started up again.

I said, don't interrupt me. I'm almost done. Let me finish.

Your behavior started up again even as you were getting ready to take your vows. I got a visit from a representative of the morals council. And he said: *Messer Titian, I am sorry to have to tell you this, but your son was seen visiting the whores of the island of Rialto. Now these things happen, of course, we all know it does, who among a group of ten gentlemen wouldn't know his way there? And he made his joke, he begged forgiveness for bothering me. But I'm afraid, he doesn't know there are places a gentleman may go and places he may not, you know what I am saying, to go to such a place as he went, there with the fishermen and boaters.*

Yes, yes. Well, I'll certainly have a talk with him. He is going to be a priest you know, and I'm afraid, he's trying to live a little diversion before he makes his vows.

And we parted. I talked to you. The end of it. Right? No.

Two weeks later, I get another visit from the same man.

Messer Titian, I am sorry to bother you again. And he takes off his hat with all his false humility. And what he tells me, I am not ready for. That you had gone to the brothels, that would not have surprised me, shocked me. After all, I was young once too. A man has an appetite. But this, this, I was not prepared for, that you had gone to the brothels where the whores cut their hair short and dress to look like men. I was sick to my stomach with disgust. A stranger telling me these things about my own son. A stranger knowing these things.

You denied it up and down. Said that he was mistaken, that he was lying. That if you went to a whore it would be a real woman and not a woman disguised as a man. You became indignant. Said I should get out of the workshop and see the actual world instead of painting the world I imagined. You said these kinds of things. You claimed your birthright, the money that was to come to you from your grandfather. You said you were moving out.

Where?

I know places, you said.

Where? To the island of Rialto with the whores?

There are places in the world you do not know about.

You think you will find somewhere better?

Yes I do.

And what are you going to live on?

I have a position already.

A position! What kind of position? A nice position with a whore? What are you going to do for food? You think they hand it out on the street corner? What are you going to do for a roof over your head?

Have confidence in me for once.

Are you going to sleep in an alcove with all the other vagrants?

I have means.

Every young man thinks he is inventing the world.

I have a position as a clerk in a merchant's enterprise.

A clerk.

Plus my birthright.

You are not touching a single coin.

I am taking it. I am leaving.

Titian and Pomponio stood up. The son, his arms crossed, stood taller than his father. Titian's hands gripped the edge of the table, his knuckles turning white.

If you walk out of this house, Pomponio, I will never let you back in.

Pomponio left.

Three weeks later, he came back in debt.

Titian, a wealthy man, the most powerful painter in Venice. His magnificent gardens that looked out toward Murano. A thriving timber business. A prosperous workshop with a priceless inventory.

Item. A field in Vales.

Item. Two fields in Chiarnusa.

Item. Another field in Tai.

The possessions of Pomponio's father once covered many

pages. The remaining three items have recently been sold off.

Once Pomponio was asked what it was like to be the son of the most powerful painter in Venice:
I would rather he were a cobbler.

A shrew skitters across the pavement. Pomponio is not startled. A warehouse near the Arsenale burned, leveled to the ground, a miracle more of the wooden buildings did not catch fire. But now a hole gapes in the ground. Who knows how many colonies of creatures were disturbed, causing them to scatter and migrate outward. He puts the broom back into the vestibule inside the door, leans it in the corner, exhausted from yet another sleepless night. When he was young, he had no trouble sleeping, just the opposite, he slept too much. He pulls a rag out from his sleeve and wipes it along the railing that runs alongside the staircase, clutching his scented handkerchief in the other hand.

When he is able to sleep, Pomponio dreams. He dreams a recurring dream: A small boy stands on top of a building that overlooks the Grand Canal. He is alone among adults, who are looking east and watching. He is trapped among the exquisite robes of the adults, silks, satins, brocades, and can never find an opening to see what they are looking at, cannot push the cloth aside or move closer to the front. He can only look above, where flags snap in the wind and standards stretched vertically with small arcs slashed into the cloth allow the wind to pass through.

Only once can he see what they are looking at. He stands on top of a building with a balustrade that runs around the perimeter. Two stairs covered in Persian carpets lead up to a platform. In the middle of the platform is a trapdoor. He puts his ear to it and hears his mother's voice say in a rasp, *Let me die, I can go no*

farther. Then he looks to the east, the direction of Persia, Damascus, Gaza. A castle floats in the middle of the Grand Canal. It is made of pinkish, pearly marble, with four domes, one at each corner, and a tower in the middle. Thirty brigantines appear, sleek two-masted vessels, moving swiftly from the east. The floating castle is guarded by men on ladders made of rope. Cannons are fired. Trumpets sound. Wooden masts are snapped apart. And there is smoke.

Pomponio settled near the Arsenale, a symbol of the city's wealth, vitality, and power. An ancient lion guards the gateway. The lion is the city's emblem, a symbol of the Present which Acts. The lion is also his father's emblem, and in Titian's last painting, a Pietà, lions are depicted as sculptures. There is an alcove with a golden dome, an arc of glittering mosaic, where the Virgin holds her lifeless son. To the left, Mary Magdalene, frantic and weary, steps out, her arm flung open, while a putto guards her alabaster ointment jar. Titian painted himself as an old nearly naked man kneeling, a cloth draped over his body. He painted his shining bald head, his chiseled hooked nose, his pointed white beard, the same profile as Pomponio's now.

And there, in the lower right corner, a tiny painting within a painting is almost obscured in the dark colors. It is a primitive depiction, one-dimensional and Byzantine, like those of Giotto's predecessors. A father and a son kneel stiffly, each with praying hands pressed together and pointing upward, a father and son appealing to the Virgin Mother and Child to spare them from the plague. The son in the tiny painting is Orazio. Always Orazio.

At a quarter past the hour, a bell at the church of Sant'Anna pounds once, shallow and metallic.

He walks by a pawn shop, with its sign of three golden balls. The brokers know Pomponio well. He has been in and out of debt for nearly fifty years. There is nothing left to pawn. The

jewels have been sold. The furniture. The houses. A library of books printed in Venezia. All of Titian's paintings. All that remains is a trunk that holds some linen sheets and a small box that contains a single ancient coin.

The *fraterna* has been broken up and scattered, the family enterprise that Titian intended to be passed from one generation to the next; the *fraterna*, an association of brothers administering the family fortune as a single unit, but in the case of this family, Pomponio was never a member of the consortium.

When Titian's workshop was being built, Pomponio sat under the pergola and watched. He sipped tamarind-flavored water and nibbled lemon cookies. Pomponio watched everyone else work: the laborers with poles balanced across their shoulders carrying hods; apprentices mixing mortar inside metal vats, stirring it continually so it did not harden; stonemasons squaring corners; his father and brother walking around the structure, checking emerging walls to make certain they were level, their heads bent together.

He lives now in an apartment on the uppermost floor of a three-story building, in the least expensive room, which is hottest in the summer, coldest in the winter. It is one room, a garret, a pigeonhole, and he must carry his water up the stairs. On a shelf on the wall, small rats, bored and fearless, move behind the canisters.

A great aunt predicted he would amount to nothing: You can tell a person's character from the shape of his face, she said, and he has a very narrow forehead, almost no forehead at all.

Of the four humors, phlegm dominated in Pomponio. His dullness and indifference were ascribed to this excess of phlegm in the respiratory canals. Lavinia, on the other hand, was melancholic, the result of an excess of bile. Orazio was sanguine. Just look at his sturdiness and pleasant disposition. His

robust color. Blood was his dominant bodily humor, they all said approvingly. Orazio was the product of earth and heat, confident and optimistic. Just like his father.

Pomponio believes that his father put his brother on a pedestal, that he carried Orazio in the palm of his hand which was cupped as if it were a small velvet pillow carrying a precious little jewel. *Lo portava così*, Pomponio says. He carried him like this. The thought still quickens his breathing. His brother and father have been dead sixteen years.

This, written about Pomponio in a letter: *A stout, prematurely balding man, collarless and perspiring.*

And in another: *I find him terminally insufferable. He starts to tell a story and, in an instant, the others in the room fall into a stupor. When he finally has the floor, which is not very often, he will prattle on and on and on about the details of something tangential to the subject. Then, he will laugh, when no one else can see the humor.*

This said about him: *He is bizarre looking, disconcerting, with yellowed teeth, he walks all hunched over. Gawky and evasive.*

Even his one remaining champion agreed, the one who had said of him at age fifty-two, *I think he's coming into his own.*

Pomponio carries a wooden ladder from the *tezza* to the front of the building. He weaves it in through the narrow front doorway, and leans it up against the wall. He gathers the material of the cassock, ties it into a knot, and climbs the ladder, careful not to trip.

When he was expected to comport himself as a priest, he wore the garments of a gentleman, silk shirts with ruffled collars and cuffs. And now that there is no expectation of his ministering to a flock, he wears the robes of a priest.

Il Reverende pre Pomponio figliuolo del signor Titiano Cavalliero.

The Reverend Father Pomponio, son of Signor Titian Cavalier.

He polishes a brass fixture with candles that hangs from a corroding chain in the darkened entryway. His foot slips and his shinbone knocks against a rung of the ladder.

Pomponio tore the paintings from the hands of the assistants in the workshop, the ones who knew how to protect them. Five years after his father died, he sold a Mary Magdalene, a Venus with a Mirror, a Saint Sebastian, all of these paintings and more, sold along with the house in the Biri Grande to a man named Barbarigo. How much work has been lost? Who can say? A Mary Magdalene, a Venus with a Mirror, a Saint Sebastian standing; how could he part with one of these let alone all three?

The Mary Magdalene, with her red-rimmed eyes, which his brother had worked on, an image of the fever-blotched Lavinia. The Saint Sebastian, a painting in which the space between this world and another disappears. Saint Sebastian, his body pierced with arrows, a saint Titian painted many times, once for the Emperor. He painted Saint Sebastian in a painting of Saint Mark enthroned, along with the other protectors against plague: physicians Cosmas and Damian, saints of ills overcome. Rocco, protector against contagion. Sebastian, deliverer from violent death and plague, which come, out of nowhere, like arrows unseen. You could wake up sick in the morning and by nightfall be dead.

The disease is blamed on corruption of the air. The change in tidal patterns. The alignment of stars. God the Almighty who has sent a plague to punish man for his decadent and disgraceful ways. A few have observed that plague is preceded by an unusual weather pattern two years in a row: Warm fall. Warm winter. Wet spring. Primarily blame is laid upon the insalubrious air.

During the days of the plague, those who walked about covered their mouths with pieces of cloth. Son would not open his door to father; brother would not enter the home of an afflicted brother. Sons fled the houses of their fathers to hide in hamlets on the mainland, in the mountains at a higher elevation.

A peasant couple from the mountains brought the plague to Venice in June of 1575. Lucia, daughter of Giacomo Cadorino, and her companion, Matteo Farcinatore. Migrant workers were blamed for spreading it further. They fanned out all over the city at night, and, when no one was looking, splashed walls and doors with infected substances. The *ungenti*, these people were called, flinging contaminated material when no one was looking. No one ever saw them, but everyone blamed them, the itinerant workers, Jews, beggars, heretics, vagrants.

In August of 1576, the city was emptied of people, doors were closed tight. Those who went out, went out in sunlight, not on overcast days, as if the sun could protect them by burning off the plague. Never at night when the air was most heavy and stained. Those suspected of having contracted the plague were carried away to the new pesthouse on the island of Sant' Erasmo, a sandspit of an island out toward the sea. Those who did not have the plague when they were carted away contracted it there and died.

The health officials quarantined Titian's house and marked his door with a cross. Titian, one of the wealthy ones, could pay for a guard to sit on a bench outside his door to make sure no one came in or went out, and he was not carried to the island of Sant' Erasmo. Titian and Orazio sat in the *tezza*, the doors closed tightly, and burned an incense made of precious herbs, aloes-wood and myrrh, to temper the air and dissolve the contagion. They drank a liquid made with the essence of marigold

to ward off the pestilence. Each day a carrier of victuals came to Titian's house and a basket was lowered from the second story, and a long-disused pulley hoisted up the food. A doctor came each day, and stood below the window shouting: How is Signor Orazio feeling today? Fever? Have any more tumors been found?

Pomponio had hurried back as soon as he heard, crossing into the house just as the quarantine was being lifted. He found the servant Giovanna da Malborghetto pawing through his father's things, and the first thing he did was order her to leave. The house was still sealed but somehow she had found her way back in. She had said she was washing down walls, fumigating linens. She was there amid the destroyed house of Titian which had been looted by vagrants even as the funeral bells were tolling at the church of the Frari. She had insinuated herself back in, and he was having none of it. The house must be cleansed of her and the rubble.

But where will I go, Signor Pomponio? she said.

Still, after all those years she refused to call him by his proper title, by his ecclesiastic title, *the Reverend Father Pomponio Vecellio.*

That is not my concern, he said.

Giovanna da Malborghetto, her neck sunken into rounded shoulders, looked up to him, her hand gripping his forearm through a linen sleeve. He could feel her fingernails.

Where will I go?

Who will clean the house?

How will I live?

It is not my concern, Pomponio said. They have almshouses. Live on someone else's charity. Two-thirds of the city already does. You have been a drain on this household long enough.

Usurper, who tried to take the place of my mother. Whore. A model stripped down naked to paint the flank of Venus. My father painted you in your prime and then kept you on as a ser-

vant out of pity. When he took other models, he was kind enough not to throw you out. Go see who will paint your picture now. Your face has not been luminescent for decades. Go, get out. My father only tolerated you, humored you. He was too kind and too generous, making a place for you in his household and elevating you to servant. Go, get out. Get out of this house, you with your false concern, hovering and bringing him soup.

Now, as he climbs down the ladder from which he has been polishing a sconce, he hears the old woman's reproaches. Though he flicks it away with the back of his hand, her voice will not be silenced. Why were you not here with him when he died? Ingrate. Coward. Your brother was there during the last days. Orazio was good, generous. And you? Where were you? You fled like the others, like the other *signori*. When the rumors of plague began, you ran up into the mountains you have always despised, always mocked as rustic and backward. You did not tell anyone you were leaving. You left a note saying there were ecclesiastical matters to tend to. You, who had never done so in your life. You are the eldest, you should have been there when your father discovered the bubo in his armpit on the twenty-fourth of August, the feast day of San Bartolomeo. You should have been there when the fever took hold. You should have been there to cradle his bald head in your lap, as your brother did. You should have been there sitting next to him as he lay on his death bed. You should have been there three days later, when he perished in the depths of the night when one day yields to the next.

Pomponio, unable to bear the voice of that old woman in his head, incessantly nagging and shrill, picks up the bucket from the floor and hurls it against the frame of the door. You are wrong. You are so very wrong. Titian did not die on a deathbed. He died on the floor trying to raise himself, calling out for no one, wanting no one, reaching for pigment, waving an angry fist in his empty workshop, demanding one more day.

Pomponio was wronged again, denied the final chance to make peace with his father. To provide in the final moments something his brother could not. He had always imagined that he would sit by his father's bed during the last hours of his life. He would hold his father's restless hand, and soothe him. But fate, he thinks, fate has cheated me of this. He does not remind himself he chose to leave the city, so that in the end no one was there when his father died.

Pomponio has been denied. Again. Always hungry for approval. But long-limbed, thick-lipped, given to erratic motion, his awkwardness repelled, pushed others away. Talk of this plague had begun the year before the summer it captured the city. Pomponio believed the worst, that he would perish, and so left. He did not flee, he was not a coward, he made an error in judgment, that is all. He could not imagine that Orazio would be ferried across the lagoon to die; sanguine Orazio always landed on his feet. He did not imagine that his robust father could succumb.

Pomponio walks up the stairs. The stairwell is little wider than the span of his shoulders. He leans his neck forward so as not to hit his head on the slanted ceiling. He arrives and stops to catch his breath.

All his life, everywhere he has gone, he has stumbled over his father's greatness, even here, in these meager circumstances. In the corner of this room sits a trunk, a *cassone*, the very chest depicted in a painting in which his sister is still a girl. She kneels in front of it, peering down as if looking for a hand towel, while their mother Cecilia, a bedcover flung over her shoulder, directs her. Lavinia, fair-haired, bent over in a white linen dress, sleeves puffed up at the shoulders, looks down into the trunk which is open like a casket. Their mother, hair piled high, sleeves rolled up to the elbow, instructs her.

The trunk is dark, balsam-green and lichen-blue, with raised scrolls that are flicks of white. The scene is a figment of his father's imaginings: Cecilia, alive, instructing her eight-year-old daughter. And in the foreground of this domestic scene, stretched out on a couch, on white silk sheets whose creases swallow air, a sleeping dog curled at her feet, lies pear-shaped, delectable Venus.

The *cassone* sits in the right corner of Pomponio's miserable room, overpowering it. He bends stiffly and lifts the lid. He kneels in front of it and removes folded sheets. The creases are permanent, the corners perfectly matched. The linen smells of mildew. Pomponio cannot make a move in this vast city without tripping over his father. Everywhere he turns are reminders that he is the failed son of a great man. And now he is left to carry them forward, their weight ripping apart his spine, shattering his fragile vertebrae. How is it that he remains? Why not the youngest, Lavinia? Why not Orazio? Or the brother-in-law? Why is it that he alone is left to carry them, dragging their weight behind him on a sheet?

He has emptied the trunk of the linens and at the bottom is a silver box. He lifts it out. He stands up slowly and steadies himself. From the sleeve of his cassock, he pulls a black skullcap. He places it upon his bald head. He drapes a narrow stole of royal purple around his neck, a priest's Lenten vestment. Over his shoulders, he throws his cloak, a purple so deep that it is almost black, and he drapes it over his right arm so that he will not trip walking down the stairs.

With the box wedged between elbow and waist, he walks downstairs.

He passes through the threshold of this home he has made, heading east through a crooked walkway toward the heart of the great sea-beast.

He carries the silver box under his cloak, which was once an exquisite piece of clothing, a heavy velvet now trimmed with

moth-eaten ermine. Inside the box hidden under the cloak is another box. And inside this box is another box.

He walks along the rio Sant'Anna, making a low guttural recitation:

Mother of the Mother of God, who was born of Immaculate Conception.

He crosses an arched footbridge and continues along the rio San Gioacchino:

Father of the Mother of God, who was chased out from the temple and fled into the mountains.

He turns along the rio della Tana, a wider canal and walkway, moving toward the Arsenale, site of the recurring dream in which a fleet appears on the horizon and disappears in smoke. He presses the box tightly under his arm, under his cloak. He holds to his nose a handkerchief, which is perfumed to temper contaminated air.

He walks along mumbling.

Sicut enim homo peregre proficiscens vocavit servos suos et tradidit illis bona sua.

Not looking up from the pavement.

Et uni dedi quinque talenta, allii autem duo, alii vero unum, unicuique secundum propriam vertutem.

He could be mistaken for a wandering mendicant, except for the lace handkerchief he holds up to his nose and the ragged cloak that is trimmed with ermine.

He speaks aloud in a low, whispered voice:

What is in my box, you want to know? You, old woman, head wound in a servant's scarf, your eyelids folding over themselves, your lower teeth worn down into a swag, you, old one, who berates me unceasingly for not sitting up with my father. And the rest of you, all of you, he says, pointing to closed shutters and doors. All of you who want to know how it is I could

pulverize this legacy. You who cannot imagine what is was to live in the great man's house because you are so busy bestowing accolades. Divine Painter. Prince of Painters. You who weep over lost paintings, over lost documents, I ask you, What is in my box? Do you want to know? Something you would like to see? Perhaps the floor plan of the great house of Titian? A sketchbook? You want to know about these things? Put aside the ledgers and the documents; you will not find them there at any rate. These things are gone. But still you look to see what Titian placed on the table beside his bed. Was there even a table there? These things are gone and will not be known, and even if you can puzzle out a small piece, there will be more questions still. You will keep asking, looking, hoping that in some forgotten attic of some impoverished nobleman there will be a packet of letters or his last will and testament. He revised the will so many times. In one version, did you know, I was written out completely?

Pomponio talks aloud, nodding his head, punching the air with his fist.

On the rio dell'Arsenale, he pulls the handkerchief away from his face, addresses the open air:

I am the worthless son of a great man. There, I have made my confession.

The worthless one. But I stood as tall as my father. I have his height, his hooked nose. Orazio was smaller, and, therefore, more endearing. Orazio had the almond-shaped eyes of my mother, my father's high forehead. Lavinia and Orazio got her Venus-skin. I inherited his harshness; I inherited his grave reserve without anything graceful to temper it.

Go ahead, tell it, write it all down, how I squandered the great man's fortune: the house in Biri Grande, the workshop, the house and courtyard in Cadore. Two houses on the mainland. The books. The paintings. Those pitiful two fields in Vales, in Chiarnusa, the field and a half at Tai.

I divested myself of all the holdings and now live in uncertain circumstances with my very few possessions.

Handkerchief in his hand, he crosses himself.

In this district of Castello, he enters the parish of San Martín, where they tolerate the vagrants. Vagabonds, the beggars who wander around pretending to be employed in useful commerce.

To his left, down a narrow walkway, he hears a high-pitched woman's voice, a quaver: Cup of porcelain! Stockings of wool! String of highest quality! Halfway down the *calle*, he sees a flicker of russet and forest green. A blanket draped over an arm. A palm fleetingly held open that recedes into an alcove.

He continues walking, his head nodding triumphantly as he talks, as if he were preaching the gospel: *Ecce habes, quod tuum est*.

He speaks aloud, not in Venetian, but in the language of the Church: *Serve male et piger!*

Wicked and slothful servant.

His winding path makes no sense; it is directionless, but who would expect anything different from him?

Right, then left, until he nears the rio di San Francesco, where twenty-five years ago, the Anabaptists met on Sundays in the shadow of the church, flaunting it, until they were extricated and purged.

Over arched bridges and through the *campi* of churches, he continues his meander toward the Grand Canal.

He passes the church of San Bartolomeo, looking down at the pavement as his feet move forward. This is the German church, and nearby are the inns where the Germans live, corrupting the air with heretical beliefs, trying to influence knife grinders and weavers into disbelieving the doctrine of the Church. He passes the church of San Lio, with Titian's paint-

ing of San Giacomo. Sixteen years dead and Titian is everywhere.

On the other side of the canal, after crossing the Rialto, Pomponio walks by the prison for debtors, his shoulder brushing against the building.

At a landing, Pomponio steps onto a ferry.

He stands and recites as if he were preaching. A mother grabs the wrist of her small son, pulls him into her skirt.

He glides past the Fondaco dei Tedeschi. The exterior walls were painted by Titian. Can he go nowhere without signs of his father? The frescoes have started to fade, eroded by wind and rain, devoured by the lime of an ill-prepared surface. This place is inhospitable to frescoes; it is too damp and wet.

He glides past the palaces of Grimani and Benzon.

He enters the parish of San Samuele, where, when Pomponio was a small boy, his father had his first workshop.

His remembers a ladder.

His father is upstairs. Pomponio, with a scab on his knee, stands at the bottom. There is a very wide space between each step.

Pomponio has waited forever to ask his father. He is nine years old.

He has held his tongue until now, until the very day of the procession. He has kept his buzzing anxiety jittering inside as long as he can.

On the twenty-third of October, the feast day of San Giovanni, this very day, in less than two hours, there is to be a great procession, a mock naval battle, in the Grand Canal. They are to sit with the duke from Ferrara.

The morning hours are passing, have passed, without anyone having spoken of the procession, and he can contain himself no longer.

He takes the first high step up the ladder, gripping its sides. Then the second. He climbs the steps quickly, sick to his stom-

ach with fear and desire. He comes to the opening, grabs hold of an iron ring on the floor above, and hoists himself into the loft, and as soon as he emerges, he sees his father in profile, staring at a canvas.

He blurts out,

So are we going or not?

His father's face turns slowly in his direction. Titian is in a daze, as if his eyes cannot focus on what is before him.

Titian says, What? and looks around to see where the little voice comes from.

Down here, I am down here, Pomponio says. His little hands are clenched into fists.

His father looks at the boy, who is fidgeting, fidgeting, knocking his knuckles together.

Are we going to the battle?

The father's face is blank, confused, with no sign of having understood him.

Are we going to the battle or not, the ships? the little boy says again, now briskly rubbing a fist against his lips.

Titian's face contorts in understanding, his eyes stretched wide and frantic, like an enraged animal, his mouth small and compressed. There is silence, and then he explodes.

The fifth day of August, he says.

He raises his hand to strike the boy.

Pomponio crouches and holds a crooked arm above his head.

Your mother dead on the fifth day of August. Not even three months. And you ask about some circus, some carnival.

Titian stops himself from inflicting corporal violence.

Get out of my sight, he says to his first-born child. He calls him Glutton.

Titian turns away from him, does not look at Pomponio again.

Pomponio edges down the ladder backward, his legs weak and shaking.

Eighty days before this, the night of the fourth of August, the door between his bedroom and his parents' had been shut tight. On the other side of the wall, he heard his mother's voice weak and desperate in the final hours of childbirth. *For the love of God, let me die, I can go no farther.* Their father's sister Orsola slept next to Pomponio. And, next to her, Orazio, who slept on his side clutching a small piece of soft cloth, his eyes almond-shaped, like his mother's, a flat arc underneath the brow. Pomponio lay on his back, on the left side of the bed nearest the wall, his arms stretched rigid alongside his body. The sheet was stiff and starched, crushing his chest and legs.

At a stop on the Grand Canal, he changes to another ferry that takes him across the canal to San Tomà. He preaches and the passengers cede him a corner. The boat floats into the dock and bumps the wooden dock. He climbs out, his cloak brushing the water.

He walks through winding passageways toward the church of the Frari, where his father's great altarpiece hangs. The one that established his career. The opening salvo. The Virgin assumed in the great arc of clouds supported by a host of angel-children. And the other Madonna, the Pesaro Madonna, which is a portrait of his mother, with her almond-shaped eyes and full lips. She holds a standing infant on her lap. She strokes the top and bottom of the baby's plump foot between two fingers. The baby grabs the edge of her milk white veil, and tugs, a sturdy, robust boy, a portrait of his brother.

Behind the Frari is the neighborhood where his mother was alive.

Pomponio stands at the entrance of a *calle* that dead-ends into a small canal. The *calle* is narrow, not even the width of a tall man laid across it, and the sunlight has difficulty entering. A child throws a wooden ball against a wall and another child

chases it. It was perfectly fine, it was perfectly adequate, why did they have to leave?

Halfway down on the right is the building where they lived. A single step led up to the doorway; his father bent his head to enter. On the pavement of the vestibule was a mosaic, a picture of a sea bass, cyan blue and Neptune green. Pomponio sat for hours, rolling marbles in the cracks between tiles. Each small tile was land and the space in between was water. Glass beads were boats. Even if they had to walk over him, they let him sit undisturbed. It was one of the few activities that calmed him.

They lived on the second floor, and to walk to the kitchen you walked through the gathering room, the *sala*, then through the bedroom where Titian and Cecilia slept, then through the room where Pomponio and his brother slept. Before the children were born, the living quarters were commodious, and to walk between two rooms to get from kitchen to the *sala* was not bothersome. Only after Pomponio came, and then Orazio, and then Titian's marriage to Cecilia, did Titian begin to grumble: Doors slamming, crumbs in the bedroom, and I can't go into the kitchen at night without waking up Pomponio, who is such a delicate sleeper, can no one make that boy calm down?

Pomponio heard crickets buzzing in his ears right before he went to sleep. If he woke in the middle of the night, the sheets pressed so hard he could not breathe. In the day, he was tired and listless, and when someone spoke to him, he looked away and did not listen. He would sit for hours nearly motionless, then erupt into a demanding frenzy; unable to sit, unable to lie down, he would pace and drum his fingernails on a wall. When someone went to comfort him, he stiffened and pushed him away, as if his skin were being pricked relentlessly. He would let no one touch him, unless it was his mother.

After they left, all his father would say was, What idiot designed this house, separating the kitchen and *sala* with the bedrooms? What fool thought to make it up this way? Slam, Slam, Slam, that's all I heard. And children running back and forth.

Pomponio remembers his mother telling his father, But this is a wonderful home, husband.

In ogni caso, questa tezza è diventata troppo stretta.

In any case, his father said, this shed has grown too tight.

A memory. Above him, his mother leans out the window, her elbows on the sill, her full figure spilling out of the frame. Her head is wrapped in a scarf and the sleeves of her dress are rolled up to her elbows. She calls out to a woman in the window directly across the *calle*. Clothes hanging on a line, between the two buildings, dripping water.

The above woman yells, I'm making lamb for the feast day.

So am I, says his mother.

His mother shakes a sheet, flicking her wrist, to see if it is dry, then shouts, Do you use marjoram or rosemary?

A memory. His mother saying under her breath when his father is out of earshot, It takes two days and nights to dry a lightweight shirt in the alleyway, this cavern, and he goes through two a day.

Another memory. His mother pulls Orazio aside, bends down to him, and whispers in his ear. Be a sweet boy and let your brother win a game of marbles.

There was nothing of this place in his father's paintings; it was all porticos and antechambers and atriums and alcoves. The mountains of Cadore misty in the background. Nothing of this *calle* that dead-ends into water. Nothing of the jumbled rooms on different levels, where he slept, secure between his parents' room and the kitchen.

I am the only one who remembers it. Titian blocked it out, rarely spoke of it, except to say it was like a cave. And Orazio, my dutiful, obedient brother, never mentioned it either. Lavinia, who was not yet born when we lived there, was inconsequential. After we moved to the Biri Grande, it was all Light and Space, Space and Light, that was all I ever heard about.

He walks alongside the Frari, and enters the *campo* in front of it.

He is mumbling again, reciting the gospel. *Et timens abii.*

I was afraid.

People sidle away as he passes.

He is reciting a parable aloud, the one about a great man who goes on a journey and calls his servants to him and entrusts his property to them. To one, he gives five talents. To the second, two. And to another servant, he gives one. The one who receives five talents goes and trades with them, making five more talents. The second servant makes two more. But the servant who receives one talent digs a hole in the ground.

On the arched bridge going over the rio dei Frari, Pomponio says, *Et abscondi talentum in terra.* And he hid the talent in the ground.

On the calle di San Tomà, another mother yanks her small son away from him, and they hug the wall to let the vagrant pass.

He walks along, muttering. He stops at the doorway of an inhabitant he does not know and recites the rest of the parable. How the Master returns to settle accounts. How the Master says to the first two, Well done, good and faithful servants. How, when he comes to the third, the servant grovels, and says, Master, I knew you to be a hard man so I was afraid and hid your talent in the ground. The Master calls him wicked and slothful. He takes the paltry talent from him.

Pomponio arrives at the landing, waiting there with the others. He recites the parable again, decrying the injustice of punishing the one who was given less, of banishing him to the outer darkness.

He steps into another vessel and floats past the Fondaco dei Tedeschi, past the Ca' da Mosto. He floats for awhile, then steps off the barge. He walks along the rio dei Santi Apostoli, following it to where it becomes the rio dei Gesuiti. He hears

the clangor of bells at the church of the Gesuiti. Then, the bells of the church of the Mendicanti dully rumbling later from the east, a minute later, just as always. He turns toward the calle Colombina, walks toward his father's house, which he sold, along with all its contents.

The house is closed up. The new owner has made a journey abroad. The servants live inside, like little mice, tending to it.

After the quarantine had been lifted, he pushed the door of the great house open with difficulty. It was blocked from inside, wedged shut with a heavy beam torn loose from the ceiling. He squeezed inside the door, the wooden insignia of a lion stripped from it. Everywhere he looked in his father's house, there was wreckage. The floors were littered with food and broken furniture. The table in the *portengo* where he had argued with his father had been sawed in two. The chairs on which they sat had been carted away. The chair with the marks left by a teething child was gone. A painting that had been cut out of its frame lay on the floor underneath an open window, water-soaked; the frame is what had been taken. Forks and knives and spoons had disappeared. A rat moved laconically across a toppled mirror.

Upstairs, in his father's bedroom, on the floor, was a shattered faience pitcher. Pages torn from books. And soiled bed sheets, stained with blood, blood from a woman who was suffering from the moon, but not suffering very much, for there, in the bed of Titian, in his father's bed, a woman had lain, and it was not likely she was there alone or that she was sleeping. He could look no more. He went to the window, pushed open the glass pane, and vomited.

The house had been ransacked, its contents strewn on the walkway, jettisoned into the small canal. Men, women, and children had carried off rugs and tapestries.

In the *tezza*, in the workshop Titian had built, the destruction was the same. Linseed and walnut oil. Vitriol. Mastic. Yel-

low orpiment. Lead white. Cinnabar, red lake, pavonazzo, sinoper, crimson, umber, kermes, turchino, ultramarine. It was as if a giant forearm had swept from east to west across the floor and toppled everything.

Pomponio was left with boxes and boxes. Titian had not specified what was to be done with them. Was his death unexpected? Titian was more than ninety years old. But he worked until the end and he did not have time to prepare. Boxes and papers were not labeled, Throw this out, Give this to charity. No, nothing, leaving Pomponio to decide what was important, what was not.

Upstairs, in a room off the hall to the left was Titian's bedroom, the defiled room, which Pomponio had to enter a second time. There were bottles of ink. Pens. In the right corner near the window, the *cassone* with bed linens and towels. So much was ruined, stolen, and here he was left sitting alone in the empty house, needing to decide how to dispose of this, how to dispose of that. He sat on the floor of his father's bedroom. On the table beside his bed, there was an empty glass and one slip of paper with the words, *Dona Katta venir nostra pecata bene pixt*. Beside the bed, house slippers, which had molded to the shape of his father's foot.

What was in Titian's chest of drawers? He opened it. An engraving, buttons, letters tied together with a black ribbon, fingernail scissors whose handle and blades made the shape of the body and beak of a crane. There were small rectangular cards with death notices and prayers printed on them, those of his uncle, grandfather, mother, sister, Titian's friends and colleagues. Handkerchiefs folded into perfect squares. A coin from ancient times, a talent from Damascus. What was in his father's top drawer? Little accumulated sentimental tokens. How was he to decide what to keep, what to send away? This son, so unable to find favor. There was a white silk scarf with a

stain and a tiny velvet pouch containing three small teeth. There was a piece of cloth wrapped around a plait of hair. Who is to decide what to keep, what to throw away? Why am I left to decide?

They could make an entire museum with the contents. What museum would not scurry, send acquisitions experts, to get a hold of the skullcap, the zucchetto, that sat, certifiably, on Titian's bald head?

Pomponio sat on the edge of the bed, staring at the overturned remnants.

Why did Titian not see to it himself?

What am I to do with his comb?

Pomponio was left alone with all this wealth and he could not judge what was valuable and what was not. He sat in the defiled house, ignorant and nearsighted, refusing assistance. His brother-in-law offered to help, but Pomponio spurned him. I alone will decide, he said, in a voice of weak pomposity. I alone will decide what will be kept, what will be sold, he said, all the while, despising his father for leaving behind so much, and missing him already like a burr embedded in the lungs that has been suddenly ripped out.

There were crates filled with pieces of paper, drawings done over weeks and months and years, accumulating, page upon page. When one crate was full, it was put in a small alcove where brooms were kept. Titian did not need to see them anymore. Scribblings. Titian said they kept him company, these doodles, they were chicken scratchings. Drawings of Venus's neck. A child's hand petting the fur of a tolerant dog. Pomponio sat in front of these crates: Why did he leave me as his curator, the talentless one, dragging around all of the greatness behind me? Or, am I to dispose of it, give it away, sell it, only to hear his voice reproaching me?

Pomponio, paralyzed with fear, swallowing bile, knowing he has never made a correct decision in his life, carried each crate, one by one, down the narrow staircase, down the through the

marbled hall, through the door, across the courtyard and out the gate, setting each of them onto the walkway to be carted away by scavengers.

Pomponio walks now toward the outer edges of the city.

He has walked out of the district of the Biri Grande, beyond the temple of the Old Ghetto, beyond the church of San Giobbe.

He walks along the embankment of the canal, on the opposite side of the city from where he now resides. He walks along the back of the fish, up on the top of its head.

There are dark spots everywhere along this embankment. Piles of dead rats, mounds of baby rats, which have all been washed in by the tide. Their fur slick and matted. They are everywhere and he must walk past them to get to his destination. He runs, screaming. As long as he screams, he can block them out. The scream insulates him and keeps him from gagging, keeps his spine from going limp.

He is past them and speaks again to the open air:

What do I carry? you want to know, here inside this silver box?

He is speaking to the old woman he threw out of his father's house and to all those who have said he is worthless.

The box has a red lining, he is saying, conspiratorial. It does not lock. I am giving you clues. It is intended to sit on a dressing table. Teasing you. There is a box inside this box. A box made of Florentine paper. And inside that box, another box, which is made of marble, a box large enough to hold something valuable. I took something valuable from my father's top drawer and placed it in here. What is it? I am taunting you. A letter from my father, urging me to live a respectable life? A jar of pigment touched by the hand of a genius?

Do you hear me? Pomponio shouts to the open air.

The box is safe and sound and watertight, he says.

In August of 1590, a year of influenza, on the twenty-seventh, which is a Monday, the Reverend Father Pomponio Vecellio, son of Signor Titian Cavalier and Painter, walks past piles and piles of dead rats, kicking a small one out of his way.

He carries a box under his moth-eaten cloak.

He reaches a place where there are three steps going down into the lagoon. The steps are slick with kelp, a green that is almost black. He takes one step down onto the first stair, and the water pools around his shoes. He steps down onto the second. Then the third. The water is up to his knees, and his cloak and priest's robe billow around him. Seaweed clings to his legs. Then he twists his body backward like some ancient, frail discus-thrower, and he unwinds and flings the silver box and its precious single talent into the sea.

Stockings for sale!

She sits at the end of a bench in an alcove, two narrow doors locked behind her. Each hand is burrowed into the sleeve of the opposite arm.

String! she says.

A knitted cap nearly covers her eyes. A coarse blanket is thrown over her shoulders. She wears shoes but no stockings; strips of cloth are wrapped around her feet.

Behind her on a rope hang a porcelain tea cup, striped stockings, a cloth doll. On the bench, clusters of unknotted string, wooden pegs, drawings in a wooden box, a paintbrush made of boar bristles. She has laid out her worldly possessions.

A beautiful rag doll! she calls.

Each day, she sets up her wares. The merchants nearby tolerate her. Praise the Mother Most Merciful, she says aloud. Day after day, she sells nothing. When someone wishes to buy the doll or the string, she names an exorbitant price. They curse her, but she cannot afford to sell the meager inventory; it is all that stands between her and vagrancy. She has a license to sell but not to beg. During the day, she has found this safe little spot. At night, she takes shelter under an arched bridge on the rio Ca' de Dio, sleeping in a recess not visible in daylight.

Giovanna da Malborghetto cannot move to another part of

the city; in another place, she might not be able to stay out of the way of the authorities. The local officers from the health board know she is here in the shadow of the church of San Martín, but turn a blind eye. She is safely overlooked here. Who knows what would happen in another district, in another parish?

She begs strategically, in a hushed voice.

Then, if you won't buy, can you help me out a bit, sir?

Not even a drop of milk you can give me?

Most people are hardened, and she is careful to choose a generous-looking face when she holds out her hand, tentatively, furtively, to say, *Le mani dei poveri portano le nostre offerte in Paradiso.*

The hands of the poor carry our offerings to heaven.

It is barely light on this Sunday morning, and she calls out to three young gentlemen whose arms are draped about one another. They weave and veer. They sing, returning from a Saturday night of diversion. One, with dark curly hair and a high, generous forehead, resembles the young Master, yes, something, she sees in his eyes, a steady gaze, a wince almost, as if he sees the suffering of others and can feel it himself.

The Doge will touch the head of a pilgrim, will you not toss me a single thin coin?

The man with kind eyes passes without a glance. She hears them as they walk away. Their voices bounce off the walls:

They should haul them all out to sea.

They should dump them on the other side of the border.

They should send them back to where they came from, says the gentleman who had reminded her of the young Master.

She has begged cautiously for nearly a year; she has no license to beg. The citizens plea with the authorities for relief from all of this beggary. This begging for alms must stop, officials and citizens agree. Healthy young beggars are condemned to work in the galleys of the Republic's ships wearing

coarse grey cloth of the conscript, but still this is not enough. The citizens cry for vagabonds to be rounded up, as they were a generation ago, and dumped on the other side of the border, in the State of Milano, which is where they all come from anyway. Let them work like we worked. When we came we were different. They should all be rounded up and put away like the lepers and the lunatics.

It is easier for the young ones to keep moving. Their limbs are strong and they can move quickly, carrying their belongings with them. But the old ones, she is now seventy-eight, how did she live so long, must prove they are not begging.

She has incorrectly judged a face and she must hope the young men will not bother to make a complaint.

From the east, at half past eight, the Maragona knocks a robust gong, and seconds later, behind at San Martín, a thin metallic tamp.

On each foot, she wears a wooden shoe that was carved for a man's foot. Each foot is bound with strips of rags. Her feet are infected where they have been cut. The balls of her feet go numb first. A tingle, a shooting pain, then numbness. She prefers numbness to shooting pains and throbbing. It is late autumn. She is outdoors every hour of the day.

She used to wash her feet under the bridge, but this ritual has ceased because she cannot bear to unwind the strips of soiled rags from her feet; it brings her pain to touch them. Her toenails have grown too long, and curve like claws around each toe, hard, dead skin. The hoofs of a mule receive better care because the muleteer takes his beast to the blacksmith.

She is rocking back and forth, back and forth, when the bells at San Martín peal at nine.

It is the eleventh of November, the feast day of San Martín, which falls upon a Sunday this year of 1590, a year of influenza, just as it did in seventy-six, which was a year of plague. The

priest, named Ermengaldo, swings incense from side to side as he walks down the aisle of the church, the metal lids clattering. His voice rises up in the damp, dank church. Breaths exhaled in response taper upward. He prays for deliverance from contagion, invoking the names of Rocco, Cosmas and Damian, Sebastian.

He leads them in prayer for deliverance, then he prays for consolation. He attempts to guide them away from malice. The spirit of San Francesco is dead, and the rejection of worldly goods is no longer a sign of humility. Beggars are emblems of indolence, of sloth, of the failure to use God-given talents. Blessed are the meek no more.

He speaks of San Martín, a soldier who gave half his cloak to a naked beggar. Martín lived away from this world and took the word of God by mule to forgotten places. His road to sainthood did not begin with a bolt of lightening but with an impulse to hand over an article of clothing.

His parishioners are tired, they have their own cankers and lesions, they have already lost so much, and mostly they reject his words. *Cart them all away*, they mutter when they see another crumpled form huddled in a doorway.

In the center aisle, the faithful have formed a line. In front of the priest, a hunchbacked man carries a statue of the saint and a nun carries a cross that contains a relic, a remnant of wool cut from the cloak of San Martín.

The procession stops in front of a relief of *San Martín and the Beggar* chiseled a century ago. This church, its patrons eagerly boast, was rebuilt by the great architect Sansovino, famous friend of Titian. The procession begins its wide circle around the church, turning left into the calle della Pergola, winding its way through the *campo* of the Arsenale. They pray for release from the stranglehold of this current epidemic, with its fever and wasting. Two years ago famine, and now this year, in autumn, influenza.

Again they petition San Rocco, protector against contagion. How many times his name has been uttered. Plague in forty-

one, fifty-six, seventy-six. Influenza in fifty-seven and now again this year. They gather together to pray, but it would be better if they would stay in their homes, not breathe upon one another, not exhale the airborne particles that cause the illness. They blame the epidemic on the stars and stagnant air, on beggars and on heretics. In three days, many will feel the first chill in their arms.

They have almost circled the church now, turning right into the calle Stretta. The priest stops before an alcove where an old woman sits with her wares displayed on a bench. She should not be vending on Sunday. The priest stops in front of her and she looks up, her face round, her eyes enormous, her closed mouth a perfect bow.

Sweet woman, serene in the alcove on the street, he says. He blesses her. He has tried to convince her to go to one of the homes for the desperately poor, but she has resisted. Here, accept this coin, he says, and presses a coin into her hand. Others have taken pity as well. The fruit seller gives her something at the end of each day; the baker gives her bread. Most of the beggars are not as fortunate and do not evoke a single generous thought. But the face of Giovanna da Malborghetto can unlock a tightened chest.

Her face is still luminous. Her lips full, a bow, a pucker; the space below her brow, a flat expanse of arc. Fifty years ago, strangers gasped when they saw her. Stop! Look! The servant girl discovered. Her skin seemed lit from inside. And even now, her neck nearly horizontal to her spine, there is something that causes an occasional passerby to relax his guard and reach into an alms purse to dig out a coin. Once again, it is her face that saves her, that yields her meager concessions. She could have been a servant anywhere, she had that kind of beauty. She had her pick of houses.

It was a good house, the best a servant could hope for. A clean and dry room near the kitchen. A room? Six feet by six

feet. It was always warm in winter. She could smell the cheese and salted meats. The sheets which she herself had pressed were scented with lavender.

It was the seventh day of September of 1576, a Friday, the day she was evicted from that great house. Upon his return to the house, Signor Pomponio had found her looking through a chest of linen, which she was going to wash with lye. He ordered her downstairs. She sat on a chair in the marble hallway, facing a window, her hands folded on her lap. The Master and the young master Orazio, the ones who had affection for her, had perished weeks earlier, and he alone was left, the eldest son. It began to rain outside as Signor Pomponio spoke. It started up suddenly, a torrent from the first.

Go back home, he said. Go back to the mountains where all you mountain people come from.

She gazed at a strip of wall adjacent to the window.

Go back there and leave the city in peace, he said. Stop ruining it, stop infesting it, all of you people coming down in search of the Land of Cucagna, the Land of Plenty, where you think you can eat and drink and sleep without doing a day's work. It's a myth, go back, we have enough of our own without foreigners corrupting the air. You look at the city down below and think it will hand you bread when you arrive at the gate. No, better than bread, sweet honey cakes. Go back to where you came from. You sneak in, then hide yourselves, stealing food when no one is looking, breaking into our houses.

She sat there staring, saying nothing. There was no one to protect her. Signor Cornelio, the brother-in-law, would have stopped the barrage, but he, too, had been banned from the house.

You dare insult me with your silence and your brooding, your sulking mouth accusing me.

Yes, he continued, my father came to the city from the mountains, you dare insinuate with your silence, impertinent servant, but he came from a noble race, with skill and genius.

He took nothing from no one, he made his own way. Those were noble men of noble times, noble emigrants who sought out the city in earlier times. They brought something of value with them. But you and your kind, what do you bring? Lice. Scabies. Plague. You bring nothing and expect everything in return.

His face was transformed into that of some tortured wild beast.

She sat there, a servant who knew her place.

She did not think to speak back to him and say, I have lived in this city for many years. My lifetime has passed here and I will never see a mountain again.

A foreigner. And you have already taken enough from this city. One out of every four getting handouts of some kind. Go away, go away and leave this great house alone. Go, there is nothing for you here.

She sat there, hoping that if she remained humble and docile, the outburst would conclude. She hoped he would ask her to clean the floors and tend to the linens. She would rid the house of pestilence, burn incense and wipe the walls again with vinegar and lime. She was a servant all her life, who deferred to higher-ranked servants and honored the name of the house.

She did not reproach him for his absence when his brother and father died. The Master fell ill on the feast day of San Bartolomeo, and three days later was dead. She did not utter a word about his death; it was not for her to judge.

And you cannot speak the language, Signor Pomponio said. You refuse to learn the language properly.

What he said is true, and she has always known it: she speaks a fractured language. Words brought down from the highest valley; the nearest town was called Malborghetto. Miserable little hamlet. *Funathe, careto, dharlin.* What language are they speaking? The porters, the fishmongers, even Venetian-born beggars look at outsiders with disdain. *L'á magnòu par colathion.* Learn to speak the language. The gentlemen and notaries wrap

their cloaks around themselves tightly; there is something that frightens them, these foreigners saying words they do not know; it is infuriating, not being able to pick out one single word from their babble.

She came down from the mountains of the Friuli in a year of great famine. There was one every five years. She came down with an aunt and an uncle; she was eight years old and she was charged with watching their four children. Her mother had died in childbirth, her father had died in a landslide.

They were among the thousands who came down in the spring, pushing broken-down carts and guiding swayback mules through the mud. They left little sloped fields and houses of stone, and they streamed down a great river valley, hoping to return in a season or two, back, not with a fortune, but merely with enough.

Before they had reached the plain, her aunt and uncle had sold their goats. The livestock was to have been insurance so that they could get established. In Pordenone, they cut her hair and sold it to a pillow merchant.

Her uncle said they could find work in the wondrous city, splitting timber, making lace, making glass. Venezia is a splendid city, the greatest; it loves a man and woman who love to work. This is what her uncle had said.

For the next three years, they cut her hair once a year, and sold it, until she left them to go work as a servant in a rich man's house. By the age of sixteen, head wrapped in a white cloth, she had been a servant for five years in the district of San Marco, in the parish of San Samuele. *Avevam i bei camp in elt*, she would say to the other servant girls. We had beautiful fields up there. She spoke the language of the fields. She mixed with it Venetian, words like *cugno*, which is what she calls her alcove.

Twice in the year of the plague, she was ordered away from the great house. The first time by the young master Orazio,

who told her to leave the city until the pestilence passed. He had wanted to keep her safe, to send her back among her people and to the salubrious air of the mountains. She had nursed him back to health, stroked his head when he had fever, and he did not want her payment for service faithfully rendered to be death by plague in this city. This plague was different from the one that preceded it, and the city was paralyzed waiting. Would they close the port? Would they seal the city? There was rumor of a death by plague in Bolzano, another confirmed in Ferrara. City dwellers were hording provisions, storing drinking water.

Signor Orazio told her to return to her mountain village so that she would be spared. His misdirected, misinformed, good intentions. There was no hamlet anymore. The five houses had been emptied during the famine of her childhood, then wiped away by landslide. This was the home she had known for twenty-six years, here in the Biri Grande, in a tiny servant's room next to the kitchen, but she could not say this to Signor Orazio. It was left unuttered. She could not say to him, My house exists no more, my people are gone. I would rather stay here and risk plague; if I perish, so be it. I have passed my sixtieth year.

He gave her a leather pouch with many gold coins, which he calculated would allow her to make the journey and to survive until the plague had ended.

Giovanna da Malborghetto said nothing when Signor Orazio sent her away. The time for speaking up came centuries later.

Those who could flee the city fled, scattering frantically, going headlong into the plague itself. Rumors abounded. It has been there, but not here. Those who had money to secure travel papers left Venezia; those without documentation travelled at night and crouched and slept during the day, hoping they would not be apprehended and carted away. Then the city was shut off from the world. At the homes of the wealthy, food sup-

plies were passed through slots in the wall so that a servant would not have to touch a porter.

She left the house in the winter of 1576, but she did not leave the city. She went to the district of Castello, where she knew of a hostel for pilgrims, for noblewomen and merchant's widows making their way to Jerusalem. And there she told them that she was a servant in the house of Titian, the painter, and that she would clean and do laundry in exchange for room and board. The proprietress asked why she was no longer in the employ of the household, had she stolen something? No, she said, and explained that the Master's son had wanted her to flee the city to safety. She had not wanted to show him any sign of disrespect and could not bring herself to tell him she had no home to return to. The young assume the world remains the same, Giovanna da Malborghetto said, and that only they are changing. The proprietress agreed to keep her on.

The proprietress had once been a raven-haired pilgrim who travelled from Paris into Italy. She travelled with a band of pilgrims through the Apennines toward the city of Fiorenza.

But before entering Fiorenza, she lingered, she told Giovanna da Malborghetto, who served her a cup of tea. As they sat at the long table, after the others in the hostel had left to say their afternoon prayers, the Mistress spoke of her journey:

Outside Prato we lay in a tent.
And when we woke the blanket was covered with frost
and the field was covered with dew.
He said, Oh? but how did I wake up here?
I must have taken a wrong turn.
When we sat for the midday meal he dropped a flower
onto my lap,
the late-flowering aster which had blossomed early.
Meaning? I asked him that very night.
Meaning, he said, variety.
We lay together four nights,
and then we parted company,

a pilgrim is supposed to pray,
not prey upon young men,
but he was lovely,
wiry, and I was a widow for fifteen years,
it was a lifetime ago.
There was a rock on the ground under the blanket,
and this young man was so gallant,
and while all the others in the world were so serious
Martín did not have a care
he was going to live and live well
and he laid down his cloak on the ground
and he insisted that I sleep near him so as not to be hurt,
so as to keep warm.
He read verses to me from a volume:
And as my hair is changing, I think
only of what she is like today and where it is she dwells.
He was very gentle in his fury,
he was not in a particular hurry,
he said that I could repent later,
once we got into Fiorenza,
the Dominicans would be happy
to hear my confession and to accept my offering.
I remember that he liked to play cards,
and that, by candlelight, he taught me to play *tresette*.

She travelled from Fiorenza to Assisi, and then to Rome,
winding her way down the peninsula. Eventually, she made her
way back north to Venezia, where she planned to stay just a
short time until the day the Doge blessed the heads of pilgrims
who were bound for Jerusalem.

She fell ill, she told Giovanna da Malborghetto, and the
group went on without her.

I sold my gold chain at a pawn shop near the Rialto, receiv-
ing not half of what it was worth.

It is not that I feel humbled by my present circumstances,

now that I have been reduced to a caretaker at a hostel, the key-carrier, who makes sure that no one comes in uninvited; I was once a woman of wealth. No, I have accepted this lot with humility, with gratitude even. It is just that I had so hoped to see Jerusalem. I believed, with all my heart, that somehow it would come to pass.

Giovanna da Malborghetto remained there four and a half months, until a day in late August when word of Titian's death spread across the city. The bells tolled and he was buried in the Frari. Giovanna da Malborghetto threw her few possessions into her canvas sack and returned to his house.

The Mistress grabbed her wrist and said, Don't go. It would be foolish to step out of this house, there is pestilence all around.

Giovanna da Malborghetto said to her, I did not live this long in order to be afraid. He was a great man. I was his servant. There will be things to attend to. I will be needed.

She left the hostel and began to walk across the city. Over her mouth she tied a handkerchief that had been soaked in vinegar to purify the air; it stung her nostrils and lungs and made her slightly dizzy. She did not encounter a single person until she came to the rio di San Daniele, and that person ducked away into a small walkway so he did not have to pass her. There was not an open window on that sweltering afternoon. Doors were bolted shut from the outside, a cross marked on the door of each infected house. The only movement was a line of six penitents who passed by, beating themselves with knotted cords:

Misericordia andiamo girando
Misericordia non sia in bando
Misericordia Iddio pregando
Misericordia al peccatore.

When Giovanna da Malborghetto arrived, she saw a cross painted on Titian's door. The locks were broken. Everywhere

inside she found mayhem. Violation. And she did the only thing that she could do; she begin to cleanse it. No one was to allowed to enter an infected house, but she was not afraid of the plague. Let it take her. When the health officials came to tell her to burn furniture, she refused: The house of Titian has been ransacked, looted, and now you want to destroy what is left? You will not see another like him in your lifetime. No, I will fumigate everything. I will wash it all down, see that it is aired out. No, the official said. It is not possible; chairs and linens must be burned. No, she said, and she produced a gold ducat from her purse. He bowed his head to her and went on his way.

She washed the walls with vinegar. The Master is no more. Signor Orazio gone. Long drips streaked the walls where acid etched into grime. She swept the floor and spread lime dust across it. She was sweeping when Signor Pomponio walked in and found her among the debris.

When Signor Pomponio finished his tirade against her, his diatribe against foreigners, whores, and beggars, he put his hand against the wall to steady himself. He told her to leave immediately. She asked to go to her room near the kitchen to gather her few items. Her small, safe room.

Pomponio watched over her to see that she took nothing that belonged to the household. As she folded a blanket, he said, That is not yours.

Yes, sir, I brought it with me. It was made by my mother, green and russet; see the stocking stitching and the moss stitching with its nubs, a double layer of knitted wool covered by flannel. Please, Signor Pomponio, I beg of you, it is the only thing I possess that was touched by my mother.

Pomponio made a sound of disgust, a snort. Fine, but I'm watching, don't try to take anything that belongs to this household. The vagrants and looters have taken enough.

Giovanna then asked him if he would allow her to see Titian's workshop. She had not seen it since the time she sat

while he painted her picture, since the early days of her life. Pomponio, his face twisted and jaw clenched, permitted this. How odd, how startling. She had not believed it was possible.

Fine, old woman, he said, look to your heart's content. He called her "old," although she was only ten years older; the poor age faster than the privileged.

Giovanna da Malborghetto climbed the stairs, gripping the rope on the wall to her left. As she stepped onto the top step, into the great vast workroom, she saw pots overturned and paintings lying flat on the floor, trampled and ripped.

She sat down on a three-legged stool in the middle of the room, covered her face with her hands, her mouth sunken into her jaw.

Signor Pomponio had permitted her to walk up the granite steps, to enter the *tezza* so that she would see the ruin. He allowed her to see the plundered workshop only so that she could see the state of his heart; she had always thought he had none. *Orazio has heart. Orazio is good.* But none of her affection was ever offered to him. She had never patted his shoulder with ease, never teased him in all the years she had lived there.

Take a good look, Signor Pomponio said. And be quick. I don't have all day for you to sit there and sulk. I have business to attend to. The affairs of the estate.

She stood up and brushed her apron flat against her thighs. She stepped over broken glass and the scattered pigment, lifting her hem. She searched through the paintings that remained after the looting:

A penitent Magdalene with red-rimmed eyes.

A Saint Sebastian, protector against plague, stacked over it.

In the corner, *The Flaying of Marsyas*. The looters would not touch it. Marsyas, his satyr's body strung upside down, like a pig for slaughter, tied and bound, and hanging from a tree limb. His skin stripped from his body, flayed, his heart and liver exposed.

In his final years, Titian painted slashed and twisted and hacked flesh. Torment, remorse, redemption. But in his middle years, he painted flesh that pulsated.

She found one Venus, but no, this was not the Venus she looked for. This one was plump, a blond Venus, with pearls in her hair, a patrician holding a mirror.

She continued to search through the rubble.

I was a girl, barely twenty. He was a man in the prime of his life.

Giovanna da Malborghetto stepped over broken pigment jars, thinking that she has had the fortune of being depicted. Few leave any record of themselves. Perhaps a name listed in the Book of the Dead, an age, the cause of death. But a face, a body? Nothing. And she had neither son nor daughter to remember what she looked like. Titian captured her body and face on canvas. He held her chin in his hand, turned it toward the light. This was her fortune. She had skin of fullness that breathed, the color of peaches; now, every visible part of her body sinks inward, caves forming in the space between bones.

Signor Pomponio, impatient, grunted.

But Giovanna da Malborghetto continued to look for a hand in a portrait which might have been hers. A thigh. A flank. A belly folding over itself. Healthy. Well fed. Well kept.

She would sit perfectly still for hours, unclothed.

She would lie perfectly still.

Move your foot that way. Turn your ankle this way.

Stand next to the window. Stare straight over my shoulder.

The patron should be in ecstasy. Making a portrait of his lover who resembles this unknown beauty. What could be more perfect?

She came from the mountains, but she got out just in time, the Master would say. She is not hardened like the rest.

She would smile.

A year longer up in those mountains, and she would have

been corrupted for sure. Callouses on feet that never would have softened. A full face, nothing sharp about it. How ever did you escape the harshness, little shepherdess? he would say to her.

He called her to sit for one painting, having seen her as she carried folded linens at the house of an acquaintance in the parish of San Samuele.

Lend her to me, he said. A model gets twelve *soldi* for undressing. If I paint her she gets twice that.

She sat for one painting.

She sat for a second.

And a third. And more.

His young wife dead, he rediscovered flesh, and devoted himself to it.

In those days when the Master had painted her likeness, her feet were slender, perfumed, and rubbed with ointment. Her long toes were perfectly straight. She lay propped up on an elbow, leaning on a pillow, her head tilted, her neck stretched and exposed, a breast lifted upward. On her smallest finger, she wore a moonstone. Her feet were crossed at the ankle, the shallow arch of the sole of her foot a place for an index finger to trace.

Signor Pomponio hovered, gawky and birdlike, as she looked at the paintings for some sign of herself. Proof of another life, of having been touched by greatness. Proof that she had lain on silk and been taken for a goddess. But the painting she sought was gone. It was in a great hall of a palace; more than forty years had passed. When she returned to the house as a woman in her middle years, this time to clean and launder, Signor Titiano had not painted her. He squeezed her thick middle, he patted her head. She fussed over him. Eat this. Here is a scarf, Sir, to cover your throat. She kept out of the way and sometimes he would knock at the door of her room off the kitchen at night, but rarely.

It was never a question of love. A certain affection, perhaps. He was a great man and I was a servant.

Signor Pomponio followed her closely, watching to see that she took nothing from his father's house, and, finally, bored, after having watched her study the faces of so many paintings, he said to her roughly, That's enough. And he turned to go down the granite staircase.

When Giovanna da Malborghetto saw his head disappear down the stairs, she grabbed a boar bristle paintbrush as big as a fist and an earthenware jar of blue powder and concealed them both in her sleeve.

Downstairs in the great dining room, amid the strewn litter, she asked Signor Pomponio once more, begged him.

But where will I go?

It is not my concern.

After living so long under one roof, after living so long with one family, she did not know where to go. She would not go to the nuns or to any of the hospices. She had not fallen that low. She would not go to those places for destitute people, people with skin disease, people whose minds were destroyed, the beggars, the riffraff, the slothful, the indolent, the whores who want to repent. Those places were for the desperate, the vulgar and mean. And she would not be part of it. Had she not been in the employ of a great house, a servant to a great man?

The coins she possessed would allow her to live half a year. She made her way back to Castello, to the hostel for ladies who were pilgrims.

When she reached it, she walked around back to the servant's entrance and knocked. No one answered. She knocked again. A metal plate slid away from the window in the door, and someone asked, What is it? What do you want? Gio-

vanna da Malborghetto stated her business: I worked for the Mistress as a servant until a few days ago, surely you remember me?

Go away, the voice said. You are not needed.

Please, may I speak at least with the Mistress?

Go away, if you are smart.

Please, just one word.

The voice responded, Each morning, I have drunk a draught of wine mixed with the essence of marigold. I have fasted and taken nothing else for meals. It is the best protection, but I will perish in this plague.

Please, show me this one kindness, I have nowhere else to go, Giovanna da Malborghetto said.

You must leave now before the authorities come and find you here.

Giovanna da Malborghetto saw lips come close to the small paneless window in the middle of the door. She could see no other feature, only the lips, which said, in a harsh whisper, Go now, Giovanna. I found tumors in my groin and neck. I have fever and am vomiting. This house is about to be marked for quarantine and no one inside will live out the week.

In the spring, a year after the plague had appeared, it disappeared. She had spent nearly all of the money.

People emerged from their houses, and commerce began to thrive again as if the plague had never happened. After the plague, servants, even aging women, were a valued commodity. She found employment in a good house for ten years, but when the matriarch of the decaying family died, the sons sold the house to pay off gambling debts and Giovanna da Malborghetto was again without a roof.

Every day is now too long, more than a thousand hours. Her feet are never healed, are never completely rested.

At night, in the great house, she had bathed them. She had

caressed them, rinsed them in lavender water. She had rubbed them hard with a dry piece of linen until they tingled.

Oh, she cries out, I was Venus once.

The days of her week have become confused. She can no longer tell them apart.

Who laughs on Friday cries on Sunday, she says aloud.

She aches and her temples throb; fever and chills run up and down her body. She has had nothing to eat or drink all day. The influenza has made her delirious.

Across the lagoon, she can see minute details of the mountains. A gorge. A cliff rising straight out of the earth. Suddenly there is color, a spring green so tender it squeezes tight the muscles of her heart. And white, fluttering and new, quivering like a thousand moths.

Oh, she thinks, I have seen the chestnuts bloom, I did not think I would again.

She has confused the season.

In the morning, a man finds her stiff body curled into a ball, wrapped in a blanket that is russet and forest green. He wears a crimson tunic and breeches. His crimson cap is a tight band around the head, with a sack that hangs down from it. He does not bother to close her lids; he is in too much of a hurry. He empties her pockets of coins, ransacks her possessions. Flings aside a doll, a chipped cup, a bent-up pot, a boar-bristle paintbrush. He finds nothing of value, nothing he can sell; he never finds anything of value on the bodies of vagrants. He hurries lest someone see him and accuse him of stealing from the dead. The body-haulers are watched carefully now, the citizens and common people are quick to report them, they hate them so much, those who are paid good money to carry away the dead. This year, the city has hired men to transport the bodies of those who have died of influenza; in years past it was the plague. He is nearly done looking, but before he begins to wrap

the body in a hempen blanket, he pats her clothing one more time, slides his hand across the coarse wool of the dress that clings to her body. Nothing. Then he tries the hem of her blanket, and he finds something there, a small object sewn between the layers of flannel and wool. He rips the blanket apart, flays it, separates the wool from the flannel. He finds an ointment jar. He expects to find nothing of value, some worthless medical concoction, but when the lid is off and he peers down into it, he cannot believe his eyes, he does not trust his eyes. He sticks his head out from under the bridge; he needs the light to see if what he thinks is true. He tilts the jar outward, holding it in the sunlight, and, yes, yes, it is confirmed, he kisses the jar, there is a powder inside that is worth more than gold, a pigment of blue; blue, blue, glorious blue, the most precious pigment of all.

He whistles upwind toward the oarsman, hoists her body over his shoulder.

*I*t is a tavern like any other. Small, with walls made of stone, a low, low ceiling that curves up toward the center into a vault. It is an intimate enclosed space, snug, secure. Subterranean, though well above ground. Good walls, stones well laid, but it could do with a few layers of gesso, Martín de Martinelli thinks as he looks upward. It needs to be plastered and painted, maybe he should make an offer: Your own private Cappella Sistina right here, up in the center vault. No, no, he says to himself, leave it alone, you are just passing through.

Fine. Just let me sit with these two bottles of good red wine. I've got a few coins in the leather pouch hanging from my neck, my lucky coin still inside my alms purse. Sooner or later someone is bound to sit down and we will have a little conversation. We'll discourse. *Scoremo.* This tavern is unbelievably quiet, it's like a tomb for God's sake, there is not another customer in it, not another soul, only the owner who stands wiping down the counter with a rag.

Martín de Martinelli sits at a table in the back left corner, a slight man with a massive yellowing beard. From here, he can see who comes and goes. Under the table, between his ankles, he presses tight the knapsack that contains his tools. He pats the pouch with his lucky coin.

It's not a bad place to be, this vault, this *volta.* Comfortable

enough. Nice and dark during the day. Three tables made of oak. Casks in the wall, barrels standing upright on the floor. The stone pavement worn smooth. Nice hushed light. On the walls, a few brass sconces with candles; from the ceiling, a lantern burning with oil. A door in the front and a door in the back, both so low you have to bow your head to enter, even him, and he is not a tall fellow. Short but still in good shape. Trim. A hardened stomach, like a young man, *un giovanotto. Un' zovenon*, as they said in Venezia. Energetic, and nothing bothering him except his thirst.

Martín de Martinelli pours another cup, it's good to taste it again, effervescent and deep red, after so many years in the Veneto drinking that white stuff, which was not bad either, you develop a taste, but Christ it's good to be sitting here in the duchy of Modena, under the protection of the Este, passing through this provincial little town Castagnolo, not too far from the foothills of the Apennines, drinking this ruby-red wine.

He raises his cup.

Cin-cin. A toast to the wine cask.

Outside a church bell rings nine times, a deep iron clang, that makes his chest feel hollow.

Cin-cin. A toast to church bells.

He tries to catch the eye of the owner, who stands behind his counter, a single plank of pine resting on wooden trestles.

Quiet in here today, Martín de Martinelli says.

The man behind the counter answers without looking up: It's still early. My God, it's only nine o'clock. Everyone is either at work or at Mass.

In Venezia, the taverns were full at any hour of the day.

The owner looks and says, Well, this is not Venezia.

Still, it's strange that no one has wandered in, it looks like a good sort of tavern.

The owner lines up cups on the wooden counter.

It's slow, he says, because it's a holy day.

Which one? asks Martín de Martinelli.

Which one? All Saints'. What else would it be on the first day of November?

It's November already? Martín de Martinelli says. So soon? I lost track of my days. What day of the week is it?

Thursday.

The owner turns his back and starts to wipe a spigot.

Then tomorrow will be the day of the dead, says Martín de Martinelli.

He raises his cup. To the health of the dead.

The bartender spins around, braces himself on the plank, and leans over it.

Enough. Quiet. I do not know who you are, you are not from here, so either keep your mocking to yourself or get the hell out of my tavern. They can close me down in a second, they watch the taverns like hawks. I shouldn't be opened at all, but I can tell them I am in here just cleaning. So shut up, foreigner, or get the hell out. The procession will be passing by this door any minute, as soon as they get out of Mass, and I don't need anyone calling attention here. I've got enough problems without being accused of serving heretics on a feast day. I am just trying to make a living, keep my head down and stay out of trouble.

Oh, said Martín de Martinelli. I had a friend like that once, who kept his head bent down. You know, he developed spasms in his neck and couldn't stop scratching the lesions of his skin. Well I understand, believe me, that they will throw you into prison for nothing. That they can execute you for coughing when you should have been sneezing.

Cin-cin. Martín de Martinelli says aloud. A toast to the tavern, gathering place where intelligent men can come together to exchange opinions freely.

Martín de Martinelli cannot stand silence and he tries another subject.

He calls over to the owner of the tavern.

That vault up there, he says, pointing. Imagine this, I will

prepare your wall well, plaster it, and adorn it; this is my line of work and I have worked for the best. I've done it all before, painted arms and faces with cheeks like little apples. The dome would be celestial blue, a color not to be believed, which I myself would supply. Then, if you would buy me just a tiny bit of gold leaf, I would cut out stars and affix them to the vault. I would put up each star ray by ray. It would draw them like moths to the flame. So what do you think?

What I think, says the man standing behind the plank, What I think is that if I had wanted stars, I would have consulted an astrologer.

Well, says Martín de Martinelli, it is your choice, after all, but you will not see a more competent artisan walk through your door again.

Martín de Martinelli stands up. He is inclined to walk out of this inhospitable place, but there is still one unfinished bottle, the other one unopened. He sits down in a different chair, settles with his back to the bar.

All a man looks for in a tavern is a little society, a little conversation and company. Here, nothing. But he will stay a bit longer. It is nice and dark and dry. But it is not like those taverns in Venezia, no. Oh, he practically lived in those taverns. Every day, he went from tavern to work to tavern again. A bit of sleep and then the day began again. He has always had an appetite for work and found release in a tavern. The most inhabitable tavern was behind the fishmarket at the Rialto. It was always full of workers from the duchy of Modena. From Reggio, Bologna, Parma, Piacenza and from the mountains up above. Oh, he had found his place there, enfolded among that crowd, among his fellow countrymen who spoke the dialect of his youth, he had almost forgotten it existed, but the moment he walked through the door, he found companions, *soci*, and he settled comfortably into the tinnitus and rumble of that language.

Mô guarda chi ghê.

Look who's here.

Ecco, cl'arriva San Martín.

San Martín himself.

This is how he was greeted. This is how they greeted anyone who had the name of a saint: a saint has arrived. San Giovanni. San Pietro. Sant'Andrea. San Tomaso. San Filippo. San Giacomo. San Giacomo-il-giovane. San Bartolomeo. Four more and we'll have a quorum. In the meantime, a round for everyone.

Nobody laughs anymore. Everyone is so serious, the women, the men.

Oh, San Martín, someone would say as he handed him a cup. And what miracles have you performed lately?

Cut any cloaks in two?

Helped any wandering strangers?

A miracle? No, not this week.

Oh, you are slipping, you are slipping, you are getting old.

No, no miracle, Martín de Martinelli would say. But I did perform an unusual act of mercy.

She was ugly?

Yes. Yes.

Bravo, bravo. Your act of mercy is worth a month of rosaries.

And they continued in conversation like this, an easy unthinking male banter, never knowing each other's full names, not knowing where the others lived or worked. There were tradesmen coming and going. In a city the size of Venezia they came from all over, they were such migratory creatures.

It was a tavern not unlike this one, except that it was welcoming. There was a long wooden bench along the back wall. The benches were carved with intricate designs, angels and flowers, because, after all, those who drank there were artists in their own right. The air was thick with the smell of sweat from bodies that had worked all day; there was the scent of plaster, sawdust, pitch.

The men at the back table were engaged in serious talk and

he drifted easily toward them. They were carders and silk weavers, tailors and jewelers, and they sat in the back and they discoursed. They called the bar *the altar*. They called a cask *a tabernacle*. The cups were chalices. Every mundane thing was given the name of something holy. The bartender was the priest. Harmless games, really; men in taverns always make jokes, always mock those with power. But this was different, he could sense it at once. The joking did not end there, with irreverent jabs, no, it was the way to initiate a philosophical dispute. Oh the debates that went on in that tavern. No one agreed about anything.

The men who sat at the back table wanted to turn everything upside down. They worked on feast days and ate meat on fast days. They wanted all of the spiritual trappings stripped away, the benefices and the novenas, the cult of the saints and its parasitic commerce. Above all else, they wanted the days redefined; they did not want them reduced to the mindless repetitions of ritual and the awed touching of relics. They rejected having the days and the calendar broken into fragments, filled to the point of bursting with all the prayers that must be said at any given time. They abhorred the day broken into its seven canonical hours, at each hour its requisite prayer. They deplored how each day was devoted to a saint, no day existing without one, each saint with his history. No day opened unencumbered, no day opened free. Oh, you could lose each day to its devotions.

In that tavern, someone was always banging a fist on a table, waving a fist in the air. They argued over the Virgin birth, they came to fistfights over transubstantiation. *Are we not men capable of praying directly to God without a whole chain of messengers between us, the angels and communion of saints acting as gatekeepers?* Someone defended the place of confession, saying that it was no good if you said it only in your head, that it was no good if you did not speak your sins aloud to someone else, but that person could be anyone, it could be the person sitting right

across the table, as long as you spoke the words aloud. No, on the contrary, said another, your sins are between you and God. Period. Some wanted to keep the sacraments but do away with the feast days; some wanted to keep the feast days but do away with the pope. Others said good works mattered not one iota, that only grace mattered. There were those who said, God is three persons, and those who said, No, he is not.

Where are those days? They are nowhere near here; it all ended in the spring of 1565, and here he is sitting, in a lifeless cavern in Castagnolo with a half-full bottle and one still unopened, waiting for a single conversant traveller to enter. Is this too much to ask?

He turns and says over his shoulder to the owner, *Vieni qui.* Come here.

The owner of the tavern gives no indication that he has heard.

Stay there then.

Martín de Martinelli clasps his hand around the neck of the bottle. *Amico fedelis nulla est compartio.* Nothing is comparable to a faithful friend.

Oh, he arrived in Venezia so emboldened. In 1561, he stepped off that barge.

Give me five talents. I'll give you back fifty. No, five hundred.

Water into wine? Now that is a little too much.

He had his credentials from a workshop in Fiorenza. A letter of recommendation. He had been a master worker for a master. He was trusted with a wall, could read its properties better than any of the others. He could predict where a stress fracture would appear.

After Pontormo died, Martín de Martinelli saw that the workshop was proceeding all wrong, and he left in a rage after punching the foreman Orson' in the face, knocking out two of

his teeth. He went from workshop to workshop. Orson' was after him. Teeth cannot be replaced; he wanted compensation. Martín de Martinelli tried another shop, and then another, but he was too quick to start a fight, quick to borrow money and slow to pay it back.

Fine, he'll leave the city, he'd had it with the Florentines, stingy and doing it all wrong, stuck in their old ways. He wanted to be in another city, where they knew about color, he wanted to see the *coloristi* of Venezia; he had never been to that city before. He had his reputation, he had a letter to prove it. Oh, what he had paid for that letter. Was he not carrying in his mind and hands centuries worth of information? Any workshop would be grateful to have him. He left Fiorenza owing a little bit of money, hardly anything, to a fellow tradesman. They had written the amount on a piece of paper, and he would make good on it once he was settled.

The first thing he did in Venezia was to take himself to the church of San Marco, the pilgrim's destination. How could he start elsewhere? Outside, vendors sat on chairs and stood in the piazza hawking their wares, little carved saints, certifiable relics, votive candles, rosaries with beads made of Murano glass.

At midday he stepped into the church. He entered the atrium, turning to his left. He dropped his head backward. Under a cupola, a shaft of light suddenly illuminated the space, and the gold in the dome above stupefied him. The seven days of creation. The mosaics dazzled, gold and shades of blue. The birds above were these: a duck with a turquoise band around its neck, a horned owl of tawny broom, a waterbird with a beak that curved at the end, his long throat aqua, his body royal blue. Above them all, there was a thin, curved crescent in descending bands of blue: cobalt, azure, ultramarine. Below, a swan of oyster white, and next to it, standing on a single leg, a pure white crane, a *gru*, flapping its wings.

Ingenious, ingenious mosaicists.

In another vault, two cranelike birds stood on either side of a fountain. Their reed-thin beaks reached toward ribbons of water that spilled over the fountain's lip. Against the background of gold, their bodies were periwinkle and lavender.

Periwinkle, the color of early friendship.

Lavender, the color of distrust.

Martín de Martinelli thought of Bartolomeo de Bartolai, long-legged *gru*, whom he had not bothered to remember for many years. He thought of him hunched over in his shed at night, struggling to make his pathetic mosaics with his pitiful collection of shards, trying to arrange so many unconnected pieces with his clumsy peasant's hands, trying to make, of all things, a mosaic, when mosaics had been retrograde for centuries already. Except, ah yes, in Venezia, threshold to the Orient, where they still value anything that smacks of Byzantium. But the rest of the artistic world? Stiff figures of saints made from tiny specks of stone? No, it was gone, gone, gone, and the mosaics were being slowly plastered over.

Bartolomeo de Bartolai. He had intended to send back the money he owed him once he became established in Fiorenza, it is what he had planned to do all along, but one thing led to another, and he would have the sum only to lose it again before he could find a trustworthy messenger.

He remembered how, one night, they had walked home from the tavern in Ardonlà. How they had walked up the steep path away from the river. It was a three-mile walk, and Bartolomeo de Bartolai keep tripping. It was the only time he had ever seen him drunk.

If you stay here in these mountains, Martín de Martinelli had said, you will die hunched over and eccentric with bones deformed by diseases that come from not having enough to eat. You will go out of your mind with hunger. Bartolomeo, come with me, go to the city to make your mark.

There was a full white moon, and Venus burned white and distant beneath it.

Yes, yes, maybe I'll go, yes.

Come with me to the city. You'll live in a villa, wear a cloak made of cloth from Damascus.

Yes, yes, maybe I'll go, yes.

They sat down, they were so inebriated, and they took a little rest.

When Martín de Martinelli woke up on the slope, a rock digging into his back, he saw that the moon had darkened. In the lower left part of the circle, there was a spot, a shadow.

At first he thought the alcohol was blurring his vision. He rubbed his eyes, and when they were clear, he saw that more of the moon had disappeared.

Wake up, wake up. Look up and see what is happening.

He shook Bartolomeo de Bartolai out of his drunken sleep.

The moon continued to disappear, the stain moved up and across the moon, until the moon was half gone.

Bartolomeo de Bartolai woke and surveyed the sky without agitation.

It is God's will, there is nothing to be done.

No, no, watch, more and more is gone.

The moon turned a dim red color, a wolf's eye at night.

The moon's disappearance is an evil sign, said Martín de Martinelli. He was not a man of superstitions, but he yielded to the stars.

Do not become unsettled, said Bartolomeo de Bartolai.

The moon was gone, a darkened imprint on the sky. The stars shown even brighter; Venus taunted the darkness.

Are you not afraid? asked Martín de Martinelli.

Afraid? Afraid of what? I am a tiny speck; the arc over which my life will travel has been set. If the moon shines, or if it does not, it will not change my fate. No, I am not afraid. The sky is a giant altar made from a speck of light. In the beginning, there

was light, and light can change shape, explode, disintegrate, be pulverized, and travel anywhere it wants. It can exist in a thousand places simultaneously. God is anywhere you see Him, anywhere you say that he is; he is not just in the churches, though he is there as well. We can say, *God is Light*, that is why we fear the night and welcome the day, because during the day he is everpresent. The sky is his altar, his *ara*, and the Father and Son and Holy Ghost are all specks of light.

They sat and looked at the darkness left by the eclipsed moon. Bartolomeo de Bartolai, unperturbed, named constellations. Cigno, the swan. Aquila, the eagle.

Martín de Martinelli, cocky, brazen, bold, was terrified of the darkened sky and the words of his friend.

You cannot say that God is a speck of light. They will hang you for saying such things. You cannot say that God is an inanimate object. You may liken him to one, you may say that he is like light, yes, but he is not light, no, you must keep such thoughts quiet or leave and go away to people with whom you can freely speak such beliefs.

Oh, said Bartolomeo de Bartolai, see how our positions have shifted under this darkened sky? The shadowed moon terrifies you. This is an odd moment that finds you cowering and me speaking. On the altar of the world, the moon's disappearance is like an acorn falling. Take heart, Martín de Martinelli, the lunar disruption will be of short duration, you see already how the light creeps back over the top of the moon, a tiny little crescent. You need not worry about the moon, or about me uttering heretical thoughts. I keep my mouth well closed.

A hand now grips the shoulder of Martín de Martinelli. It presses, it crushes.

His heart, startled, constricts, a tiny fist flinging itself against its chamber wall.

The fingers dig deep around the bone.

A tall lanky man leans into him, stares down.

Martín de Martinelli pats the leather pouch inside his shirt, pulls his cloak around himself.

He tries to bat away the hand away, looks up.

This gangling man wears a dirty sheepskin coat that falls below his knees.

Martín de Martinelli puts both feet on top of the knapsack on the floor.

Allora? says the stranger. And so?

Get your hands off me.

Allora? the stranger says again, in a way that expects reply. What do you have to say for yourself?

What? says Martín de Martinelli. Get your hands the hell off me.

He sees a long-faced man with a jutting chin, vertical creases stretching down the cheeks. No beard. There is something in those ice-blue eyes, something familiar in the leather-tooled creases around them. Something in the angle of the high, wind-burned cheeks.

What do you want?

The stranger is on the verge of grinning, he takes pleasure in seeing this man squirm.

The stranger does not remove his hand from the shoulder of Martín de Martinelli.

He grins wide, three teeth are missing, two on the bottom, one on the top. He juts his chin forward.

Mi gnosc mia? You don't know me?

Martín de Martinelli, wary of strangers who claim to know him, says, It depends on who you are.

The stranger bursts into a graveled laugh.

His fingertips digging into the shoulder, the stranger says, I would never have recognized you, Martín de Martinelli.

He taps Martín de Martinelli's shoulder with the back of his hand, a flick, a tap, a familiar little shove.

After all these years, I would have never recognized you, but you look exactly like your father.

Who? Who in hell?

Martín de Martinelli stands up, bent at the waist, and peers into the stranger's face.

Who? Who in this place?

Don't you remember me? We last saw each other in a tavern. Oh, Martín, my memory is better than yours and I am so much older.

Still no recognition.

Fiorenza, Fiorenza. You listened to that siren song.

Martín de Martinelli squints in uncertainty.

How about a hand of *tresette*?

Still nothing.

Lucky boy born under a star.

The stranger laughs again. Water rolling, knocking against rock, gravel shifting against itself and echoing. The laughter shakes his body.

Oh for the love of God, says Martín de Martinelli, looking at the man.

His body is completely altered; he is slight where he had been massive.

It is the laugh.

Look who is here, Martín de Martinelli says, *Mô guarda chi ghè*.

Sit down.

The man pulls out a chair and sits down across from him. He blows into his hands for warmth.

I would have never recognized you, the man says, except, like I said, you look just like the miller used to look; I see you now have his great white beard.

Martín de Martinelli turns toward the bar, shouts for the owner to bring another cup. He turns back toward his companion, crossing his arms in satisfaction.

I may look exactly like the miller, he says.

He stretches out his short legs.

But *I* have no wooden leg.

Martín de Martinelli grips the bottle by its neck.
A hollow leg, yes.

The last time we saw each other, says Martín de Martinelli,
was in a tavern. And here you find me again, looking for some-
one to talk to. I could never stand the quiet. And who should I
find but you.
Dio cane.
Lè stran' el mond', lè stran'.
The world is strange.

Well, of course, where else would you have run into me but
in a tavern? I was beginning to despair of this particular estab-
lishment, I was going to finish this bottle, then, enough, off I
go. No one to talk to, no one to listen. Not a friend in the world.
Drink, drink, I'm buying, and who knows if I will offer
again.
The silence was killing me, and, *Dio bono*, if I don't find
someone from Ardonlà who walks right up to my table.
How many years ago now? Thirty-five? Forty? And who
would think to see you down here on the plains? A long-lost
friend from my youth, aren't you, Zacagnèr? Let's drink to
long-lost friends. *Cin-cin.*
He presses the bottle into the hands of the muleteer.
And you, Zacagnèr? You've seen something of the world? A
muleteer would, going everywhere transporting loads. Going
here, going there. Like me. Oh, I have lived a life. Let me tell
you what a lucky son-of-a-whore I am. Born under a star, oh, so
you remembered. Well, let's drink to my lucky star. Venus, it
was Venus who burned so bright. Is your cup full? Good, good.
Are you warm enough? Good.

You know, Zacagnèr, when I was a boy, I saw a fresco painter
who came up to Ardonlà. He painted a fresco inside the church
in a week. Then he left. And I thought, now there is a life.

When I finally left, I was fifteen years old, I hid myself among a group of pilgrims passing through. And I had the good fortune to attach myself to a handsome widow, who said it was her idea to repent all at once when she got to Jerusalem, but first she had to make the pilgrimage. So you see, it's true, Zacagnèr, luck was with me from the beginning.

When we parted in Fiorenza she said to me, I cannot quite catch your essence.

Is that not poetry?

And she gave me two small books. One by the thinker Erasmus, the other, sonnets of Petrarca. She told me to read aloud to her. A young man, to an elegant beautiful rich lady. How could I not? *But her best form, which still continues living and will forever live high in the heavens, makes me fall more in love with all her beauty.*

And Fiorenza, Fiorenza, for many years, did not disappoint me either.

I worked in the workshop of Pontormo. He depended on me. I know there are some who would thrash me for saying it. *Improbable! Impossible! The guilds are a tightly closed society, how would the likes of him have gotten in?* Well, believe what you want, but I'm telling you, even stone walls are not impenetrable, and I knew how to find my way through. Pontormo turned to me. *O, montanaro, preparalo bene, veh!* Prepare the wall well. I could spot a flaw in the wall from sixty meters away in a cavern without any light. He turned to me to examine the plaster for the final step before the paint was applied. And still they will not believe me. Because I am not in the reports, it means I did not exist? *Merda.* I knew all of them. Piero, Batista, Danielo.

Pontormo had a book he wrote in every day, and I once climbed the ladder to the loft where he slept. I'm bold as well as lucky, eh Zacagnèr? He wrote about his aches: Monday great pain in my body. Tuesday great pain in my body. Wednesday the same. He wrote down what he painted: On the sixth of

March, I did the whole torso. On the seventh, I did the legs. He recorded all his meals: *Adì 27*. Bread and cooked apples. *Adì 28*. Woodpigeons with Bronzino. *Adì 29*. Two eggs. He wrote down everything he ate, which was hardly anything at all, and he expected everyone around him to eat as little as he did. Oh Zacagnèr, he even recorded the weather: In the year of 1555, during the moon that began in March and lasted until the twenty-first day of April, during the entirety of that moon, there was born a pestilent infirmity that killed many good and honest men.

By the end of my time in that *bottega*, I had become a master tradesman. *I* was the one who prepared the walls for Pontormo's frescoes for the chapel at the church of San Lorenzo.

I was there when Pontormo painted the frescoes in San Lorenzo.

By that time the denunciations had already begun.

But Pontormo was the master; he will endure, and I had the honor of preparing his walls.

They harassed him mercilessly, saying he was secretly a spiritualist who rejected rituals and the prescribed prayers.

A new bottle is open. Drink, Zacagnèr, drink.

They spread gossip about him, said that during the night he picked up dead bodies, bloated and deformed, so that he could have realistic models. Why in a time of so much easy death, would he have needed to do that? Every epidemic, every single famine, left victims lying in the streets, arms and torsos exposed, legs twisted. The imbroglio began before the frescoes were finished.

We do not want to see it, they said. *Cover it up for the love of God.*

It is repulsive. All those dead bodies piled on top of one another, sprawling and draped over one another. You call this art? You call this beauty? What kind of disgrace is this?

Cain pummels Abel. Thwack. Eve cowers, her torso writhes,

her belly folding over itself. Isaac's neck is stretched, smooth and exposed. And if this were all, his critics said, if this were it, fine; but what we must object to most is his depiction of the Flood, bodies no longer human, arms draped over torso, heads disappearing under bodies, in piles, in heaps; after the Flood recedes, this is what is revealed, but it is too horrible to look at, and it is too much to expect us to stand in the viewing space in front of the wall and face this, no, it turns the stomach. It makes one gag, his critics said, all those bodies twisted into unrecognizable shapes. To which body does that limb belong? Where is the body of that head? No, it is too awful; cover it over, cover the damn thing up, plaster it over.

And what they could not see, Zacagnèr, I will tell you, here, let me top off your drink, what I will tell you is that the conformists will win and one day it will be covered with a layer of plaster. And another thing, drink, I know you're thirsty, another thing, is what they could not see. They could not see that the arm draped over the body of another was molded into the space beside it, as if it were shielding the other being next to it and giving comfort. They did not look at the expressions of the faces. Peaceful sleepers. They did not see that a sleeper's head was cradled in the crook of his own arm and that his arm was balanced on the knee of another who was once a mortal companion.

In Fiorenza, it had become so easy to give offense. You were unable to open your mouth to make even the smallest criticism without someone reporting you to the authorities. Not a thought in your head of heresy, only a little joke at the expense of some puffed-up little monsignor. I did not want to live like that anymore.

Venezia, I thought, now Venezia would be different, it had such a reputation for tolerance. Everyone knew about repression in The Holy City, but in Venezia, the great Republic, there was freedom. Jews and German Lutherans were free to believe

their teachings. Venezia would never bow before a papal nuncio. Besides, I was ready to go.

And I'll just sum it up here, Zacagnèr. Sixty-one, sixty-two, sixty-three, and even into sixty-four, now those were brilliant years for me. I was unbelievably prosperous. Oh what a lucky man I was; the jewel of the Adriatic was good to me. You cannot go around with bowed head, humble and faithful servant, no, not in Venezia. When you climb an arched bridge, you must look directly ahead as if you know where you are going.

And then I found a tavern just behind the fishmarket.

We were free men in that tavern, debating the debates. I even recited a bit myself.

Ahem! I cleared my throat: Now, the theologians we all know are a touchy lot. But if I don't bring them into conversation, they'll denounce you as a heretic on the spot, for this is the bolt they always loose on anyone to whom they take a dislike.

Erasmus, whose books were all forbidden. And they asked me to say a little more:

The priests say it is a greater crime to cobble a poor man's shoe on a feast day than to butcher a thousand men.

Well, Zacagnèr, it all went on in relative freedom until the spring of sixty-five; then, that year, Venezia capitulated, and the pope's church began its purging during the season of Lent, the season of repentance.

But Venezia, now Venezia was *furba*, very clever and sly. Because although she complied with the Pope's demands and continued her executions, she did them all in private, never in a *campo*, no, she ferried the condemned man out to the edge of the lagoon and wound a rope around his waist and neck and ankles, and attached a stone, then dropped him into the sea. So, Venezia has been able to maintain its reputation as being a tolerant place because it has not been flamboyant with its punitions. The Germans and Jews and reformers got more quiet;

they practiced their faiths in hidden ways. The rest of us scurried like mice. We still met at our tavern, but we took turns sitting on a bench outside, acting as a lookout. We began to sew small volumes into our hems, to conceal rolled sheaves of paper in our sleeves. I sold my volume of Erasmus to a bookseller near the Rialto. But, still, I kept it all in my brain. Up here.

One night in sixty-nine, there was a bigger group than usual gathered in the tavern, playing cards and rolling dice. Oh the wine was flowing. It was a Saturday night. It was a strange thing, though, because on this particular night no one, for once, was talking about doctrine. No one was expounding, no one was riffling through the pages of the Bible in search of a particular passage. It was as if everything serious had been set aside for one night. And that was the night the officers of the tribunal came bursting in and hauled everyone away. Weavers and tailors. Carpenters and silk dyers. Rope makers. They hauled out Paolo Gaino, a carder from Modena who could never keep his mouth shut. They had bribed the man who was keeping watch, handed him a pitiful little sack of coins, so no warning was given.

But you see, Zacagnèr, how lucky I was. When the officers barged in, I was out back taking a piss. As soon as I stepped into the back door, I saw what was happening; there must have been two dozen officers, and me, lucky me, I turned around, told the others standing at the trough to finish up and run, and I ran out back through an alley. I ran down the calle Donzella, and into another, and into another, wandering around in them, and I ran into the front of the first church I came to, which was San Giovanni Lemosinario.

I sat there in the confessional all night waiting until I could slip out. And when the first light of the morning came and I began to hear others coming in to say their prayers, I stepped out and I walked up to the front altar. Do you have a knife on you, Zacagnèr? Here, I'll carve a little mark on the top of the table to show you.

The church was on a Greek cross plan, like this,

 do you know what I mean?

I should have gotten out of there as fast as I could, but I stood there, instead, gazing at the high altar, up above on the wall, at a picture of San Giovanni distributing alms. The sunlight was coming through the windows on the south in a way that was exactly hitting the bald spot of his head, it gleamed; his skull was like a sphere of bone. He was pictured as a bishop. His eyes were deep, dark sockets. His eyelids were smooth tissue, like gauze. He had a great, white, yellowing beard. He sat there, his thigh bulging under his surplice, oh, he was well fed, his russet cope cut his torso in two, his fur-trimmed robe spilled over the edge of the stair. And I remember this, Zacagnèr, there was a fleck of white on his toenail.

I should have fled immediately, but I was immobilized. I wanted to see how Titian had worked the painting. The saint looked like what Titian had himself become. Oh, the power to predict, because he was still a young man when he painted it. I made the sign of the cross, so as to better hide among the believers. The sacrastan was preparing the altar for Mass, but still, Zacagnèr, I could not tear myself away.

The focus of the painting was where? Oh Zacagnèr, give me back that knife again. It was to the lower left of the center, off toward the side of the painting. The saint's hand pointed down to the upturned palm of the beggar. The saint's hand was clean; the beggar's was dark with dirt. The space between their hands was a thin band, and against that darkened slender space, was a coin, still in the bishop's hand, with a flick of white on its edge.

The saint was San Giovanni Lemosinario. The word *ele-*

mosinare, to beg for alms, comes from *to have pity* in Greek. You sit in taverns listening and you're bound to pick up a thing or two. Do you know how many ways there are to say *beggar*, Zacagnèr? *Pitocco, mendicante, accattone, furfante, falso bordone, vagabondo*, but best of all is *perdigiorno*. Someone who loses the day.

Well, Zacagnèr, I left the church and the beggars were already setting up on the steps outside. They were filthy and hostile; they had no meek humility. A child scratched my leg, but I reached in my pocket and I flipped her a coin anyway.

So I escaped.

The free-thinking men and women began to flee north or else they chose to be silent. They went into hiding or else they were hauled in. Paolo Gaino was released, but he was arrested again in Modena. Once you open your mouth, it's hard to keep it shut, eh Zacagnèr? You know, you're a true *montanaro*, and you've learned to remain silent. So much the better for me. Even better than a drinking partner who does not talk much is one who has no memory. Erasmus said this too.

Well, to make a long story short, I spent the next few years fairly well, steering clear of trouble. Work, though not as abundant, was steady, and I was able to make my living.

The arrests continued; there were bread shortages. There was the fire at the Arsenale in sixty-nine, the year the city's luck changed. The old decade ended poorly, but the new started even worse.

In seventy, the war over Cyprus.

After the victory at Lepanto in seventy-one, the Venetians all spilled out into the *campi* and celebrated, they were delirious; they thought that Venezia had regained her might.

In seventy-three, Venezia made her peace with the Sultan, but at what a price. Humiliation. She had lost Cyprus forever. That same year, on the feast day of San Bartolomeo, in France, on August the twenty-fourth, thousands of followers of Luther

and Calvin were butchered like hogs and flayed. See how the reverent honor the holy days?

My luck started to run out in seventy-four. The stars had shifted. I had a job preparing walls at San Nicolò. They had commissioned frescoes for the ceiling. Veronese. Tintoretto. The king of France was coming, and Venezia wanted to be resplendent. I showed up for work one day, a Wednesday, the scaffolding had been already erected, and the foreman informed me that work had been halted.

I thought it was a normal lull. When I first came to Venezia, there were enough frescoes being commissioned to keep someone like me well-fed, but it shifted, it changed. Until that moment, my luck had held; until then, there was just enough work. Time was a great bolt of cloth, slowly unwinding. Then, suddenly, the future before me was no longer vast. It looked somehow foreshortened, and there, waving in front of my face, was my own distorted hand.

That autumn, I was walking along the calle dell'Arco, no work in sight. For the first time, I asked myself, Would it have been so bad after all to have become a miller like my father? It was a foggy day, and there were great clouds in the sky above the lagoon. I turned a corner. And for a moment, behind the buildings I saw mountains. Mountains! I was walking in the direction of the sea. I was seeing things. Oh, this was not like me. I am not a brooding man, but a man of action, so I took myself to a tavern as fast as I could.

Mô guarda chi ghè! That's what I wanted to hear.

I went back to that tavern near the Rialto, the very one where everyone had been arrested. I started to frequent it again. When I went there, I spoke my mind, but I was careful not to use my name.

The Tre Savi of the Inquisition continued their holy work. Sanctified inquiries and blessed interrogations. I kept going back to that tavern night after night; it felt like old times. But

one Saturday night, there was another round of arrests, and this time I wasn't pissing out back.

They started in right away with Pontormo. That I had worked for a heretic in Fiorenza: Don't deny it. We have others who have testified.

There was a little pimply fellow sitting off to the side, writing everything down.

They started right in with the fresco of the Flood at San Lorenzo.

Is it not true that Pontormo was a Spiritualist?

They questioned me and I gave it right back.

I told them Pontormo's fresco was precisely within the teachings of Christ.

You are not answering the question.

I ignored their questions and made the answers I pleased.

Pontormo's frescoes show suffering and comfort, I said.

Answer the question: Did you or did you not work in the workshop of a known Spiritualist?

I quoted the Bible to them. Oh, they did not like this.

When they asked a question, I quoted from the Scriptures. I quoted long, and I spoke quickly so that the little runt writing would get a cramp in his wrist. I spoke in a torrent:

He will separate the sheep from the goats, and he will place the sheep at his right hand, but the goats at the left. And then the King will say to those at his right hand, *Come, O Blessed of my Father, inherit the kingdom prepared for you from the foundation of the world, for I was hungry and you gave me food, I was thirsty and you gave me drink, I was a stranger and you welcomed me, I was naked and you clothed me, I was sick and you visited me, I was in prison and you came to me.* And to those who did not see the suffering around them or who denied them the mercy due the hungry, the thirsty, the foreign and unclothed, the sick and those condemned to prison, those like you who ban them, send them away, punish

them, ignore them, make them invisible, the Lord and master will send into eternal punishment.

They said my logic was incomprehensible.

I graciously summed it up for them: Venezia is full of goats.

Someone warned me to be quiet:
Just say you were confused.
Just say that someone forced you.
Just say you were insane with drink.
But that only provoked me more.

By this time, I was speaking directly to that pimply runt who was writing down all the words. Does it surprise you that I can read? My father was a miller, poor devil; he beat me, but he also taught me how to read. We tradesmen are notorious readers, and there is nothing Pontormo painted that was contrary to the word of God, according to my interpretation.

Oh Zacagnèr, I taunted them; I was in fine form. When I said, *my* interpretation, they turned purple above their collars. I said that the northerners had shown me how to interpret according to my own beliefs, and that this is what I thought: Forget about the saints, forget about the relics. I believe that the only way to salvation is to confound. To invert the world a little. And so instead of saying my prayers in a confessional, I say them in the tavern. In fact, when I tell my confession, I tell it like a good joke.

Oh, they did not like it, they did not like it at all.

God is hungry for a little irony, I said.

The Inquisitor's secretary was there off to the side writing, writing, writing.

And who invented irony? I asked. I hit the table in front of me with my fist.

God Himself.

By this time the scribbler was sweating, he was wiping his face with his sleeve.

I turned back to face my questioners. I said, God wants to eradicate all the arrogance and pomp. Extricate it, like a rotten tooth. All the prelates with their nosebleeds, the bishops with their gout.

Well, Zacagnèr, it was a big mixed up testimony I gave. Oh, they didn't know what was up or what was down. I made seven puns. I told them a riddle: *Coss' è-la cla cosa, ch'la n'ha negn-al' ne' gamb'? La sàlta foss, e mont e pian?* What is that thing that has no legs but jumps between rivers, mountains, and plains? You know the answer, Zacagnèr? The fog. I quoted Erasmus: Why is it that priests are happiest while they are depicting every last detail of hell, as if they'd spent time there? I quoted from Petrarca: My days, swifter than any stag, have fled like shadows. I recited a Psalm: All day long my enemies insult me, they hurl curses against my name. The Lord will look down on high from his altar to listen to the moans of the prisoner.

Oh they did not like that, no they did not. I sang to them a shepherd's song. In short, Zacagnèr, I handed them a great big *pasticcio*, a mix-up, a mess. I handed them a huge confusing tangle. Oh, it was a thing of beauty.

Well, they threw me into prison for my jumbled-up beliefs. And in prison, I could not see a thing, it was so dark. For three months, every day, in that cave, I would put my hand to a wall. Here. Here. Here. Moving a palm across it, and I would tell myself where the wall was damp. Here you would not dare put a fresco. Which part of the wall was driest? Here maybe you could. I figured what percentage of wall was lime, what percentage was sand. How old was the lime? Did it come from the foothills or the mountains? There was no light and the silence nearly killed me.

I was going to be shipped off to the galleys, made to wear that horrible cloth called *grisi*, it's like hemp; let the flagellants wear their hairshirts, I say, let the wandering mendicants wear this cloth if they find such virtue in suffering. But, you know,

I've said it a thousand times, I'm a lucky fellow, and I was not shipped off to sea because it was my great fortune to have been thrown into prison in the winter of 1576. Two months later when April came, it was the fifteenth to be exact, the jailer came and opened the door. Oh, you lucky son-of-a-whore, he said to me, you are free to go.

This was on Palm Sunday. He said to me, We will give you a choice. Stay in prison. It is fetid, is it not? Horrid food and stinking walls. Or, go to work. You do remember how to work?

I saw a glint of daylight in the hall outside. I told him, of course, I'll take the work.

Fine, he said, You start tomorrow. He said I would be paid three ducats a month. And one hundred just for signing on.

Am I not a lucky beast? I could not believe my ears. A job working for the city. Oh, Martín de Martinelli, I said to myself, I was rubbing my hands together, Oh, Martín, you are a lucky devil.

When I left, they gave me a new set of clothes. Crimson breeches, crimson tunic, and a crimson cap that fit snugly around my skull, a little baggy sack that tumbled downward from the headband. All the clothing a red that called attention to itself.

Well, Zacagnèr, when I walked out of there, my legs were twitching from not having walked for three months. The light was acid on my eyes. I walked out wearing my brand new clothes. Oh, I was a lucky man. A secure job as long as I showed up for work.

A job title. I was one of the *picegamorti*.

You see, Zacagnèr, why I say I was lucky?

We'd better fill the cups again. Zacagnèr, you're slowing down.

My job was to transport dead bodies from their homes, from the hospitals, from the streets, and ferry them to the cemetery, to the *campo santo*. Twice I did this work, the first time in plague, the last time because of influenza. Once the cemetery

was filled, I ferried them to the floating barges outside the city that had become the new cemeteries.

They forced prisoners to work among the dead, who else was going to do it? Just lucky fellows like me and other outsiders. Even the vagabonds refused to do it. But me, I said, Fine, I'll try my luck, and do you know, I did not get so much as a sore throat during the year I worked among those who had died of plague.

Here, Zacagnèr, let's roll the dice a little.

No?

All right, we'll drink instead.

You don't really want to know, Zacagnèr, do you?

The bodies heavy and light.

An old woman who was like the feather of a quail.

A child who was like a chick.

There were few who were heavy, because mostly the well-fed had left the city, and for those who remained, even those with means, the plague was accompanied by hunger.

The only thing that got me through was my sustenance at the end of the day. It was the best I ever ate. At the end of the day, we were well fed. Poultry, cheeses, broths. They meant to keep our strength up. But after the first month, I ate very little. I drank whatever wine was offered, and after that I could sleep at night.

There were few who would do this work, few who would risk their lives even for a guaranteed wage. The poorest wandering beggar said no.

The others died around me. Armando, Tullio, Annonte. They were convicted of much worse than me; they were enormous, strong men. I had a new partner on the barge every month. Caio. Sisto. Ugo. But they perished and I endured. I was immune to the contagion. Such a star I was born under.

Day and night we lifted those bodies.

The wealthy fled to their villas on the mainland, as if they would find no plague there. Maybe they improved their odds a bit, but not by much. The only known cure is a medicine made of these three ingredients: *cito, longe, tarde.* Priceless ingredients: leave quickly, go far, delay return.

The rest of the city waited. Time was suspended.

Doctors shouted up from beneath the windows, making diagnoses from below.

Believers gathered in the churches, not listening to those who urged them to stay apart, to remain isolated during the contagion. They burned incense in their bedrooms to fumigate and purge the air. They drank potions made from flower petals. But, if you ask me, they did not pay adequate attention to the stars.

We were obliged to bring in the sick as well as the dead, and whenever I could, I would allow the exposed to remain in their homes. It was my one small act of mercy.

Oh, the choices I made that had brought me to this point. I was the lowest type of man.

My hands were numb, my eyes were clouded. At night the small of my back ached, and this, to tell you the truth, was the only way I knew I was still human.

I was thirsty all the time. Even the wine did not quench my thirst. Hunger? Nothing.

In August, Venezia was a city of the dead. Every window was shuttered tight. The *campi* were deserted. Cats and rodents were princes moving about unmolested. The humans who moved about were somnambulant, and walked with slow dark steps, ready to flee at any sound.

Cross-markers painted the doors of the sick and the dead. Mostly they made the same design over and over, a cross of two

simple lines, like two charred faggots crossed over one another. Give me your pocket knife, I'll carve it into the table: ✝

That August, I noticed that there was one cross-marker who did not scurry away as fast as he could, slash, slash, but instead painted a distinctive cross on each door. Perhaps instead of drinking wine, he did this to give his mind relief. I rode on the barge and as the oarsman moved us along, I sought out those doors for his distinctive crosses:

I looked up above, over the edge of the canals and those crosses became a companion as I floated through the city,

a kind of respite to my eyes,

because it meant that someone was still living

who cared enough to leave a sign. But in a few months, the crosses vanished.

At a building near the church of the Mendicanti, we stopped at one marked door. I shouted up. No one opened a shutter. I rattled the door and called out again: Do not make me call the authorities; they will burn everything that you own, your clothes and your chairs and your sheets; open the door, at least you will be able to save your home. I banged on that cross. I got a splinter on the side of my fist. Still nothing.

If the authorities come, they will burn everything you own, I said again.

A woman answered the door. She was a head taller than me. She had light brown hair, covered in a soiled cap. She had dark brown eyes that were sunken into their sockets. Her eyes were like bores, they were so sharp, even from their depths, like stones that burned. Her nose was large, sharp, strong, like a falcon's but her mouth was elastic and crumbled into itself, slack, and weak with trembling. She could not have yet reached twenty-five. The top of her apron was stained with food and liquid and vomit, and in her arms she held a child, a girl stretched out nearly as long as she was, the legs bent at the knees, falling over the mother's arm, and on the other arm, in the crook, the child's head. The girl had reddish hair, skin like marble, so smooth, and in eyelids, I could see the faintest veins of blue. She wore a clean dress, pressed, and in her hair, around her head, a ribbon was tied, a deep forest green, a velvet. The mother clutched the child to her, the child was nearly as long as the mother. She pulled the child away from me and stepped back from the threshold.

No, no, she was my treasure.

No, no, you cannot take her. Let her stay another day with me.

The oarsman whistled below from the barge.

No, no, you cannot take her from me.

The child's head fell downward from the crook of her mother's arm, the neck stretched, the thin muscles strained; her skin was mother of pearl.

The oarsman whistled again.

Please, I must, please. And I extended a hand toward her as she stood there in the threshold.

Please.

She looked down at the child's head, propped it up again in the crook of her arm. She kissed the top of her hair. Each cheek. Her chin. She kissed the tip of her nose, the space be-

tween the eyes, you know, the depression above the nose. She kissed each ear, and she kissed her child's closed mouth.

The mother's arms unrolled and she extended her hands over the threshold, the child's body balanced on her wrists. When I took the body from her, the mother's hands dropped like stones and her entire body sank into itself, the shoulders caved over her chest, and she grabbed the girl's hand, kissed the inside of each wrist where the pulse had been. She grabbed my right upper arm, bruising me, and she shook me and stared into my face. She made me look at her eyes, and she said: Eleven. She was innocent. Her name was Chiara.

I lifted hundreds, maybe thousands of bodies, and in truth much of the time I was drunk and could not hear or smell, I just lifted and carried, lifted and carried, but this is one I remember, that mother and that girl. It was her eleventh birthday, the mother said. The feast day of Santa Chiara, August 11.

I carried the child's body to the edge of the *rio*, then handed her down to the oarsman, who laid her on top of the other bodies we had gathered that same morning. I expected to see the mother running toward us or collapsing in the doorway, but she did not. Her hands gripped the side of the doorway. She stood upright, straightened, her head almost touching the lintel, and she screamed, she commanded,

Gl'ava un nom' e la so' nom' l'era Chiara.
Chiara, chiara com el dì
Chiara, chiara com el sol'
Non è un dei quist'altri persi
Ricordate. Vi commando.

I order you to remember.

She is not one of the other lost dead.

Chiara, she was clear like the sun.

Chiara, she was light like the day.

She had a name and her name was Chiara.

That day, I understood that Pontormo had been a sooth-

sayer, and that in his frescoes at San Lorenzo, he had predicted the future.

So now, what do I have to show for my days of work? What has resulted from my old emboldened impulses? Nothing but a lifetime of half-finishings? Always ready to spring, when it would have behooved me to stay.

Salute, Zacagnèr.

All that I have touched is fragmentized and dissipated, and is a great confusion. Have I left anything behind after so many years of labor, so many days of work? I am a worker, after all, this is what I have done best. I have not loved well, nor been generous, nor brave. After so many days of work, all that remains are my palm prints left on scattered walls.

Well, I made my choices; they are done.

Do you want to roll the dice a little now?

No?

Well, drink up. Who knows if there will be any left tomorrow.

So here we are. Let me tell you a thing or two about a *taverna*. I think I ought to know. It's as holy to me as any pilgrim's shrine. Don't mind my little tangent, you know I like to talk. What do you expect sitting there across the table with three bottles between us?

Hoist up your cup, Zacagnèr.

Salve, o Regina, madre di misericordia e speranza di nostra vita.

Who cares if someone hears me? I'm leaving for Geneva anyway. I have a travel pass here in my pocket. Right here next to my heart. It's a forgery, of course, but a very convincing one. So, after I leave here, I've just decided now, Geneva it will be.

Another toast, Zacagnèr.

And what work will there be for me in Geneva? They're not decorating the walls of the churches up there. But yes. Switzerland. That is it.

And who the hell should I find in here but Zacagnèr the muleteer. What gifts we get in life. Here, help me with this last bottle.

Now, I was saying, let me tell you about this sacred place. A tavern, what is it? Simple you say, a gathering place. A place where wine is served. Yes. The obvious. But listen up, Zacagnèr. It is not in vain that I sat among free-thinking men. No. I soaked up little bits of information that those book-readers passed on. In the old days, a *taverna* was a wooden shed, a workshop, what the Venetians call a *tezza*. Now the ancient Romans called it *taberna*.

Drink up, because I know you are still thirsty.

Bear with me for a moment Zacagnèr, from *taberna* you get *tabernaculum*. You see where I'm going, don't you? A transportable, portable dwelling place. The ancient Jews wandered in the desert with their tabernacles, where they kept their sacred objects. So the point? The point, my friend, is that a tavern is a holy place, God's dwelling place. The profane is sacred and the sacred is profane. Oh, I have learned so much in my wanderings, how to turn everything upside down.

Oh, Zacagnèr, I'm sorry if I offended you with such talk.

Fine. No more about it.

No more at all.

But I want to ask you for one favor. It's been impossible to find a messenger I can trust.

When you go up into the mountains, you're going to Ardonlà? Is Bartolomeo de Bartolai still living? Well, I owe him a little money, a little debt I never got around to repaying; it's kind of a joke to pay it back, it's really just a way of sending him my good wishes, so could you do this for me? Here, if you would, take this earthenware jar; I've wrapped it up good in sackcloth so it will not shatter. It contains a valueless ointment, it's a joke between us, you see, but do not say you know about it or he will be offended, he was always such a morose and hu-

morless fellow. It's an ointment for his skin, for his scalp; he was always itching and scratching. It's still the same? I thought so. Anyway, don't unwrap it, it smells like shit. But I sealed it good and tight. If you could just give it to him, tell him it's from me. And oh, Zacagnèr, one more thing, when you see Bartolomeo de Bartolai, tell him I died a rich man in Venezia.

*B*artolomeo de Bartolai sits on his haunches on the threshing floor in the dark, his lanky frame folded upon itself. He looks out toward the ridge, waiting for the sun to rise, eating his meal of cheese and onion and bread.

It is time to let me go.

He says this to the mountain.

How many days have I left? Thirty? One hundred? Six hundred?

Even as his body deteriorates, he is strong. If you survive this long, you do not die off so easily. What he suffers from, he does not know, he only knows that pain has settled into his neck and jaw, his joints are somehow stiffened, but he is an old man, of course his joints are stiff, how could it be otherwise? His hands have not been harmed.

In the darkness, he cannot make out the mountain or ridge.

The sacks, the pouches, are filled with his supplies.

The bell at the campanile below in Ardonlà lumbers four times.

So this is it.

The other night, he had a dream. An angel came across the sky in profile wearing a crisp blue robe, its body disappearing into a taper. The angel spoke to a sleeping saint, San Gioacchino,

slumped in front of a shed. The angel babbled and spoke to a mendicant. And then the angel spoke to Bartolomeo de Bartolai, who stood behind the monk. The angel said:

Poiché ai tuoi serve sono care le sue pietre
e li muove a pietà la sua rovina
the stones of Zion are dear to your servants
and her ruins move them to pity
My days dissolve like smoke
and my bones burn like a furnace

He awoke and began his preparations. He left the geese and chickens with Annunziata in the house above; the sheep he gave to Zacagnèr, who will mind them until he leaves again with his mules laden down with wood. He packed up everything unused from the stable.

Now, in the dark, he whistles, calls the goat Diana to him. He pats her head. You beggar, he says, and he feeds her the crust of his bread.

He lowers his head and gives thanks he has been given a vision. He is in awe of it, but not so much so that he refrains from muttering, Finally. Now that my bones have started to separate from the muscle, they send me a vision.

He grumbles but he also says a prayer:

My heart trampled down like withered grass, I forget to eat my bread.

He waits for the sun to emerge and takes another bite of the onion.

The feast of the Magdalene, the twenty-seventh of July, has passed, and it is the first day of August, the feast of San Pellegrino, a hermit who disappeared and lived inside a hollowed-out tree after performing a lifetime of miracles. Soon, on the narrow road above, straggling pilgrims will pass as they travel to the holy site on the pinnacle. It will take them a day to walk there.

Misericordia andiamo girando, they will chant. Have mercy, we are wandering.

In unison they will murmur: San Pellegrino, come down a little lower, our shoes have broken and we cannot climb any higher.

Some pilgrims carry a heavy stone to intensify their suffering, which they will deposit on an enormous heap at the top of the mountain. *Ai tuoi serve sono care le sue pietre*, they will mumble. The stones of Zion are dear to your servants, and her ruins move them to pity.

How many years ago was it that the raven-haired pilgrim passed by on the same path above? The day he heard the hand bell rung six times, signaling that there were travellers, Bartolomeo de Bartolai ran breathlessly, breathless, up the hill. He sold her milk. Superior, superior, literate woman, ostentatious in her poverty, her garb of sackcloth and a thick gold ring on a chain around her neck, her alms purse bulging; she carried no stone. Smack across the face came her insult: How should I know about Giotto's workshop? The paint, the pigment, the grime? I do not think of how these things are made, only of their splendor once they are done. I revere them, adore them, I collect pictures of them in my mind. His cheek still stings and the invisible imprint of a hand remains. Martín de Martinelli bounded away that same day.

Once again, pilgrims will make their way to the holy site of San Pellegrino. Itinerant merchants, beggars, penitents, connivers, and whores will gather there also, a constant stream of the faithful and faithless. Then they will all disappear after three days, the festival done.

Bartolomeo de Bartolai will not follow that slow-moving ribbon; instead, he will walk down the slope to the valley, pass through Ardonlà, turn south, and follow the Scoltenna into a place rugged and unlived-in, to find the cave his great-grandmother had shown him many years ago. She dropped her wooden walking stick and danced from rock to rock along the

river's edge. She was transformed momentarily into a girl, and this is the only miracle he has ever seen.

He is left with Diana, a goat afraid of heights. Diana, afraid to leap across a ditch the width of an earlobe.

You see that ridge up there! he says to her. He points to a vertebrae-thin crest that connects two peaks. Your ancestors danced along that ridge, they did pirouettes up there, mighty and fierce and quick, the poets wrote verses about goats who found footholds in air, and this is what it has come to. The goats eat bread and have to be carried across ditches. Bartolomeo de Bartolai feeds the goat another handful of crumbs.

I could have gone, too. I could have been one of the ones to go. They were looking for men with good strong backs who could lift and carry. They were promising citizenship in the cities on the plains. I could have gone down, too. The others all went. They all got out, but by the time it was my turn, there was no one left, except for the elders, and who else was going to care for them as each returned, one by one, to the state of a child: there was no one else to lift their heads and wipe their chins. Plenty of others left their own, cast off to the deep blue sea. But not me. A fool, Diana. Am I not a fool?

The light of the sunrise begins white. A shimmer. It is rosy and butter yellow, the color of an angel's cheek. He swallows his food with difficulty, his throat is just so dry.

The canvas sacks are filled, piled on the threshing floor.

All that he needs is in those bags. Shards of broken vessels, pots and plates and jars. The rest he will be able to find.

The pine trees with their resins.

He will char twigs for charcoal pencils. He will grind berries into ink.

For food, there will be mushrooms.

He will trap hare and quail and pheasant.

There will be berries all around.
Glorious August, welcome.
Finally, a season of bounty.

As the sun nears the ridge and begins to rise above it, the sky changes to blue. Then blue sinks into itself, deepens into azure, then into ultramarine. The sky bleeds blue. Between him and this view stands the medlar-tree from which tiny Magda fell. She had climbed higher and higher one day in March, at first no one aware she had gone outside. It was his father who flung open the door and led the search. It was his mother who heard the girl say, *N'gô fame*, I am hungry. Bartolomeo de Bartolai arrived in time to see her reach toward a higher branch for a piece of fruit, which she plucked, and then she fell and broke her sparrow's neck. Magda, five years old.

The sun has emerged, already stale, and he has finished eating his meal. It is time to go. Before standing, he lays his right palm upon the pavement. The stone is smooth and not yet warmed. A weight, a force holds his hand down flat, he is powerless to lift it, he does not want to lift it, from the threshing floor. His hand tingles and aches as the stone of the *ara* pushes against his palm. There is simultaneous resistance and pull.

He recites what he was told as a child, a chant, a prayer, a work song:

The day laid on the altar is sacrificed. It is laid upon the threshing floor, laid upon worn-out stone.

The day is laid flat, like the disc of the sun, blinding and metallic. Flat, like the disk of the moon, shimmering and buffed.

Face up, face down, it does not matter.

The day is laid down with open palm, hardship.

It is laid on the threshing floor and lets loose a scream. It is laid upon the *ara*, which is also an altar. The day laid on the threshing floor is thrashed and shred and flayed apart. It is slain.

On the *ara*, the day is fractured; it becomes particles and is multiplied: seven days, twelve months, four seasons, feast days, planting and harvesting, the days making up a year, decades and centuries, waking and waiting, the twenty-eight mansions of the moon as it moves across the arc of the sky. The day laid on the altar is exposed and pulverized. Then it is laid down on the altar again whole.

The day laid on the threshing floor is saved.

He stands, a tall, bony man, greatly stooped over. A gangling, gangly man. A leather pouch hanging from his hip is filled to capacity. He steadies himself with a walking stick that is shaped like the letter T.

Diana, he says to the goat standing there beside him, even you must work to earn your keep today. You must at least do this little job for me; is it too much to ask?

She bleats, outrage, but then relents, after so many years of table scraps.

He drops a saddlebag over her spine. It is filled with materials from his stable-workshop, mastics taken from conifers, pigments ground from walnuts and acorns. The saddlebag holds little clay pots which have been sealed shut with wax, each containing pigment. The yellows were squeezed from buckthorn and broom.

On his own back, he will carry the sacks filled with glittering stones, sparkling pyrites, quartz crystals, and, from downriver, marcasite. Wrapped in pieces of wool are broken eggshells which he has cleaned and dried and dyed in different colors. There are bundles of candles, broken glass, fragments of colored terra-cotta. A fractured mirror, a shattered porcelain cup of a buttery pink. His tools are packed: a trowel, a chisel, a knife, a hammer with a point, a paintbrush made of boar bristle.

In one jar, there is pigment whose color is unlike any he had

ever seen, a celestial blue, from Martín de Martinelli, which Zacagnèr delivered.

He will leave behind his meager field.
He will leave behind his stone house, empty now of others.
He will leave behind the threshing floor.
He closes the door of the stable, he does not bolt it shut. If others want to see what is inside, so be it. The stable, his workshop, with its three separate godheads painted on three wooden panels, gessoed and painted with dyes made from berries, glittering with stones. He will leave it in the hands of whoever protects paintings. Perhaps Mary Magdalene with her ointment jars and all of her concoctions.

He will not empty the stable as he was ordered, he will not be the one to clear out his imperfect vision.

Let them come back and do it themselves.

In any case, the stable has become too small.

He secures the door of his stone house but leaves unlocked the door of the stable for anyone who might wish to view what he has made inside.

He hoists his packs upon his back, and bends, adjusts the pouch slung around his waist.

He stands tall and gangly, like the crane, the *gru*, a large migratory bird, this man from the house called La Gruccia.

Laden with packs, he loses his footing once above the fields of L'Amdaia. He slips, hitting his pelvic bone on a boulder and it leaves a deep bruise. He continues down the cobblestone path, edged by tall grasses and bramble. He makes his way down a sheer cliff, a spine, curving back and forth on the narrow winding path, and following its switchbacks, the goat Diana is strangely come back to life, picking out the places to set down her hooves. In his packs, he carries food. A fine supply of pressed cheese, soft chestnuts, medlars and apples, a cured piece of meat. The rest he will get from the forest and

field. Diana can eat grass; she will have to live without table scraps.

In the valley, he crosses the stone bridge that arches over the Scoltenna. He walks through Ardonlà, past the bell tower that San Bernardino blessed. No one stops to greet him. He walks along the river past the last inhabited places.

The days have certain meaning when they come around each year. This is the first day of August, the feast of Pellegrino. His saint's day is August the twenty-fourth, San Bartolomeo, one of the apostles, a man in whom there is no guile. He travelled far. To Lycaonia, India, and Armenia, and was flayed alive. On November the eleventh, feast day of San Martín who gave half his cloak to a naked beggar, he thinks of Martín de Martinelli.

He uses the feast days to remember: When did he first make a paintbrush? It was in the winter. It was a mild winter and they ate well throughout; even at the beginning of April, they still had food stored below. That was the winter his grandfather Severo languished. In September, he had slipped and hit his head on the feast day of Cosmas and Damian. It had rained and he slipped on wet leaves on a rock as he walked across the field. He lay there for many hours. He was a strong man and no one worried when he did not return at midday; he had taken his meal with him. But when he had not come home by evening, his mother sent Bartolomeo de Bartolai down to search. Severo lay there, still conscious, looking up at the sky. He called to his grandfather from up above and ran down, and when he reached him, Severo said, I was wondering how long it would take before somebody brought me down a pillow.

For a few days he was well, as if nothing had happened, until a granule of stone exploded inside his head. From then on, he lay in bed. On the feast day of the Epiphany, they had all gone down to Ca'd Singhiera for a gathering. Bartolomeo de Bartolai returned to the house to sit with his grandfather so his mother

could be with the others. Walking back, he found a frozen boar, which he carried on his back all the way up to La Gruccia. They did not eat it, it had been dead too long, and they did not know if disease had killed it. He skinned the animal. They sold the hide but he saved a bit of the bristle. Now, every year when the feast of Cosmas and Damian arrives, he thinks of his grandfather, and on the Epiphany, he thinks of boar bristle.

The entrance of the cave is covered with gorse. He hacks at it. Then he digs out the mud and the boulders that cover the mouth of the cave. He chisels away with the hammer, pulls out stones with his hands. For two days, he digs, putting the rocks into a pile at the edge of the river, which is low in August.

Diana refuses to enter, and sits outside the door.

Gradually his eyes adjust to the darkness. The walls are not damp, there are no trickles of water. There are three sources of sunlight: two slits in the northeast part of the dome and the entrance on the west. The cavern is not as vast as he recalls from childhood; it is tighter somehow, snug. He stands in the center of an imperfect circle, the walls curving up toward the center where they form a vault. The ceiling is twice as high as he is tall. He will need to construct a scaffold.

Suddenly, it becomes brighter. He sees an ellipse in the vault, and within the ellipse, the gold-studded mosaic. It is still intact, unchanged. Foreign creatures and plants. A tortoise climbing out of a pool of water. A palm tree, whose name he does not know, with its bending feather-leaves. Two cranes drinking from a pedestal fountain.

Light passes through two thin shafts. Ingenious Byzantines from the sea. Those followers of Sant'Apollinaris cut shafts in rock to let in the light from the north, the light the artist worships, pays for, prays for, unadulterated light. This cavern was claimed by people fleeing, and they built an altar inside the

cave. They carved the stone above the altar into a vault, and, on the vault, they made a mosaic.

On the floor of the cave, he lays out his tools.

He unwraps ointment jars filled with mastic and pigment.

He unwinds the bundles of cloth wrapped around shards of glass and terra-cotta and mirror.

To keep track of time, each day he makes a mark on the wall to the left of the entrance, using a charred twig.

On the fourth day of August, he begins his work. He washes the walls with water and lye. He uses water carried from the river.

Inside the cave, he burns incense made of pinecone shavings as a purifying fumigant.

From the mouth of the cavern, he looks across the Scoltenna and sees La Gruccia perched upon a ledge. It looks like a crane standing on one leg. Like a crutch, like the T-shaped walking stick of the followers of San Pellegrino who have given up all their worldly goods and live apart from the world. In the distance, he can see his house, precarious and immovable, and it gives him comfort.

At twilight, he begins to construct a scaffold.

On the fifth day of August, Bartolomeo de Bartolai takes a piece of charcoal, and, on the northern wall, he draws an enormous arch. He divides the arch into four rows. Each of the three lowest rows is divided into three square partitions. Standing on the scaffold, he makes the tenth partition, which touches the vault above.

Each partition is intended to be one day's work, but the first, alone, will cost him many more.

He begins on the bottom row, on the far left.

He applies a layer of plaster and lets it dry. Applies another.

And waits for it to dry. Applies another. Days later, he applies the *intonaco* in a small patch, the size of the area he believes he can work in one day. He paints into the still-wet plaster. There is never enough time, and at the beginning of each day, he must chip off the dried *intonaco* he was unable to work the day before, and he reapplies wet plaster at the edges of the previous day's work.

In that first partition, completed over many days, this is what he makes:

A hut in the mountains, and in front of the hut, San Gioacchino sleeping. He sits on the ground, his head resting on his arm, his arm resting on his knee. He wears a rosy cloak. His hem glistens, a mosaic made of shards of red glass and chips of quartz. Facing the sleeping saint stands a mendicant who wears a pointed hood; his arm extends upward and he looks at the sky. His clothing is made of clay. Between the saint and the mendicant stands a shepherd who wears a tunic of purple cloth, a *saltimindosso*, torn in three places in the hem. The purple is made with broken eggshells colored with the juice of berries.

An angel reaches toward the dreaming sleeper. Red drops fall from the angel's outstretched hand down to the shepherd's head.

The shepherd is allowed to overhear the dream. The angel, mumbling, points toward a barren slope with an entrance.

In his picture, Bartolomeo de Bartolai includes a gorse plant, spiky, unforgiving, plant of anger.

Next to the shepherd, he paints a goat.

The first section has taken him nearly one month to complete. He begins another, adjacent on the right. A line of people ascend a mountain path, heading toward a distant pass. Each figure is in profile, hunched over, head covered with hood. Feet are planted into the ground at an upward angle, a

knapsack pressing down. Each leans into the slope, weight thrust upon a walking stick. The first figure is distinct, but the next one, a little higher up, to the right, is less so. Each emigrant recedes a little more, becomes more distant: a hood, a pack, a staff, a head, a torso, legs, and arms, leaning at the same incline, repeated, until the one who is farthest away is nothing more than a splotch.

Another month has passed, it is now October. In this month, he will paint a pair of hands, open-palmed and reaching, which nearly fills a partition. A woman, whose head is covered with a scarf of rough cloth, looks upward, imploring, waiting for something to drop from the sky. She waits for food to fall. The women has an open mouth, a darkened inverted arc. Her mouth is open in a scream, a moan.

The hands and face are made entirely of mosaic; there is no fresco in this partition.

On the second day of November, the feast day of All Souls, he lights candles on the pavement.

From the mouth of the cave, he can see the narrow road above his house. He can trace its course winding along the mountainside and can occasionally pick out movement, flickers of color. Travellers are headed out of the mountains, the last stragglers, the last of the season before winter comes.

Food, praise God, is plentiful. Chestnuts, walnuts, small birds he snares in nets.

In the fourth partition, in the center of the second row, figures walk in another line, men and women with arms raised above their heads, prisoners who walk down a slope. They form a serpentine line descending a hillside; they are being herded into a cave. The figure closest to the viewer is largest and lowest on the slope; the one behind it is smaller, to the left. There are at least thirty, although with the unarticulated shapes of those farthest off, the number could be much higher.

December comes. There is plenty to eat; he is used to living on next to nothing.

The fifth partition, to the left of the prisoners, is dominated by a single image: a book that has burst into flames. Pages are covered with tiny brittle marks, segments going off in a thousand directions.

Months ago, the priest from the next valley over walked into the stable at La Gruccia, and asked Bartolomeo de Bartolai to explain the paintings and mosaics. What is this? What is that?

Bartolomeo de Bartolai had shown the stable to no one. But someone told someone that he did something in there, maybe he made magic, maybe he met with Lucifer.

The priest told him that he must cover it up. There is wrong-thinking depicted here, but you are a humble and ignorant peasant. You have the dream of San Gioacchino, but nothing about the Virgin? You have a Mary Magdalene but no Holy Family?

I copied a picture, Bartolomeo de Bartolai replied. I saw a fresco at the church of San Pellegrino where the pilgrims go. And I drew my picture from that.

These angels, the priest said, these three angels are not drawn as they should be. You have made angels that do not conform. Are they Seraphim? Are they Cherubim?

They are not angels at all, but higher beings, Bartolomeo de Bartolai said. Three Gods of equal standing.

You must not say those words together, must not utter them in tandem. There is only One God made of Three Persons. You misspeak, you are in error. To utter them in earnest and not in error is considered heresy.

Then it is best I speak no more.

Still, said the priest, I can see that you are a simple man who has become confused and succumbed to erroneous think-

ing; it is easy to misunderstand the intricacies of doctrine. Paint over the walls, destroy the pictures you have made, and the Bishop down below need not hear anything of this little shed.

They stepped out into the May sunlight together.

I like the looks of that capon strutting across the threshing floor, the priest said to Bartolomeo de Bartolai. That sheep, that tree of ripening medlars. I admire the bounty of your little piece of land. You may leave donations at the back door and my housekeeper will take them from you. I can wait until autumn for the medlars, he said.

The next month the priest came by a second time. Still you have not destroyed these pictures? There is a rumor that you work in the fields on Sunday, mix the sacred with the mundane.

Who up here does not?

Ah, my son, this is not a proper question when there are rumors that you make unholy pictures on holy days. Have you forgotten, by the way, to bring me down that capon?

January.

Bartolomeo de Bartolai stomps the pavement to warm his feet. The sun is very far south, and, even in the morning, the cave is nearly in darkness. The cold has brought Diana inside. In the afternoons, he goes outside and pokes holes in the ice that has formed over the Scoltenna and uses a trammel to catch fish.

In this month, he paints the partition at the far left of the second row from the bottom. It is San Bernardino, hooded monk, who passes through the valley and blesses the bell tower at Ardonlà; the bell tower is simultaneously struck by lightning and crumbling.

This same month, in the partition directly above, he paints San Pellegrino, who lived his final years scratching out his life's story on the inside of a tree trunk.

Bartolomeo de Bartolai recites, Awake and moaning, like a solitary bird upon a roof.

February, he survives on chestnuts. He roasts them, then eats them cold for the next week. He drinks water from melted snow.

Il mio cuore abbatuto come erba inardisce, dimentico di mangiare il mio pane.

My heart beaten down like dried-out grass. I forget to eat my bread.

This month, in the seventh partition, on the third row from bottom, he paints a naked man, whose arms are outstretched and legs are parted. Blackened spheres are painted symmetrically on the man's body: underneath each ear, on the right and left of the neck, under each armpit, on each hip, on either side of the groin, below each knee. Places where the bubos of plague will appear. Each nodule is connected to another by an arching line. The nodule on the neck is connected to the outer part of his hand, the earlobe to the thigh. These connecting threads make it seem that the man has wings.

March. He eats nothing but roasted chestnuts. He limits himself to five a day. His food supply has dwindled; he becomes hallucinatory.

He works in the tenth partition, above all the rest, which is the shape of an arch.

A borrowing from Giotto: Ten grieving angels in a bottomless blue sky. Hovering and wailing, they moan over what they witness below. Each face is contracted in anguish. Their eyes are distended slits, their mouths contorted ratchets. Ten angels altogether, some with hands and arms outstretched, one with fingernails tearing at its face, one that rips out its hair, each grieving in its own way, with a body that tapers off like a flame. Ten angels who preside over his depictions of misery below. Their cheeks are made of porcelain, which is very costly.

April. Winter persists. There is no sustenance.

Da cenere mi nutro come di pane
alla mia bevanda mescolo il pianto
Ashes nourish me like bread
and for drink I mix tears

The ground is covered with snow. He traps the occasional sparrow, catches the occasional fish. He shares walnuts and hazelnuts with the goat Diana. Without food one can live for weeks, without water, no more than two days.

In the ninth partition, he makes a mosaic that depicts an avalanche that covers the entrance of this cave with rock.

The days in this cavern have multiplied. *Lunedì. Martedì. Mercoledì. Giovedì. Venerdì. Sabato. Domenica.* They have travelled up a narrow river valley, bounced against mountain walls, become broken, refracted, *Lonedì. Marte. Mercur. Giove. Vener. Sabet. Dmenga.* The days of the week have multiplied, been repeated over and over. Day of the Moon, of Mars, of Mercury the Messenger, of Jupiter, of Venus. Day of the Sabbath, Day of the Signor.

What has been done is measured by a *giornata*, thirty-eight hundred square meters, the area two oxen can plow in a day. Son, his father said to him on his deathbed, in a darkened room, Tell me again, son, how many fields have I plowed? *Quante giornate?* his father asked. His father, who had kicked him on the leg, in the kidney, but only when he was drunk. His father, to whom Bartolomeo de Bartolai fed spoonfuls of gruel, to whom he gave tiny sips of water, whose weakened body he bathed. When he laid his hand upon his father's head to see if there was fever, his father grabbed his son's wrist and said, Where is the space between two days?

The months of the year have passed.

July, Julius Caesar born in this full month. August, month of Augustus, first Roman emperor.

September, the seventh month of the Roman year. October, the eighth month. November, the ninth. December, the tenth.

Janus, two-faced god, guardian of thresholds.

February, month of purification.

Mars and war.

The month of April.

Come May, he implores, come Maia, mother of Mercury, that is to say, mother of Wednesday.

Come June, the month of Juno.

The days have multiplied, been separated from each other and gathered into bundles, sheaves tied together with dried-out blades of grass.

L'estate. Summer. Outside, the extended season.

L'autunno.

L'inverno. Winter. Hibernum. Hibernate. Sleep. Cave. Tomb. *La mia arca*, my tomb, my ark, like Giotto's *Navicella*, a barge, the barge across the water.

Primavera. The truly, verifiably, first season. I am so, so tired of waiting.

In his stupor, he recites a Psalm over and over.

My days dissolve in smoke

And my bones burn like a furnace

In May, light enters the cave directly. The forest and fields yield nourishment; he catches frogs on the river bank. There are birds again in abundance. He has finished a quarter of his work in the cave.

Color, more color, he says.

And more light.

*** *

Bartolomeo de Bartolai begins the southern wall, ten partitions within an arch.

Opposite the panel with the women with the outstretched hands, he paints a farmhouse. The house has windows that are lit with yellow light. In the foreground lies an enormous threshing floor. The threshing floor is made of grey stone, with a smattering of cobalt. Laid atop the threshing floor and nearly covering it are three enormous stalks of an unidentifiable grain.

Each image of this wall is one of consolation. In the tenth partition, opposite the grieving angels, is Mary Magdalene. Pouring balm from a jar, she is very tiny. The ointment jar is enormous, it dominates the panel. It lies on its side, tipped downward. The unguents spilling from it are colored fragments that spill into the partitions below.

This ointment jar contains spikenard.

Spikenard, very costly. Spikenard, very precious.

Bartolomeo de Bartolai uses some of his most valuable stones for this ointment jar. Reds of every sort. Crimson. Scarlet. Vermilion. Sinoper. Ruby. Rose. Made from shining stones and glass.

At the end of autumn, he begins working on the eastern wall. He draws an arch and divides it into three horizontal partitions. Each partition contains a single face. Each face is a mosaic made of brown and lavender stones. The eyes, almond-shaped, are vast and stare out in a stark gaze. Above the eyes is a single band of black, an eyebrow joined at the middle. The nose is a vertical gash. The mouth is a black line, severe and emotionless. Each face is crowned by a pale yellow halo made with eggshells.

Beneath each face, wings are shaped like a crescent moon. Each head rests inside an arc, and the wings are made of marcasite.

Godheads or angels, it is unclear which.

Light enters from the north and east. He has finished three of the four cavern walls. But the darkness, he says to himself, the darkness, cannot be fended off, even with glittering stones embedded into the wall. Unsatisfied, desperate, he begins to chisel grooves in the wall, three hundred and sixty-five of them.

After he has finished, he walks along the river, in search of flat narrow stones. At night, he sits by a fire in the cave, chiseling each stone into a wedge. The next day, he fits the stones into the wall. Each makes a tiny shelf, no more than three inches wide, blending into the composition behind them. In the partition that depicts San Gioacchino sleeping, there is a shelf below the gorse plant. A candle set on the shelf illuminates the yellow buds, which in turn cast a yellow light on the halo.

Still, it is too dark within the cavern. The priest denounced him as a light-worshiper.

Bartolomeo de Bartolai takes the bundle wrapped around the mirror shards.

How is it he possesses such a precious object, even one in fragments?

In the villa, the Mistress had thrown a tantrum, there was an unleashing of anger: Why oh why oh why had she agreed to come live in such wilderness? She broke mirrors inside the villa, which were then swept up and carted out by a servant, his father, tossed into a heap in the far corner of the garden where the Signore had planted a pine grove that form the initials of her name. *V. L.* Behind these pine trees, beside the stone wall, he found these tiny broken marvels. Bartolomeo de Bartolai, gangly scavenger, collecting firewood, saw the shards. He took off his rough shirt and rolled the pieces of mirror into it. He carried off as much as he could. When he got home, his mother hit the back of his head, cuffed him. Do you want them to think we are vagrants?

Bartolomeo de Bartolai takes these hoarded shards and embeds them into his pictures. Mirror fragments drop from

the ointment jar; tiny mirrors are tucked in among the scrawlings of the burning book; mirrors glisten within the saint's halo and shine from the eyes of prisoners being herded into a cavern.

He climbs his scaffold. He reaches toward the center of the vault to paint around the ellipse that contains the Byzantine mosaics. He paints this area blue, a blue not native to these mountains, not native to this entire mountain chain, north or south, but originating in far-off lands, over the sea, this blue that comes from beyond the sea, ultramarine. The blue delivered by Zacagnèr completely encircles the mosaics.

He does not realize how costly is this pigment, only that it is astounding.

He finds himself in the middle of December, although he cannot be certain. He has marked each day upon the wall with charcoal, but there may have been days when he forgot or was too weak. How many days has he missed? Who can say for sure. What does it matter? He is cold and tired and hungry, and there is still more to complete.

He begins his last days of work on the western wall, brushing it clean. He applies the first layer of plaster, then the second. He divides the wall into seven parts, each of equal size, each separated from the other by a vertical line.

He begins to the right of the threshold. The first partition, directly across from the shafts, receives direct light. He embeds shards of mirror and pieces of quartz into the gesso. There is no image, no animal or plant or heavenly being. He forms the tesserae into an enormous, imperfect, mirror that accepts, then multiplies, light.

On the second partition, he lays a coat of *intonaco* and paints two bands of color: a green earth called terre verte. Above it, he paints a band of blue. Earth and sky.

On the third partition, he paints the sea, and beside it a mass